Fantasy+

① Best Artworks of Chinese CG Artists

Vincent Zhao

CYPI PRESS

Contents

Preface

Fantasy+

Vincent Zhao

When I was thinking about the title of this series, a question posed by many people years ago popped into my mind: When will fantasy move on?

Fantasy, it seems to me, should be understood more as a cultural and spiritual genre in the broad sense than just as a technical term in the narrow sense. Indeed, it is when we stop waxing nostalgically about its past that fantasy in small letters will go on forever. Fantasy, then, will endure as it should in capitals for eternity and everlastingness.

Illustration is an art form for expressing one's fantasies in a most efficient and expansive way. As luck would have it, you may not have the carving tools or clay at hand to make a sculpture, nor engines or teammates to play a game with, nor enough funds to make a film. That said, you must have had desk corners and page edges to scribble on in your childhood. Each and every person can decide on both the themes for their drawings and the medium for creating their artworks. And, as such, more and more art forms today cater for virtually anything that a fantasy-filled heart desires.

Illustration, on the other hand, is also a media that is much more cross-cultural than language. To distinguish graphic art from classic painting and modern art forms, a more exact definition might be 'commercial illustration,' and thereby can include such diverse categories as book illustration, poster illustration, cartoon illustration, game animation, concept design, and matte painting. Traditional hand-painting techniques and the emerging CG technologies, however, are gradually blending and complementing each other. They enhance, but do not replace, one other.

Frank Frazetta is now 80 years old. His prestige and achievements add significance to fantasy art in 2008. He is as old as the art itself. During the past decades, Frazetta has become a living totem for his colleagues, and his creations have had such a strong influence on succeeding generations that dozens of distinctive artists from around the world collaborated to present The Frazetta Issue that features Frazetta inspired images as part of the tribute to his 80th birthday. Fantasy art, after all, never stops. It stops for no man, nor for any particular medium of expression. While a huge number of equally brilliant art-

ists are paying tribute to this timeless hero, they themselves have become "Frazettas" in the eyes of the current fantasy art fans: such household legends as Boris Vallejo, Luis Royo, and Alan Lee; Donato Giancola, Todd Lockwood, and Tom Kidd, who continue each year to promote the glory of hand painting art; Gerald Brom, the late Zdzislaw Beksinski, and Phil Hill, sinking into oblivion while embracing their own aficionados; Craig Mullins, Ryan Church, and Steven Stahlberg, standing on the very pinnacle of the new digital art the moment they started their fantasy careers; Justin Sweet, Jon Foster, and Andrew Jones, the best examples of this generation, each a combination of the heir to art traditions and the CG explorer; James Jean, Daniel Dociu, and Aleksi Briclot, who have kindled a fire of creative passion in their contemporaries, and at the same time are never far away from the major art awards of recent years. Yes, this industry is moving forward, always.

The Fantasy+ trilogy, then, may well lose its 'positive' connotation if the '+' therein represents nothing more than a sort of continuation or addition. Now that the capitalized Fantasy has come to symbolize something

spiritual, what we are trying to find in this book are the traces of development and progress.

It follows that what you see here are not a couple of albums of paintings, which undoubtedly fail to express our themes in a more perfect way, although such albums might be easier to create. We have contacted some of the most representative authors, with whom we exchanged ideas about the current commercial illustration art. Our dialogs focused upon their work and their lives in recent years, their comments and opinions on this industry today, and their unpublished fantasies. We have maintained some control over the ratio between text and artwork, with each volume containing at least 200 carefully selected illustrations. The relationship between fantasy and progress is defined in terms of individual artists, and this approach, I hope, will facilitate the sharing of our confidence and ideas.

The first book, Best Artworks of Chinese CG Artists, stands alone as a collection of the greatest works available from that culture today. Though the commercial illustration sector in China is full of questionable work, some of it no more than absurdities, true art lovers have more pure visions. The artists collected here are so committed to the dignity of their subjects, that I was forced to set aside my prepared remarks condemning the state of the industry today. Their work is truly moving. These artists present themselves as internationalized images with clearly defined contours and high levels of achievement, and hence my text focuses more often on the artworks themselves and the colorful profiles of the fantasy masters.

Best Hand-Painted Illustrations expresses my hope of familiarising readers with those fantasy masters who still prefer to stretch the canvas and mix the paints. It must be noted that these artists often find themselves playing to current tastes in this fast spinning commercial world. Striking the two keynotes of "paying tribute" and "essential totem", they are nevertheless seen walking far away from those earliest fantasy illustration themes where muscle and violence are interwoven. Unfolding before our eyes, therefore, are beautiful images that are more multi-dimensional, and achievements that are more artistic.

Best Artworks of CG Artists features the most effective and state-of-the-art interpretation of digital technology's impact on art. Tied so closely to the present-day film and game industries, this multi-dimensional artistic form provides the most efficient means for directors and game designers to realize their fantasies. It is fair to say that the burgeoning CG will introduce more people to the world of art. And, with artists having a larger number of clients to serve, we will surely experience the best service the present-day commercial illustration industry has to offer.

We expect the Fantasy+ trilogy to stand for something; something you hope for; something you can trust. Together, these fantasies and you will grow.

Taiwei Bi (Bullet)

Name: Taiwei Bi (Bullet)
Profession: Art Editor, Freelance Illustrator, Comics Artist
Homepage: www.cgplayer.com

Man in Dreams
A Special Interview with Taiwei Bi, Illustrator

Illustrators committed to the theme of dreams, artists in the world of illusions, and professionals behind the fantasies— they are all people in dreams.

Mr. Bi has been busy with his new book series Dream of Illustrations, which features his musings on and journey to art. Hardly a moment passes by when his illustrations are not focusing on the theme of dreams. Simply put, it is the relationship between the images and their surroundings which resembles the structure of a dream. Or, more profoundly, his book strives to launch thousands of dream-filled illustrators on a voyage into success.

Yes, the people in dreams must be brought back to reality either by instilling a certain spirit or by introducing a particular technique. What Mr. Bi is doing really matters. And only this time can I truly understand the people in his illustrations. They turn out to be dreamers.

Interview

--**What projects are you busy with at the moment?**
--My new book, the second volume of the Dream of Illustrations series. It features detailed explanations on how to make professional illustrations, or more specifically, how to get the paintings published. Dream has always been the theme for all my paintings, and the word itself has many layers of meaning: for a newbie, to become a professional illustrator is his dream; but for a veteran who has been around in this industry, to create illustrations is a dream too, in that to stay the course is, sometimes, very difficult. Many professional illustrators are to a large extent striving for their dreams. I think anyone striving for their dream is worthy of respect.

--**In recent years, it seems that all your works are fantasy related. How was the design developed? Or rather how were such dreams shaped?**
--Not all my works are fantasy related. Probably you think all my works available on the Internet feature fantasy. But, in fact, a large number of my other works are devoted to other categories, like comics and commercial illustrations, whose designs have basically developed out of the small things in life. I treat each illustration with seriousness, which, in retrospect, has become my own style. I love classic stuff, and believe that no matter how time changes, our love of life and the pursuit of truth remain the same. This is the theme I have been trying to get across. As likely as not, my art style was formed by my own cultural traditions. Of course, my personal style grew out of the cultural traditions that have made me who I am today.

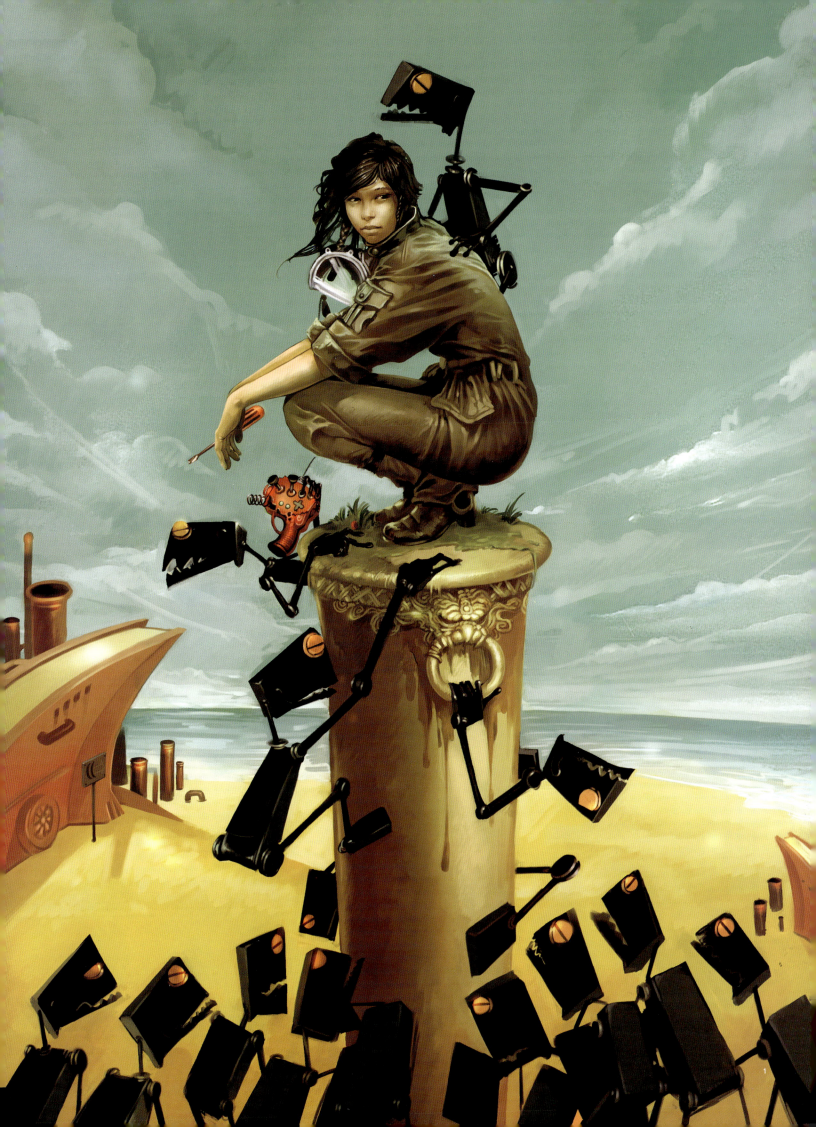

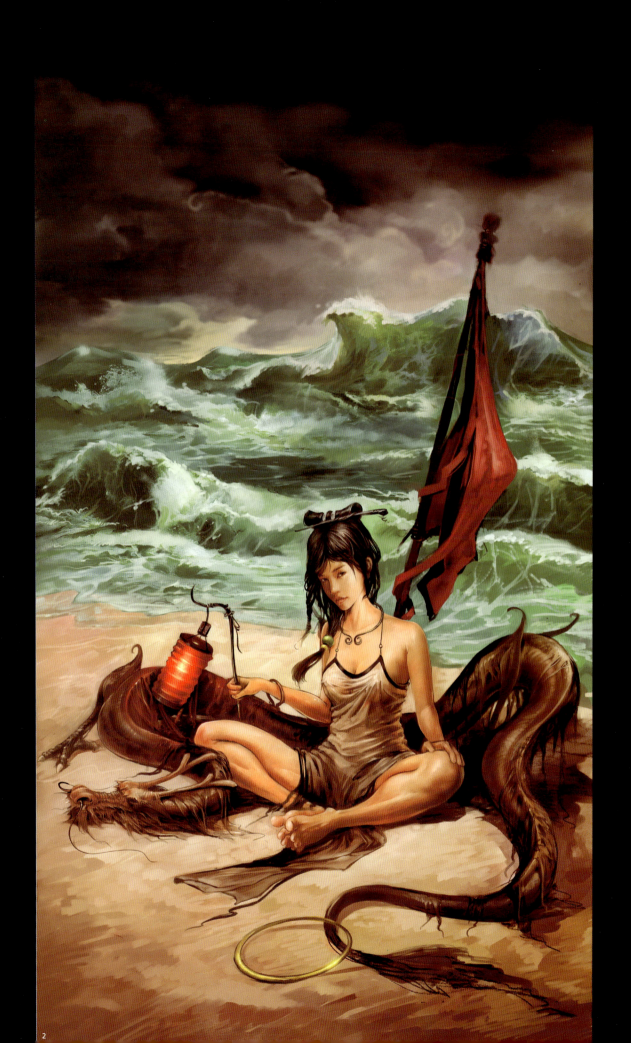

2

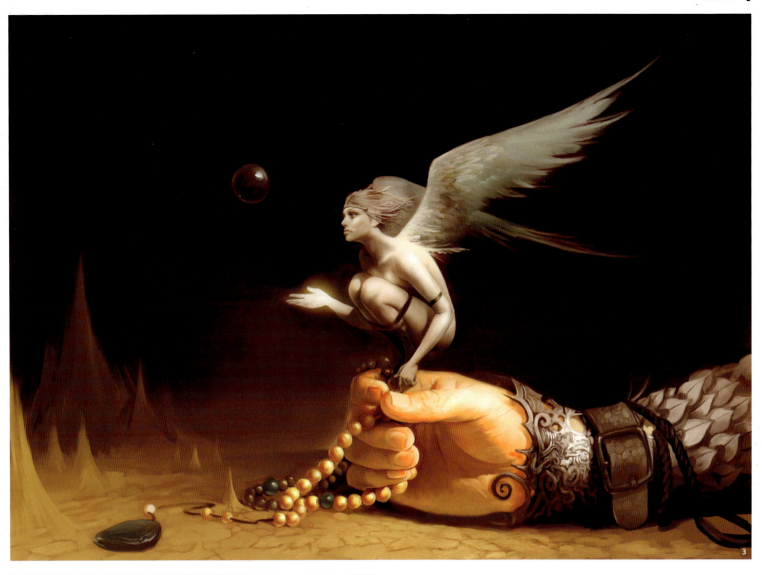

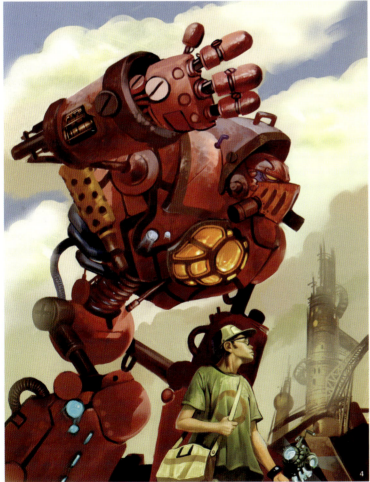

❷ Girl and Dragon

❸ Flying Bird

❹ Robot

--For the newbies who you are training at the moment, what do you expect them to learn, since you inspire them to follow you and read your books?

--I'd like them to know that creating illustrations is no easy job. The reason we continue to paint is because we love to, and although illustrations do make money, that will be a long time from now and not until we have become successful illustrators. Right values make themselves felt right in our artwork, which in turn reflects our soul like a mirror. It is only when we treat our works with due respect that our readers will take a fancy to them.

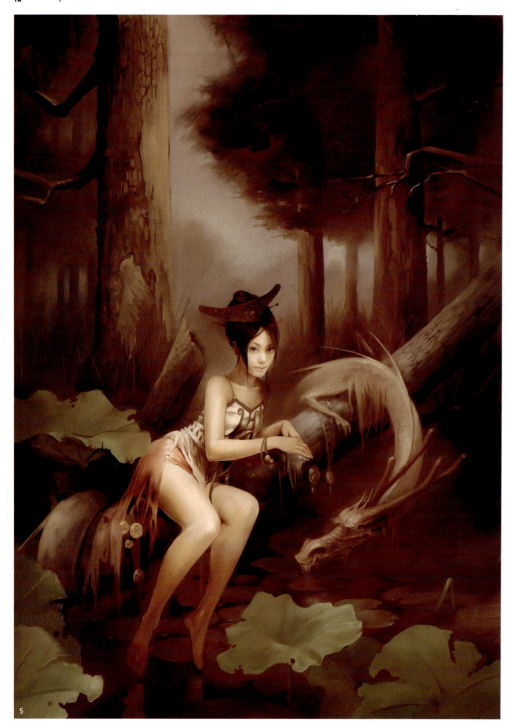

5

-- What was your fantasy when you were young? How far away do you think you are from that fantasy now?

-- I had a very simple fantasy when I was in high school, and that was to become a professional illustrator. It is basically, I should say, a dream come true. And my current dream is to travel and stay in a few places each year. But for a lot of reasons, I rarely make it come true.

❺ Tree Monster

❻ The Queen

❼ Pages from the Cartoon *Island*

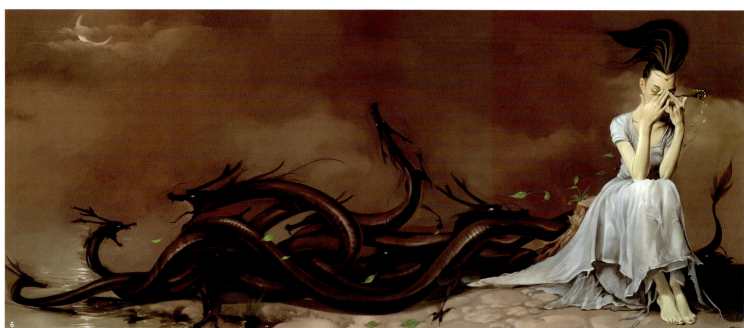

6

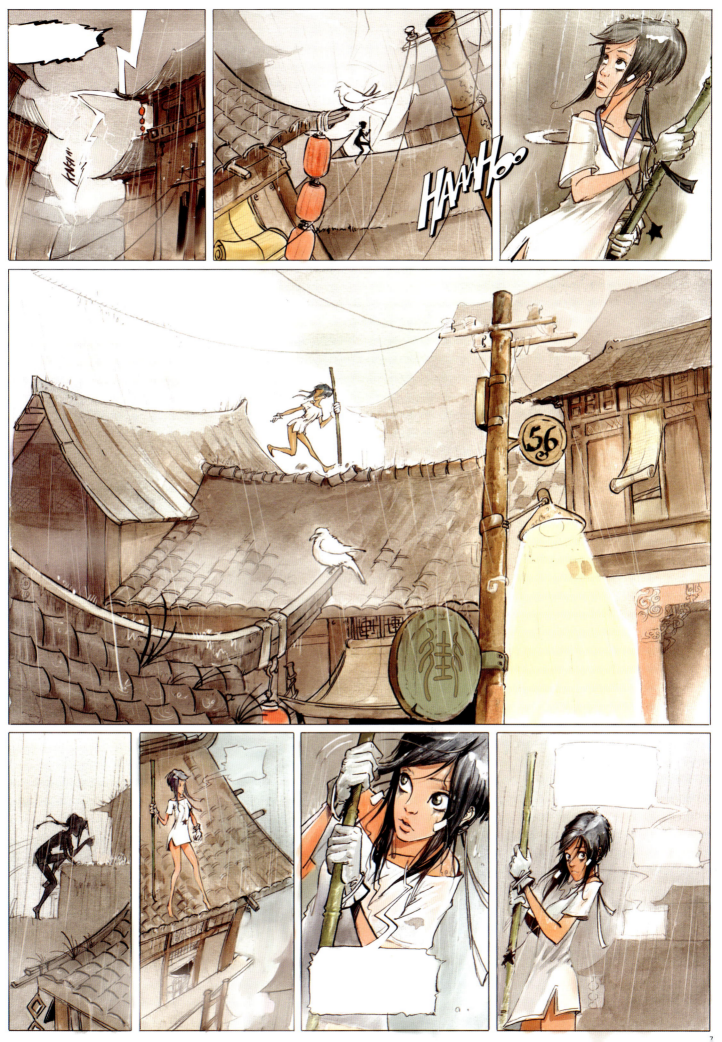

8

9

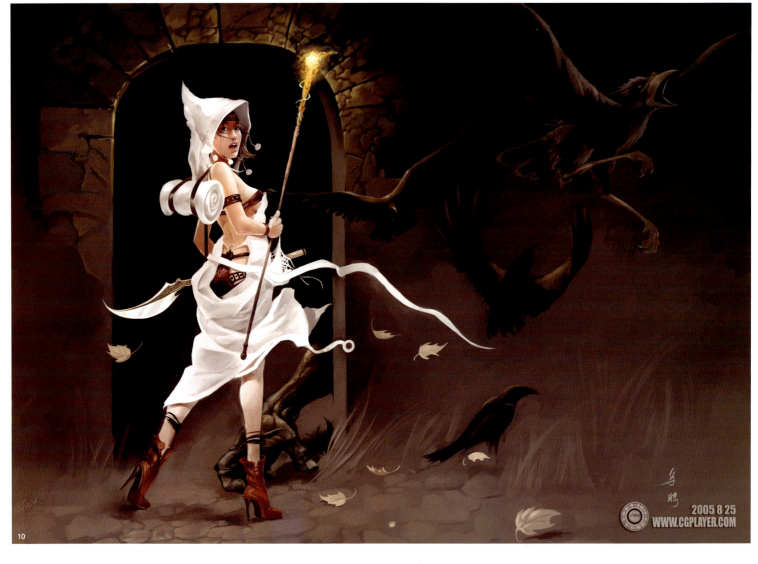

10

2005 8 25
WWW.CGPLAYER.COM

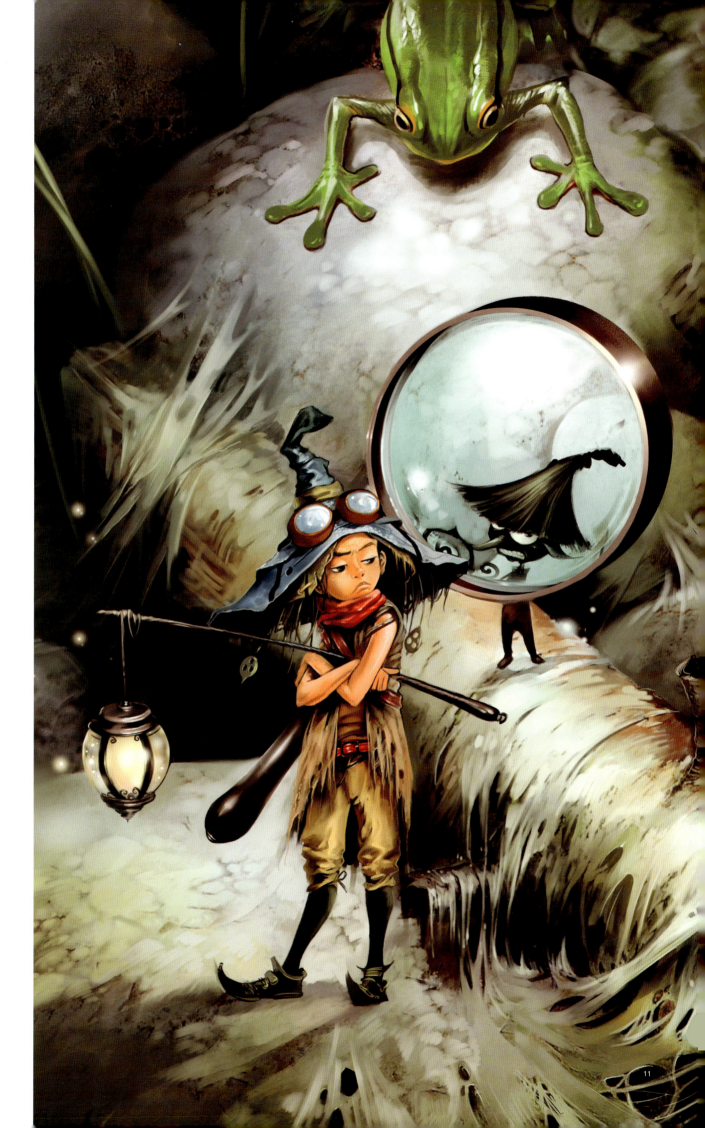

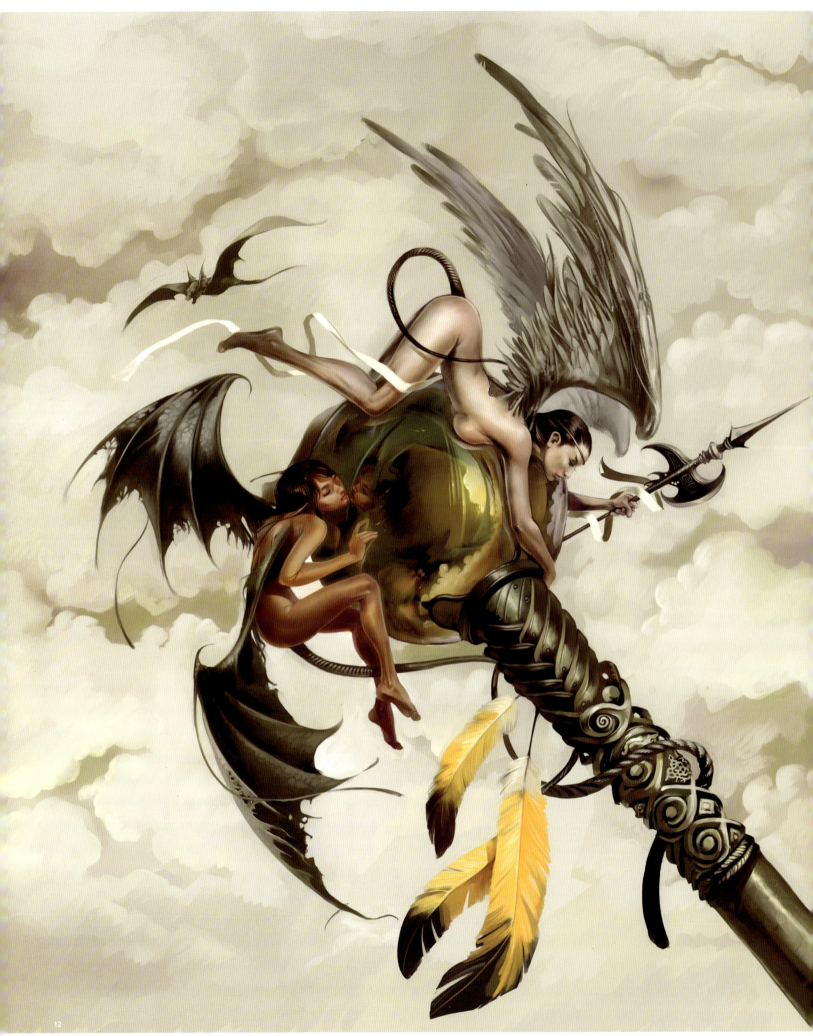

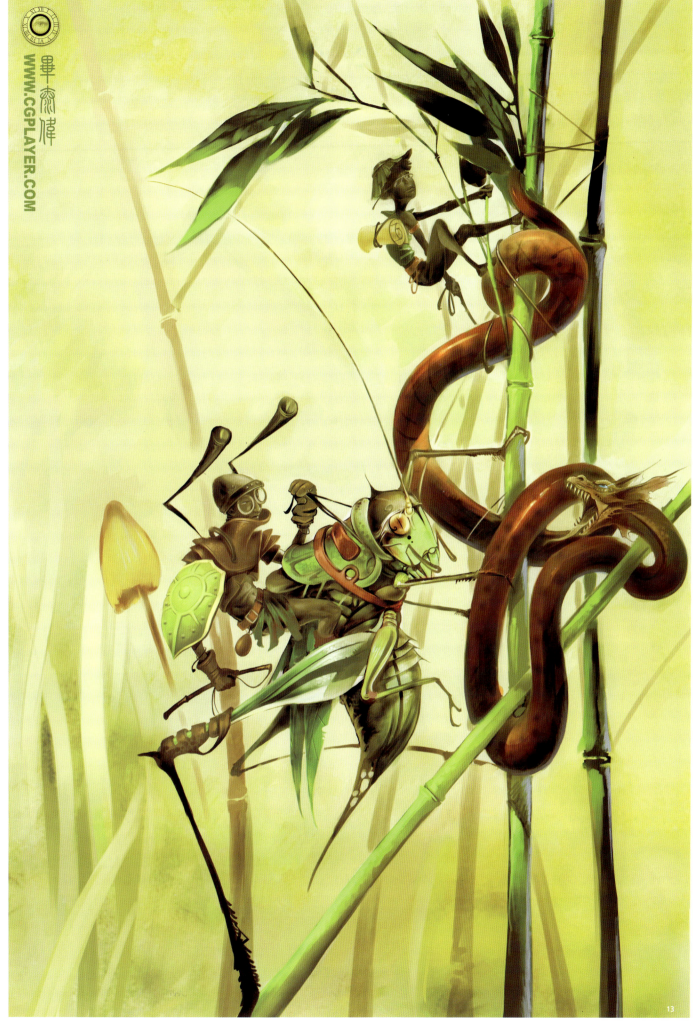

⓮ Grasshopper

Wei Chen (Lorland)

Name: Wei Chen (Lorland)
Profession: Founder and Director of FlowerCity Art Studio
Blog: http://flowercity.ppzz.net

The Beauty of Wei's
A Special Interview with Wei Chen, Illustrator

The recurring theme of Wei Chen's artworks is Beauty, the endless quest for perfection along the lines of tradition and fantasy. The flower-like faces of the spirits, the feather dress of the fairies, the silk robes of the priests, and the profiles of the goddess—all bright with the most vibrant colors, and heightened with 'The Beauty of Wei's'. Within Wei Chen, there are mountains and rivers of poetry, as well as forests of art, and these 'landscapes' are part and parcel of what he has created in the FlowerCity Art Studio.

Ever uniquely splendid and colorful, Wei Chen's artworks characterize the spirit of "The Beauty of Wei's," and hence the most exciting fantasy creations in China's CG community.

Interview

-- *The style of your works always strives for beauty and perfection. It seems that this is the central theme of your creations, isn't it?*
-- If you have done some research on the psychology of aesthetics, it becomes clear that classical art forms represent the most essential human desires and quest for beauty. My artistic pursuits, in essence, maintain the continuity of such social and historical necessities. So, unlike the products of those trendy artists out there, my creations are not likely to win the admiration of the public.

-- *And why are most of your major images female? Do you think painting female figures is the best way to showcase your creative pursuits?*
-- My artworks, I would say, represent my personal artistic interests. Those who have seen the real me can hardly, in most cases, associate my person with my works, and it is indeed paradoxical that many strangers, who have never seen me before, assume that I am a woman. My paintings are classical in spirit, but I don't like very much the so-called pure classicism, but like neo-classicism and romanticism instead. That's why my works are imbued with an air of romanticism, or, if you will, the fantasy style. Female figures are those images that I paint most frequently, although I am recently beginning to paint some fairly masculine ones. The truth is that no painter is per-

fect in everything. It is only when he is already fed up with the old themes and the imagery techniques that he is likely to try something new.

-- *What was your fantasy when you were young? And how far away do you think you are from that fantasy now?*
-- I am now working hard to be the most professional CG illustration teacher in China. I dreamed to be a teacher when I was a kid, and right now I am already a successful university teacher, with my own studio, and my own students. And I don't think I am too far away from that goal.

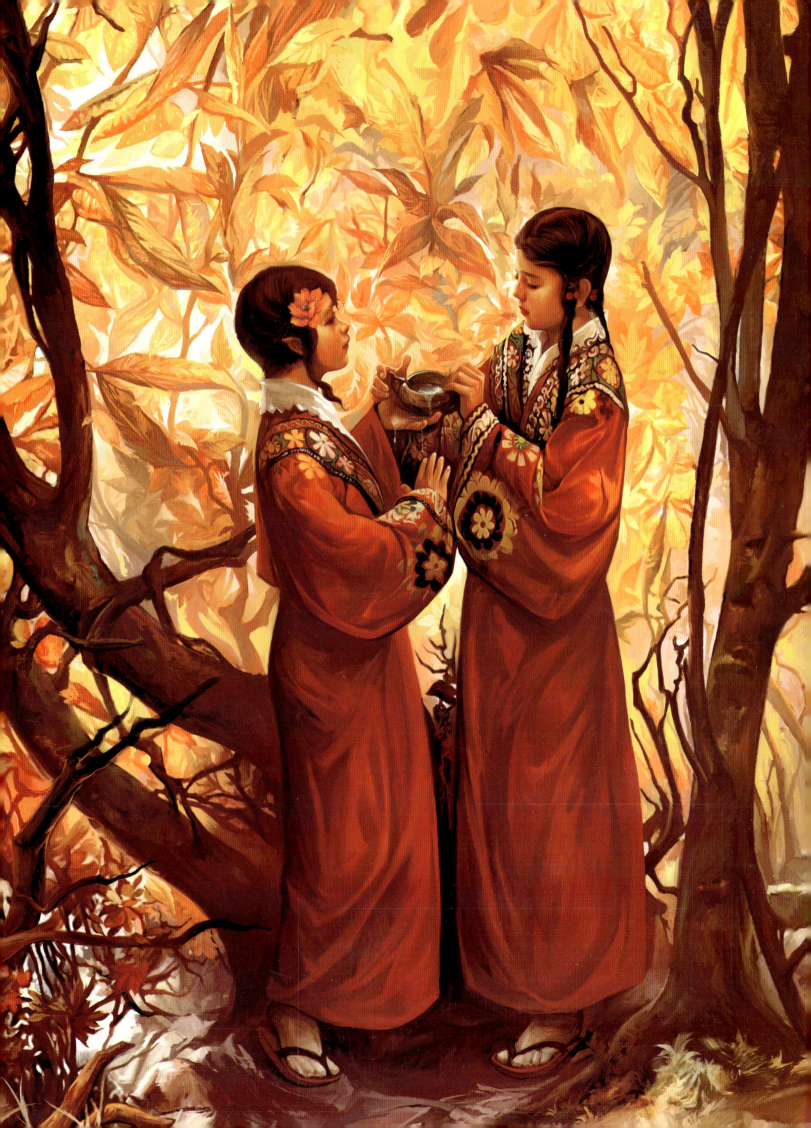

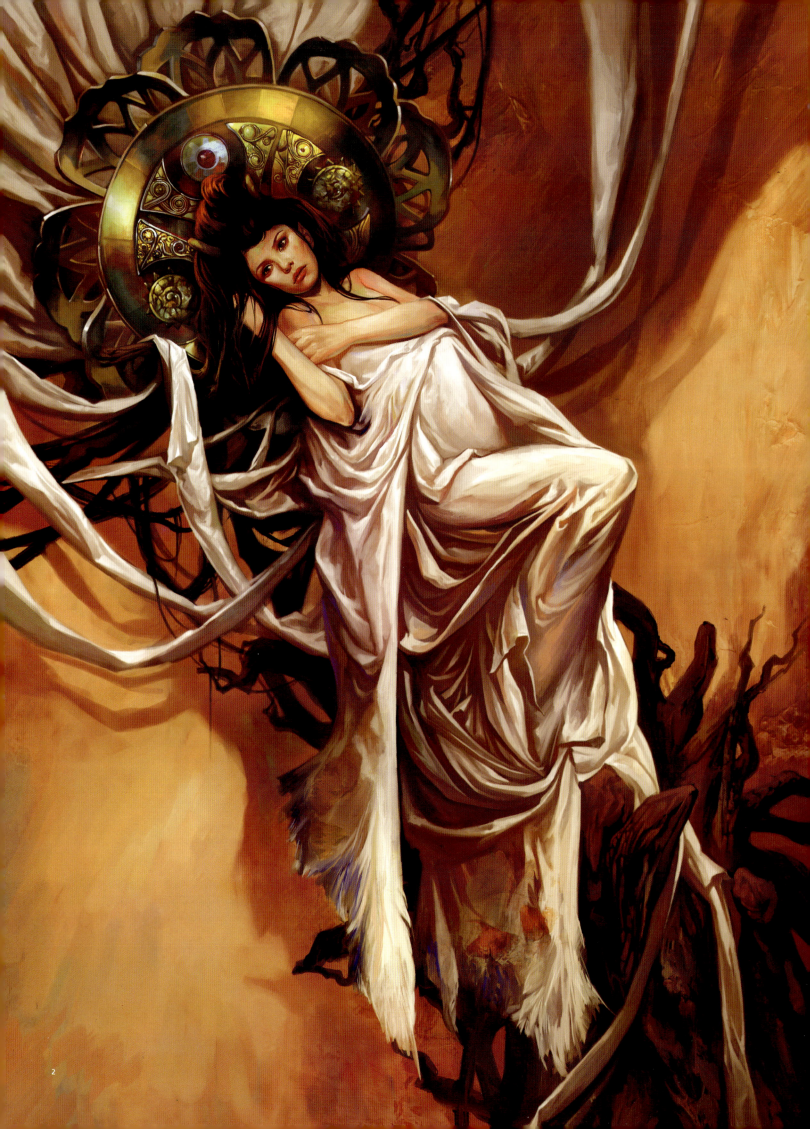

❷ Melancholy

❸ The Valkyrie

❹ Hawkstrider Rider

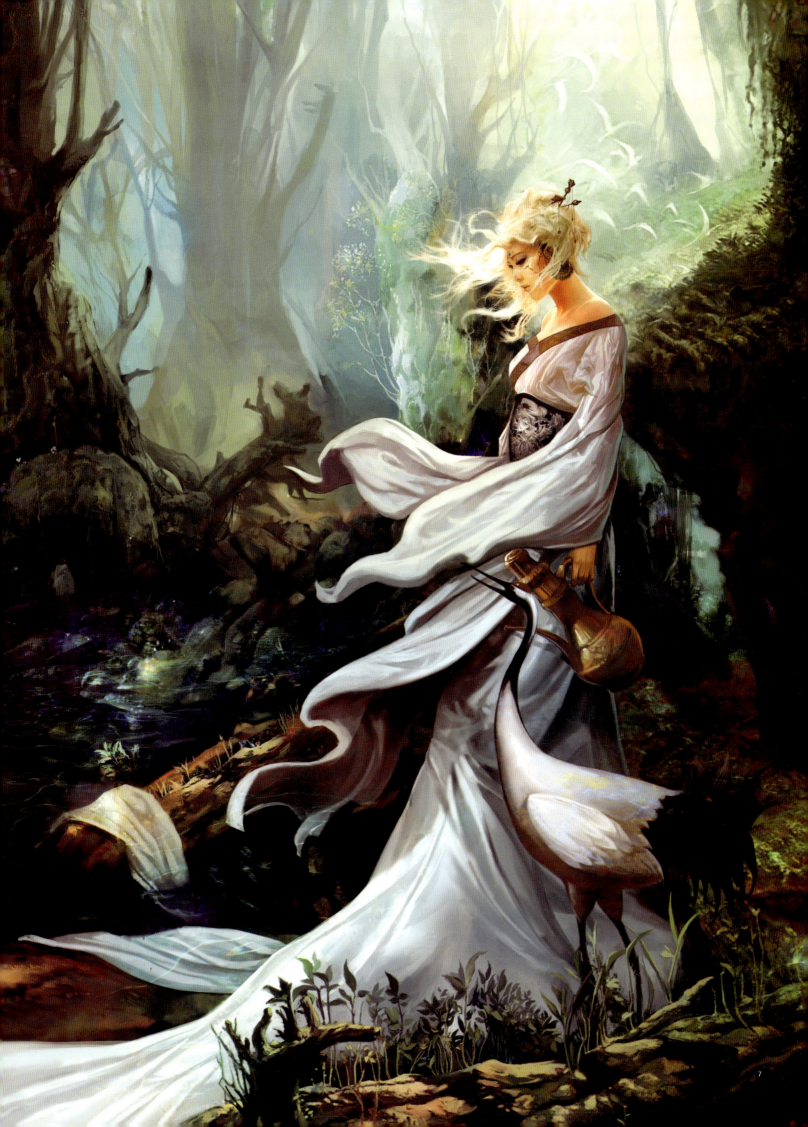

❽ The Past Garland

❾ Lantern

❿ Goddess of the Opera

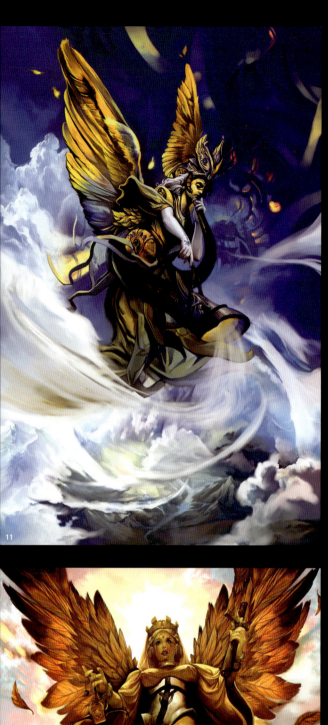

11

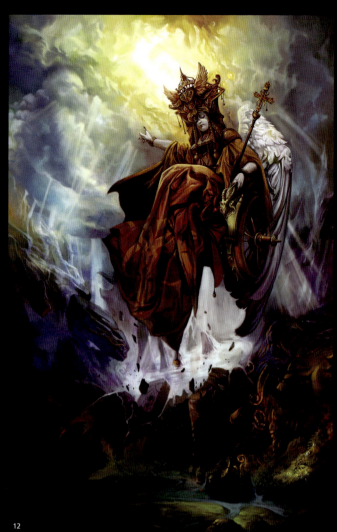

12

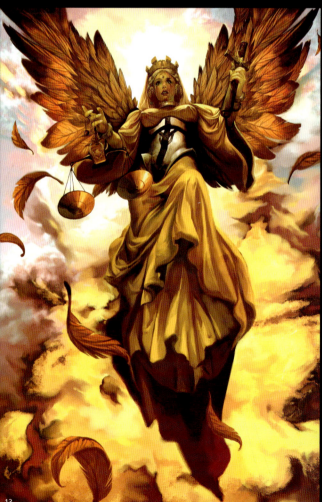

13

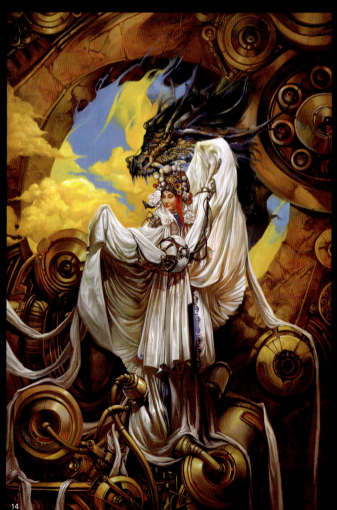

14

15

Minhao Feng

Name: Minhao Feng
Profession: Freelance Illustrator
Blog: http:/blog.sina.com.cn/u/1256629024

The King and the Prince
A Special Interview with Minhao Feng, Freelance Illustrator

The scenes fashioned by such prominent artists as Craig Mullins and Andy Park never fail to earn them the nickname "King of Scene Artists." The whole territory under their rule—the scenes created—is so amazingly majestic that it is rarely greeted without cheers or even boos. We sometimes joke about Feng's self-proclaimed "Prince of Scene Artists," saying that a "king," after all, is a cut above "a prince."

Obviously the butt of our joke is the hierarchy of power, but that tells only half the story. Although the "prince" follows all instructions from the "king" out there, who himself may be restrained in one way or another, our "prince" here enjoys total freedom. Feng believes that he was born to be a scene artist and, accordingly, his love for animals and nature adds a touch of elegance and grace to his idyllic scenes. You may well feel stifled by those kings' paintings, but in the garden of our prince you can take a relaxing stroll. Holding court on the often-told tales like The Wandering Prince, his works unfold before your eyes a new life whose beauty is as impressive to you as it is to Feng, the gardener and freelancer.

Interview

-- *You have devoted more effort to scene painting, and it seems that most of the characters in your creations have changed into landscapes, into something ornamental. Why is that?*
-- Because I love nature far more than other people do, and the first time I encountered these animated cartoon games, I was fascinated by the secondary world filled with the wildest fantasies. Characters, after all, are but a part of nature, so I wouldn't devote too much ink to the characters.

-- *What impressions do you think a good scene painting leaves on the viewers?*
-- I think a good scene painting should create a strong visual impact on the viewers, an illusion that they are experiencing the real thing. It seems to me that what is important to an outstanding painting is, first of all, a good idea, from which develops a reasonable concept sketch. Equally important are the atmosphere and mood. And finally comes the more detailed painting, which should be as striking as they are interesting.

❶ City of Gigantic God

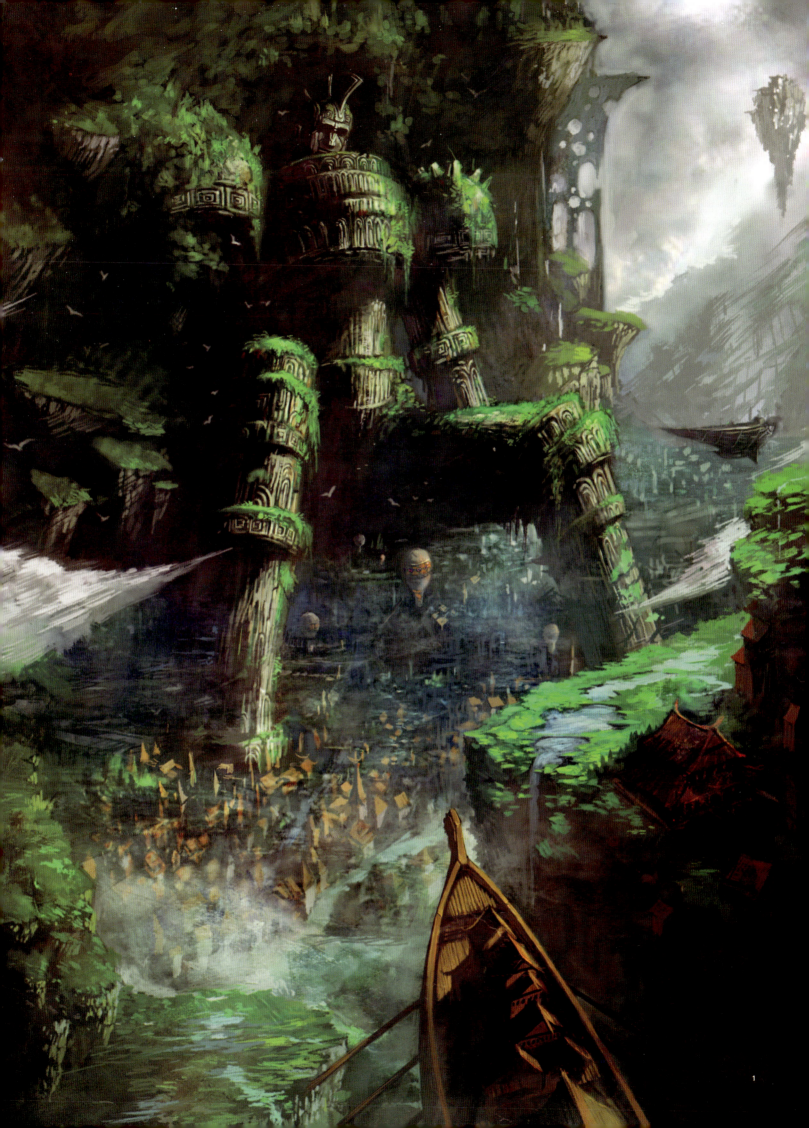

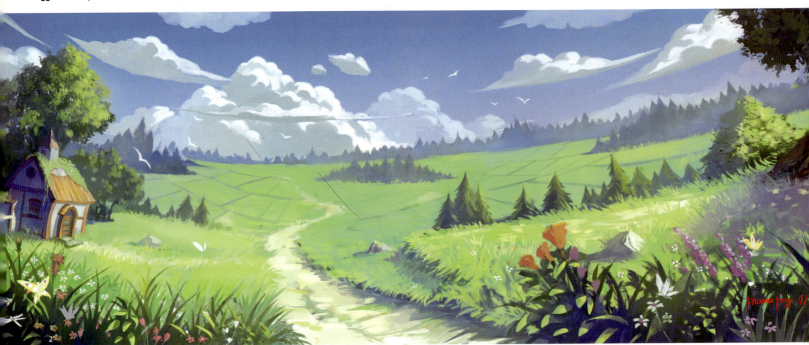

-- Whose creations do you like best? Or any specific artists whose scene paintings have influenced and inspired you more? The colors of some of your works resemble those of Makoto Shinkai. You like his animation works?

-- I like many scene artists, Craig Mullins, Mark Goerner, and Jams Clyne, to name just a few. Makoto Shinkai, of course, is among the few artists that I respect most. He has a rare ability to magnify small daily life scenes into bright and attractive compositions, where the events and settings fit together wonderfully, and the mood of the story and that of the pictures suit each other, hence striking responsive chords in the viewers.

❷ Brilliant July

❸ Colors in the Memory

❹ Long-lasting Journey

-- What was your fantasy when you were young? And how far away do you think you are from that fantasy now?

-- Well, ha ha, I dreamed to be a biologist, a musician, a cartoonist or mangaka, a novelist, a game designer,a billionaire and so on and so forth. When I grew up I came to realize that it was pretty difficult to make all those dreams come true, or rather I was not blessed. I think the word fantasy is not a noun, but an action verb. When I press on toward those fantasies, they are just by my side; in other words, they are carrying me on my way.

❺ Scorching City **❻** Sanctum Site **❼** Fighting

6

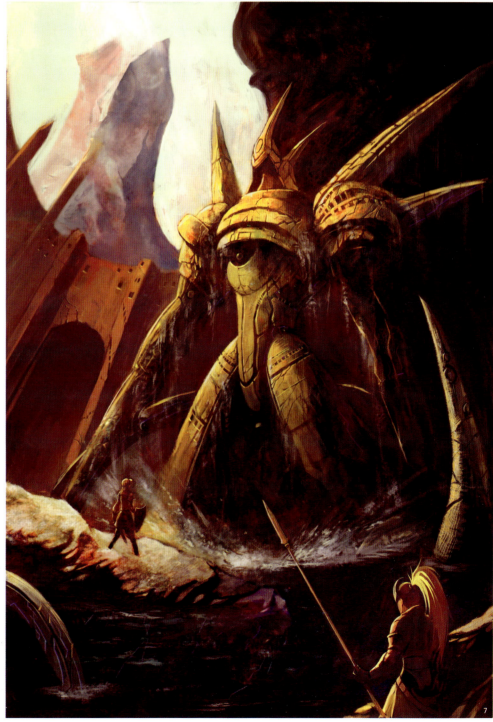

7

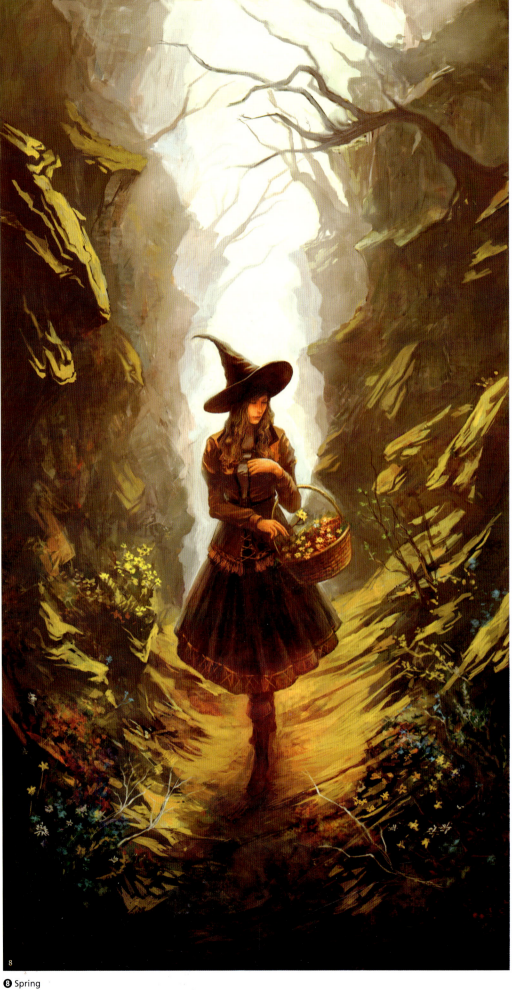

❽ Spring

❾ The Silent Relic

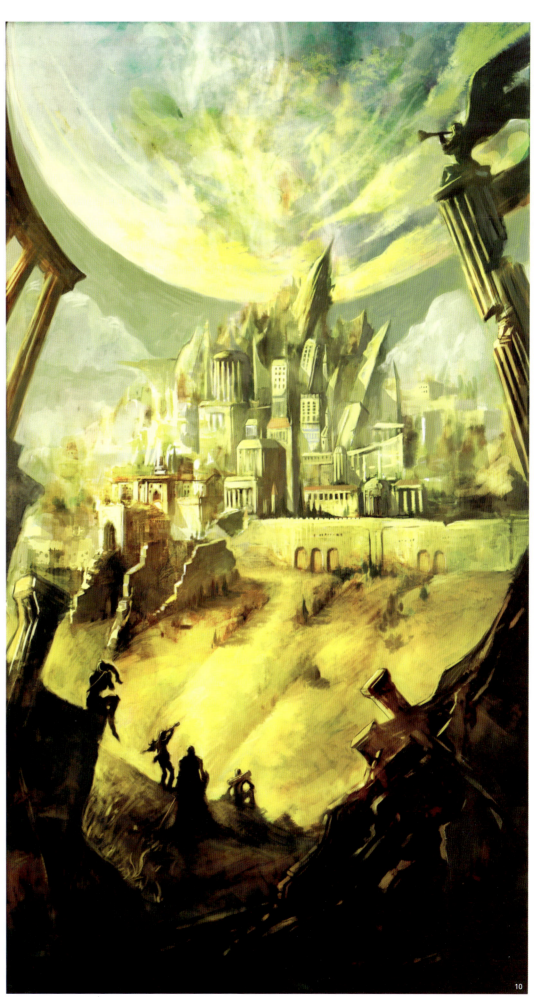

⑩ Unsinkable Moon

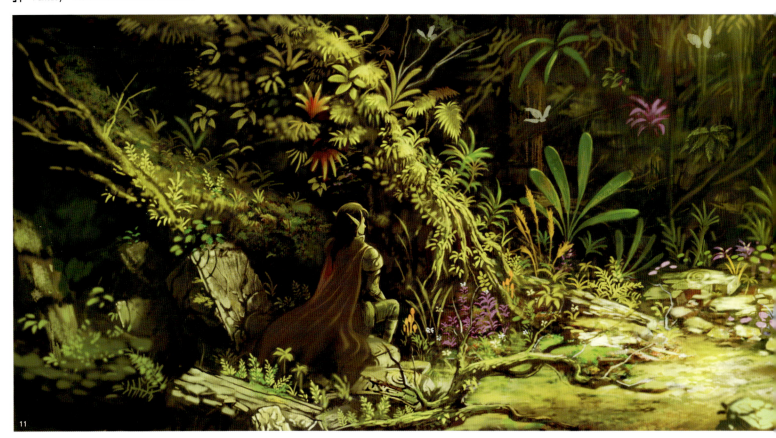

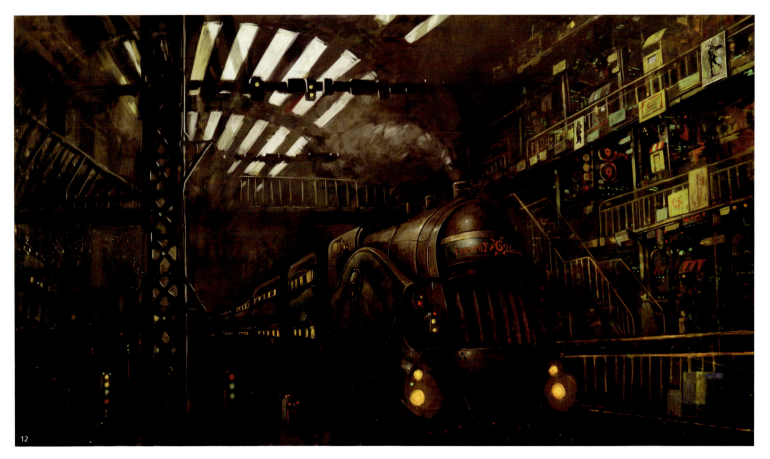

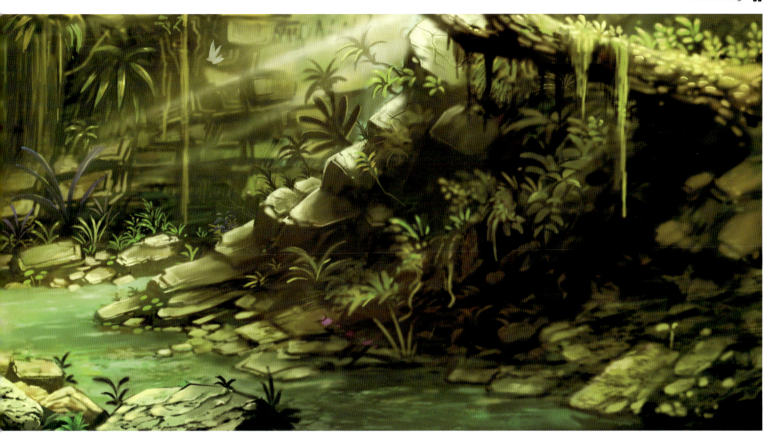

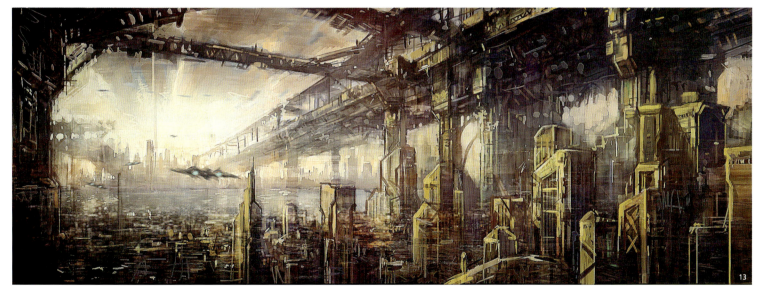

13

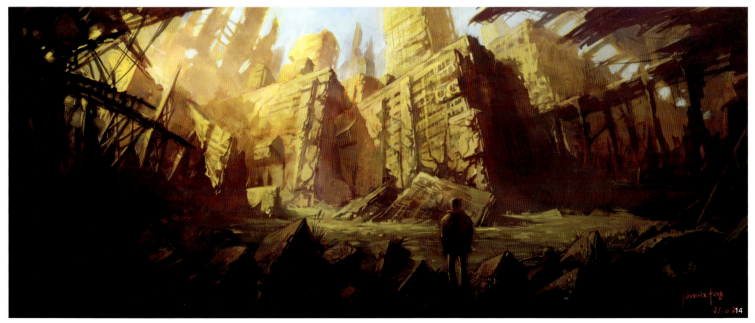

14

Name: Dehong Ho
Profession: Art Director at Redeye Studio Pte Ltd.

Launching Out

A Special Interview with Dehong Ho, Game Concept Designer

It is supposed to be a good idea for us to use The Journey, again, as the starting point for our interview with Dehong Ho, since we have tried this before and it worked great.

Shortly after our last interview, Mr. Ho started on his own expedition in every sense of the word, an experience far beyond our wildest imagination. Back to the game industry, he was ready to try something entirely new—when China's IT outsourcing market was growing rapidly, he moved on to a game company in Sin-

gapore. But it wouldn't surprise you if you knew what's been happening to Ho in the past few years: a lot of Ho's artworks have found their way into art collections published by foreign publishers and, like all artists internationally known for their compelling works, his name has rocketed to fame. The game and film-making industries know no boundaries. Within the commercial art world, verbal communication gives way to graphic interaction.

And so, he introduced himself, as he always did, into the Singapore's game

industry and joined the Redeye Studio. Responsive to the changes in his life and environments, he promptly shifted his role from a brilliant character illustrator to a scene designer. In fact, his former character illustrations are as impressive as the recent scenes in The Journey are fascinating. Unfortunately, it seems that Mr. Ho cannot show us, due to copyright reasons, any of the resulting work yet until the games are released.

Interview

-- *Does Singapore have its own cultural traditions? And what elements of culture are you ready to incorporate into your works?*
-- Singapore used to be a British colony, and later gained independence from Malaysia. Its population consists principally of Chinese, about 70% to 80%. The Singaporean culture, in essence, is largely Chinese. Paradoxically enough, many outdated traditions in China today are still preserved in Singapore. On the other hand, Singapore is a melting pot of diverse nationalities and cultures. Our games

are built on the idea of a new Singapore, an imagined picture of what it would look like years from now, after being destroyed by demons and monsters. The viewers will see how the Occidental ogres join hands with the Oriental devils to rule over a multi-cultural world, where the Chinese structures and Indian temples coexist on European streets.

-- *Today, a lot of Chinese authors see you as their example and idol, and they hope to see more of your own artworks.*

-- Well, ha ha, I have always been grateful to my friends and supporters. As far as I am concerned, the changes this year are substantial. Few works published does not mean few works finished. The problem is that I have been busy with my work schedule and, due to copyright reasons, some works are not available online for the moment. But I assure you that some day I shall rise out of silence with all my new creations.

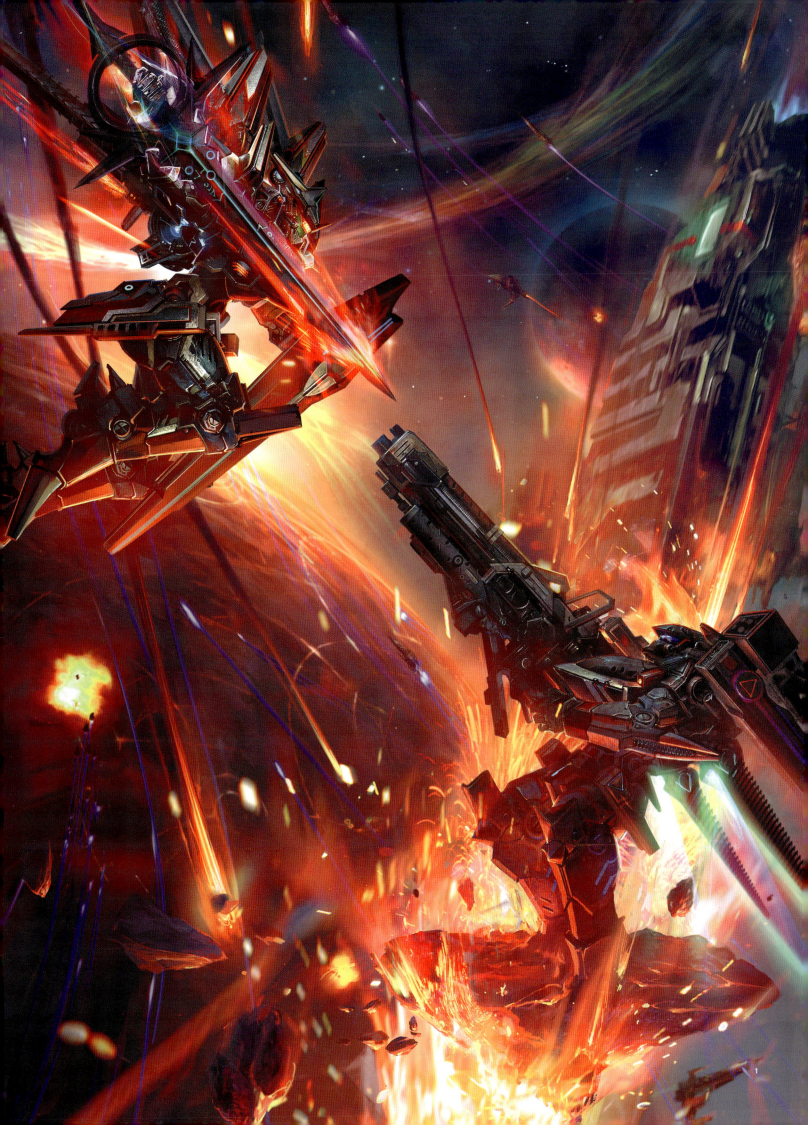

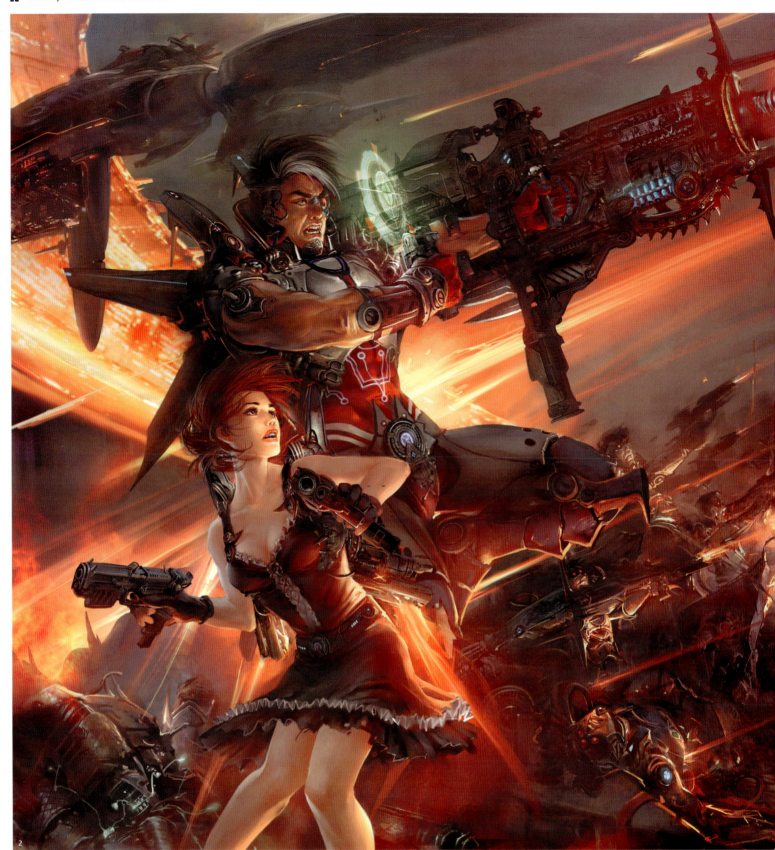

-- *And what is your plan for the future?*
-- Well, I've been looking to do film, but I don't know if I will move in that direction.

-- *Did you experience any fantasy when you were young? And how far away do you think you are from that fantasy now?*
-- I did. I dreamed of creating a world uniquely different from all we have ever known, where heavenly steeds soar across the skies, a secondary world where we immerse into that fantasy realm proper. And to realize it, we need such creative mediums as paintings, comics, games and films. Still years away, isn't it?

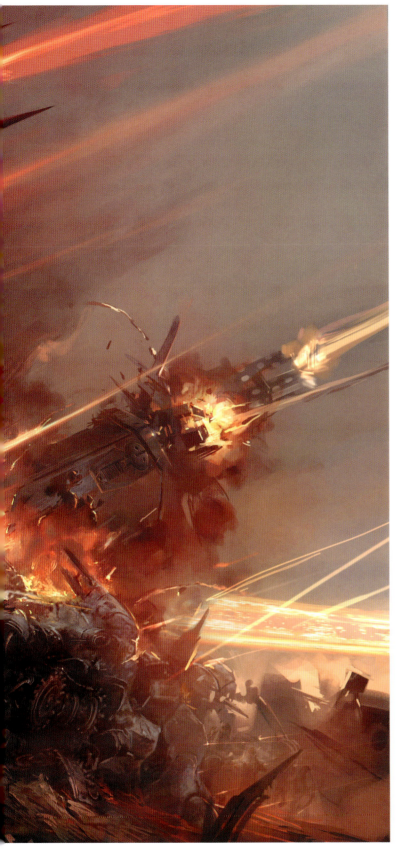

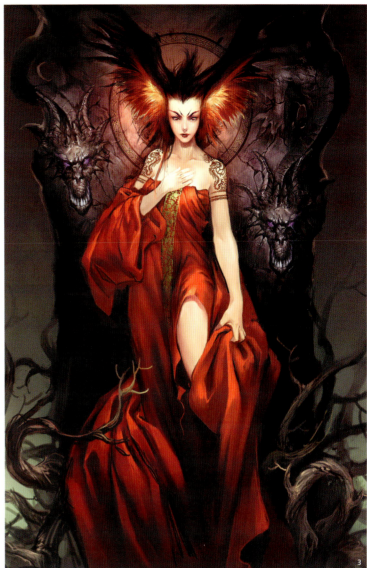

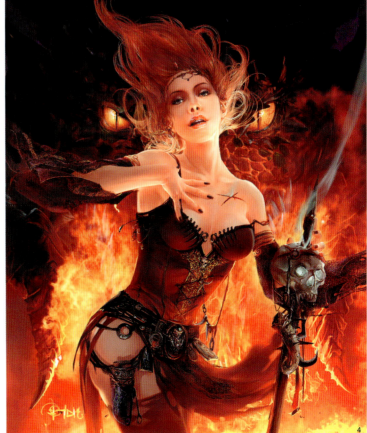

❷ Chaos
❸ Abstinence
❹ Cover of IFX

5 Trial

6 Poseidon's Wrath

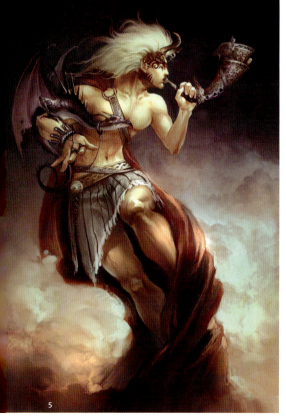

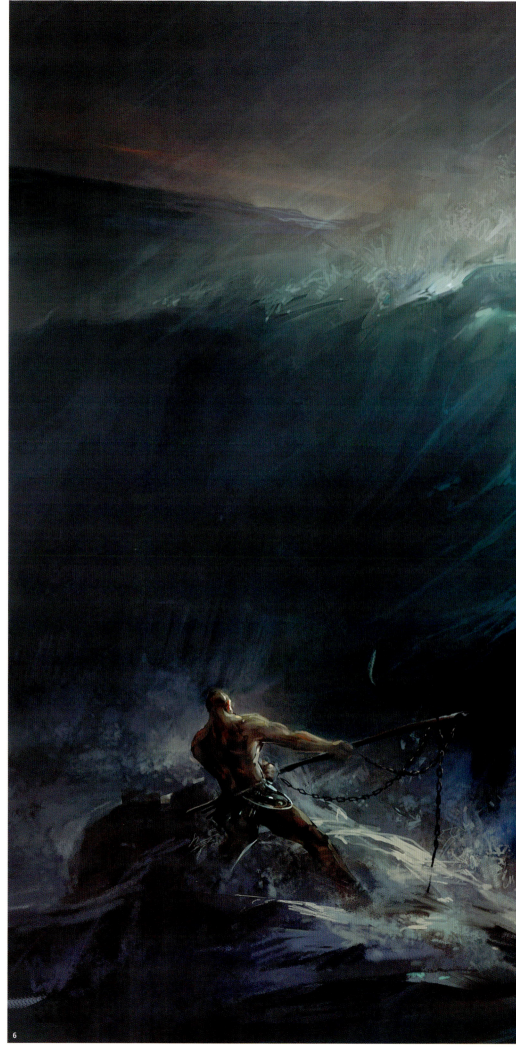

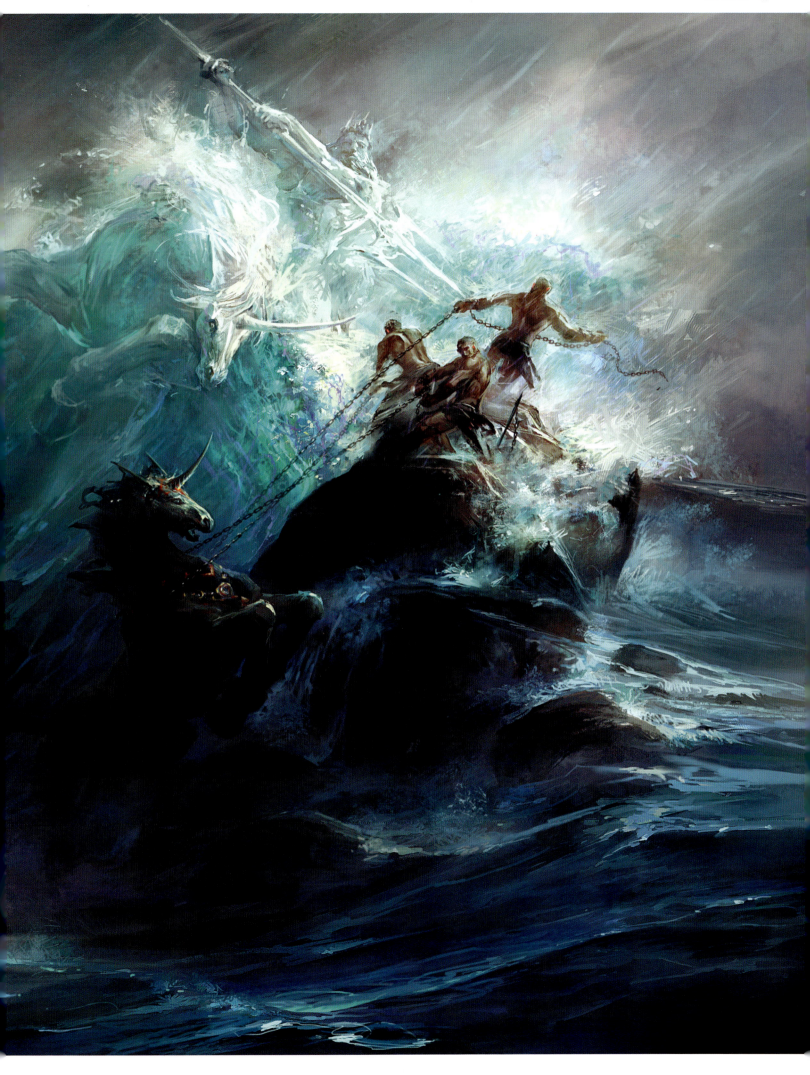

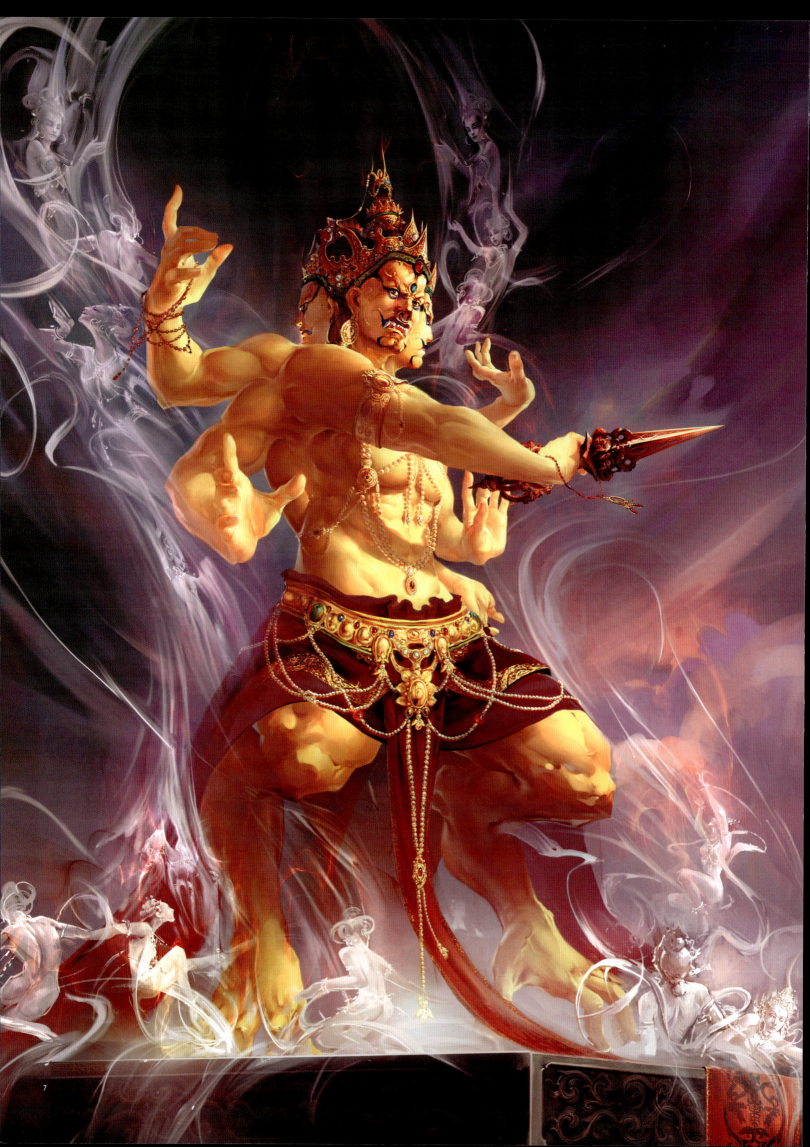

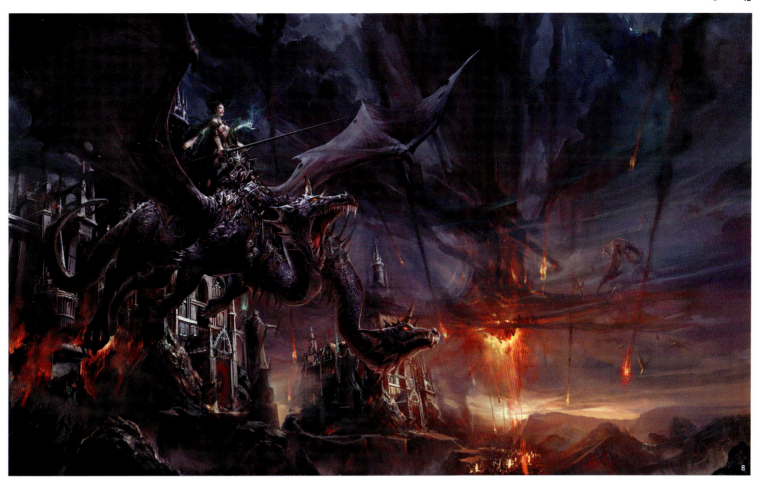

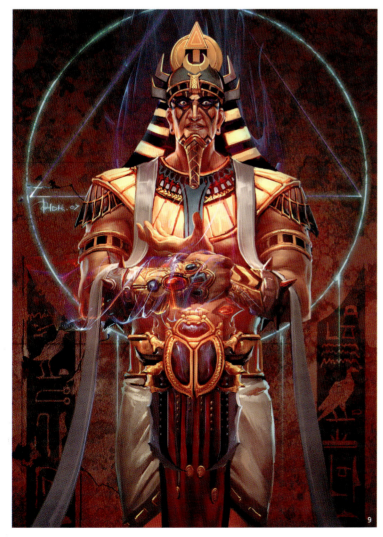

11 Journey

Jiawei Huang (HJW1983)

Name: Jiawei Huang (HJW1983)
Profession: Comics Artist
Homepage: http://baobaos.com/blog/xxx/HJW1983/index.html

Street King
A Special Interview with Jiawei Huang, Freelance Comics Artist

Now matter how Mr. Huang himself views his own creations, I think I can speak for a lot of us when I say, "We are grateful that you persist in drawing comics."

China's comics industry is so embarrassing today that it's hardly worth wasting our breath on it. The resulting sense of loss only becomes magnified by the fact that such wonderful comics (manga) as Huang's YASAN are now few and far between. Thankfully for us, Huang's gift paintings for his friends and the creations by his colleagues are still compelling. Remarkably generous, daring, and sometimes extremely impulsive, Huang says what he means like any other extraordinary artists. He is also blatantly straightforward, admitting that money is essential for his artwork and his happy life. It is fair to say that he resembles a street king, freedom loving and undisciplined, truly his own master on his way to the pinnacle of the art world.

We are grateful that Mr. Huang is still drawing comics; grateful that he still stands out there mocking the ridiculous and goofy comics scene in China; and grateful that his powerful artworks never fail to fuel our passion to fight a duel with ourselves.

Interview

-- The color and texture of your comics look really unique. Can you give us a rundown on the approach and style of your work?
-- I'm color weak to some degree, so I need to memorize all the colors, for example, what colors I should use to match the shade. I won't use dark red, of course, since it makes the images look dull. Simply put, I would use any color that contrasts against red and at the same time looks just right. I have always been matching colors, and trying to use those unrealistic ones on whatever images I am working on. As for texture features, I always strive to create uniquely distinctive designs, since I love working out details on a pencil sketch, like a rusty look or pattern.

-- In what way does CG help you in your work? And what software do you use most often?

-- The best use of CG is to apply colors. When I was in university, my major was sculpture and I seldom did coloring, so for now I generally use CG to practice matching colors, although in fact I rarely use it in my work. I devote most of my time to penciling. I know I must make the best use of it since that's what I'm really good at. The software I use most often is OC, and you can download it free from the PooBBS.

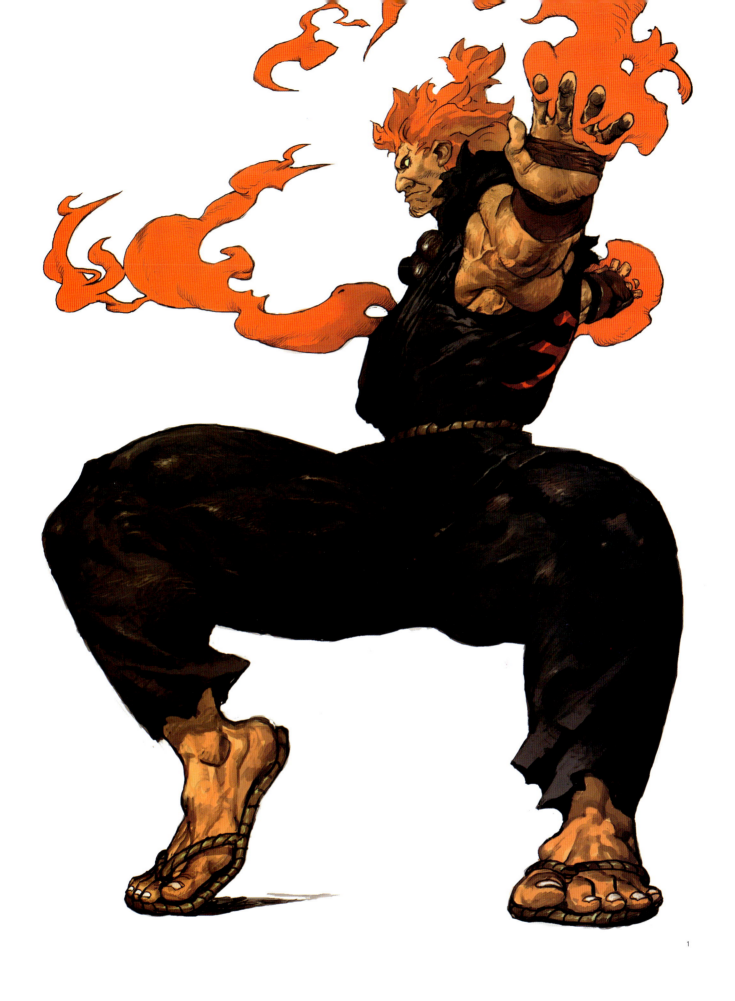

❶ Bold fiend

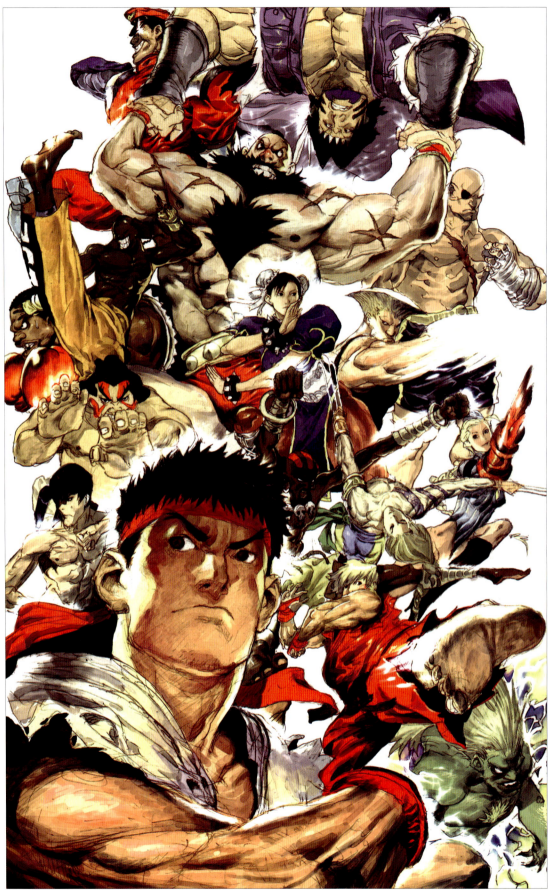

❷ Super street King

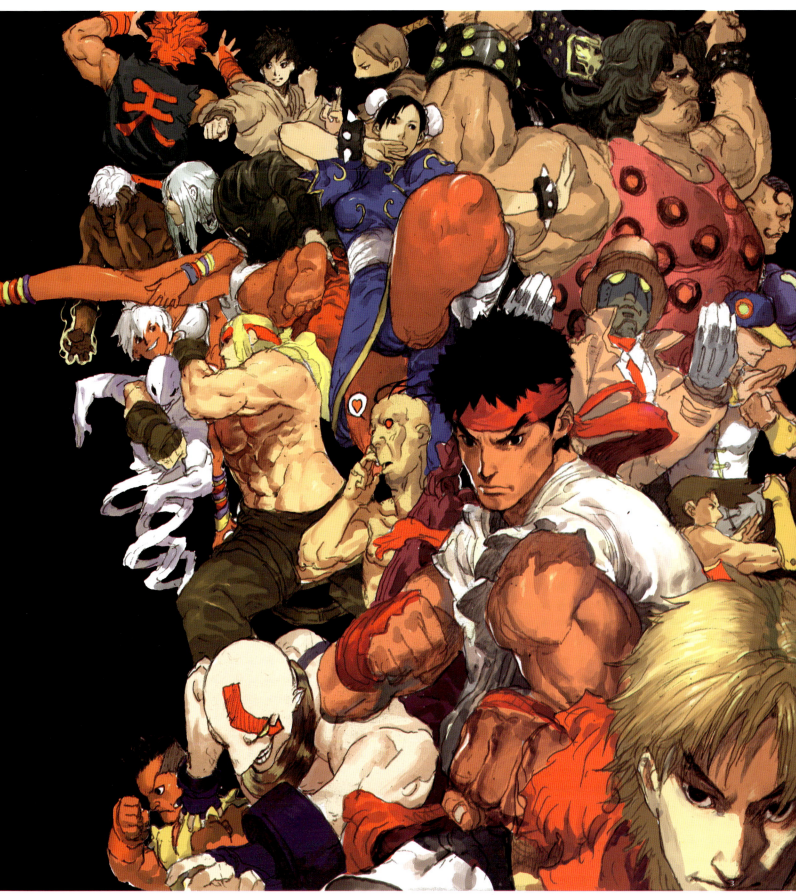

❹ Hellboy
❺ Cover of *Ya San*
❻ Hunter

-- *You said you like serious stories, but when you're talking, it seems that you're not sooo serious, haha!*
-- I am serious. But usually my emotions control me, and I sometimes find myself slipping into a serious mood. I'm no spoofer. I never draw serious comics without serious stories. Some people may think that I love striking poses, but that's just my style.

-- *You've been talking about happiness. What's happiness to you?*
-- Happiness, to me, means good health, each member of my family in perfect health. I want to live a stylish life too, but I was not born to make big money. Not too much each month, enough is enough. For now, what I enjoy most is freedom, and this is what I think is also very important.

-- *What was your fantasy when you were young? And how far away do you think you are from that fantasy now?*
-- Fairly far away. The fantasy, though, does not mean drawing. I have no chance to become a freaking awesome comics artist or mangaka, and I don't think I am living to draw. Drawing comics, after all, is my job. Everybody has a job, and it is fine if you do it well. Before I retire, I hope I can have a large deposit in the bank, spending the rest of my life giving money away. And to me that is a real real fantasy.

❼ King

❽ Valkyrie

❾ Knight

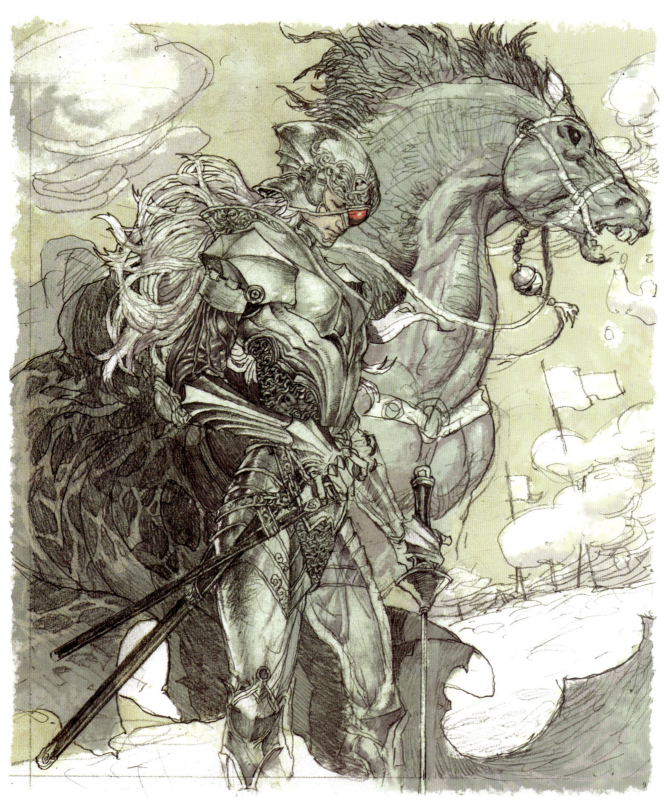

9

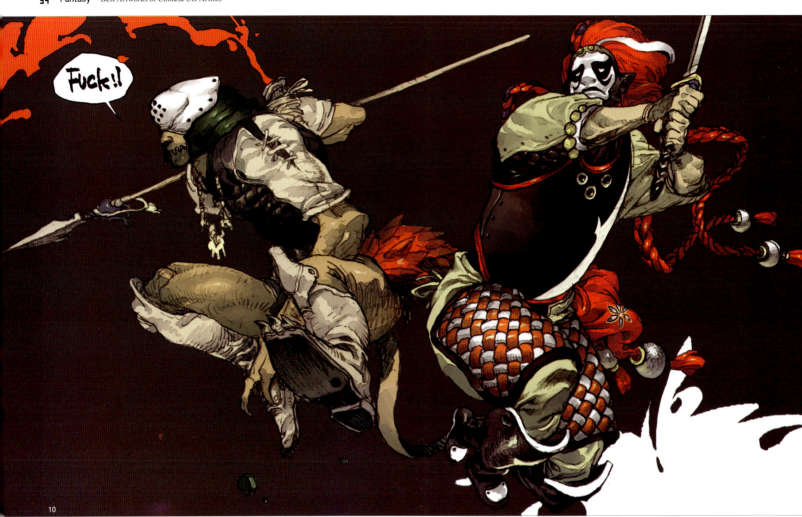

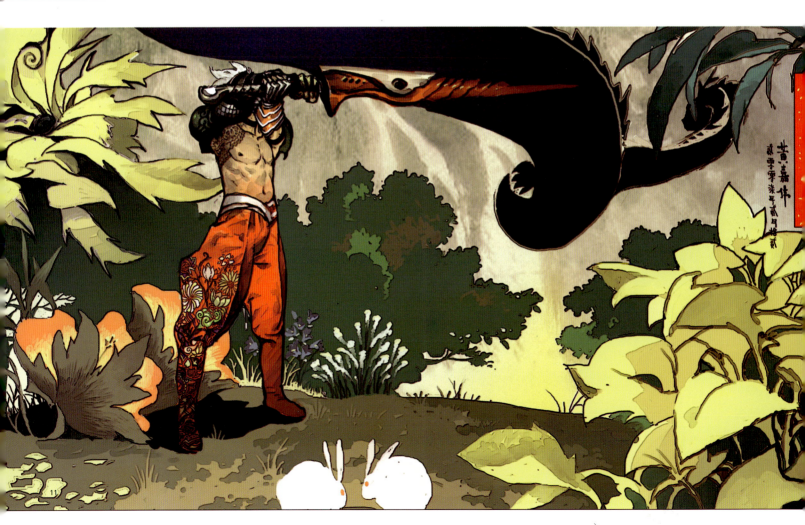

⑩ Monster 1+2 ⑪ Spring ⑫ Riding

Kai Lee

Name: Kai Lee
Profession: Game Concept Designer, Freelance Illustrator, Stage Art Director
Blog: http://blog.sina.com.cn/fuckorange

Orange's Emotions
A Special Interview with Kai Lee, Game Concept Artist

Kai Lee is losing his memory these days. Plus, he is having problems with his emotions.

If you happen to find your interviewee in one of his moods, you're supposed to determine whether the problems are personal or professional. In either case, though, Lee never lays down his brush—indeed something special for a painter. The choreographies in Dancer in the Dark a short while ago were just as marvelous as his illustrations in Monkey Creates Havoc in Heaven are today subversive and full of tension. Viewing his new creations could not have been a better experience. Knowing that Lee is as good as his word, we're now expecting more of his new works for the Monkey series.

That said, when our Orange happens to be moody, it is a sight to behold.

Interview

-- What are you trying to say in your illustrations? It seems that they are more personal than commercial.
-- The most straightforward method, the most common forms, and the most basic colors, are all bound together by the most enthusiastic spirit. Great works are always created with heart and soul. I hope my works are close to that same spirit and, even if not perfect and ideal, they may nevertheless touch your soul in my own ways.

-- How do you look at personal works of art?
-- I look at painting as just a way to relieve stress, finishing all those works by working late into the night. To me, painting is more enjoyable than sleeping. And painting, I believe, solves all my problems.

-- It seems that you like working on series of paintings, for example, the Dancer in the Dark series some time ago, but the style of Monkey Creates Havoc in Heaven is quite different from the previous. Why and how did this change occur?

-- Works in series are usually more impressive, keeping viewers in longer suspense, with more eye catchers, more fleshed out stories, and ever-improving techniques. Of all the legends in Pilgrimage to the West, "Monkey Creates Havoc in Heaven" is my favorite, so I relived his adventures in my own way. To portray a rebellious naughty Monkey King more successfully, I will keep the series going.

-- When artists design a concept, they normally have a clear plot in mind and follow certain principles. What about you?
-- I think the biggest problem for a designer is to show the audience those things behind the characters, such as their experiences, personality, and inner world. A cold-blooded murderer may turn out to be a loving father, and an awesome hero may eventually be put to eternal shame. The world is not just black and white. Only when you have successfully captured the essence of human nature can you make your designed characters look real enough.

❶ The monkey king 1

❷ The monkey king 2

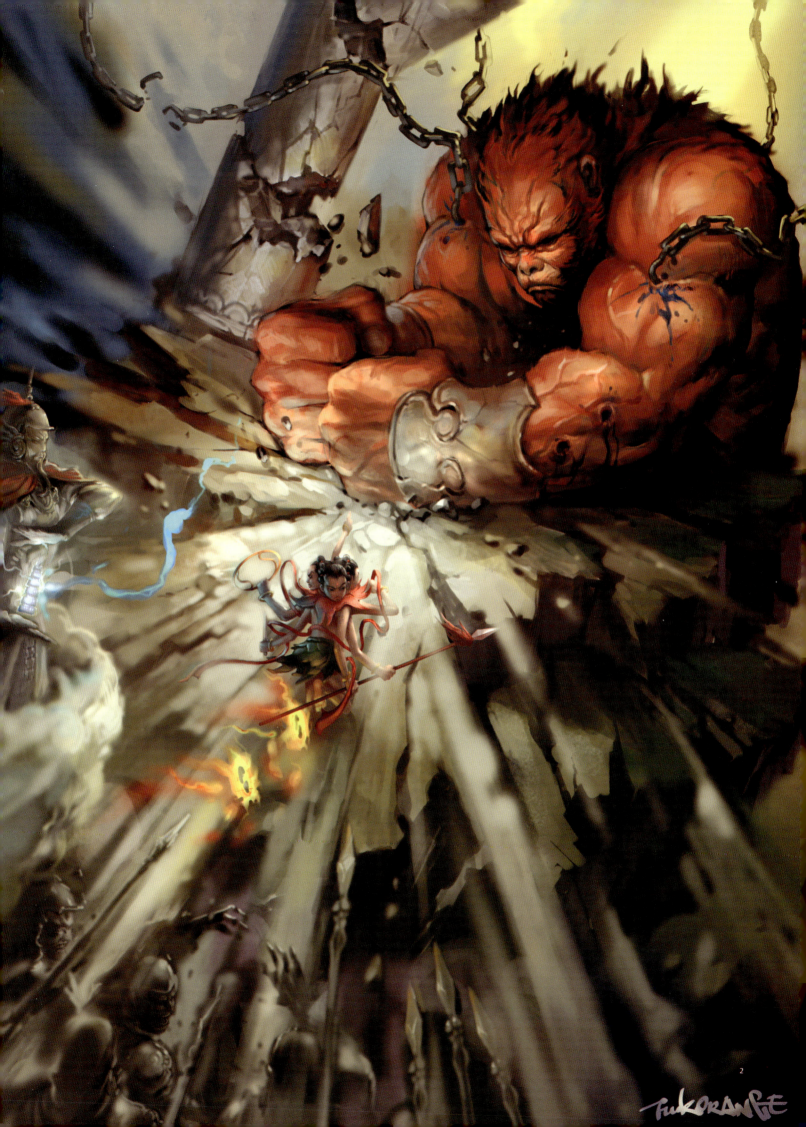

❸ Game Characters Setting 1

❹ Game Characters Setting 2

❺ Game Characters Setting 3

-- What techniques do you use to ensure that your characters look real enough?

-- All the details of a well-designed character play a part in the whole story. The shoes, for instance, tell us what roads they usually walk on; and the clothes, where they come from. Facial expressions are most important and most interesting. But if you ask me how to paint fantastic faces, my answer would be, "Paint more, observe more, and think more."

9

10

11

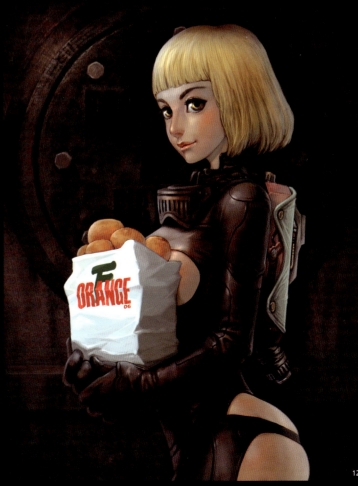

12

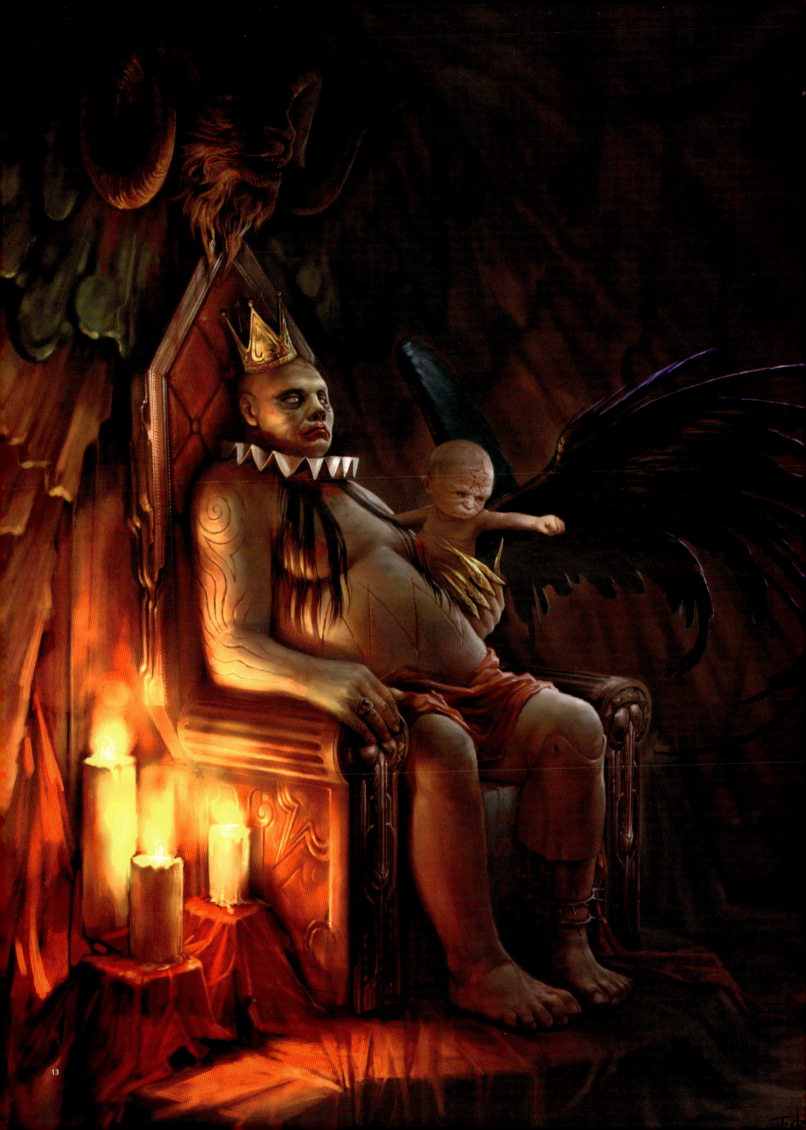

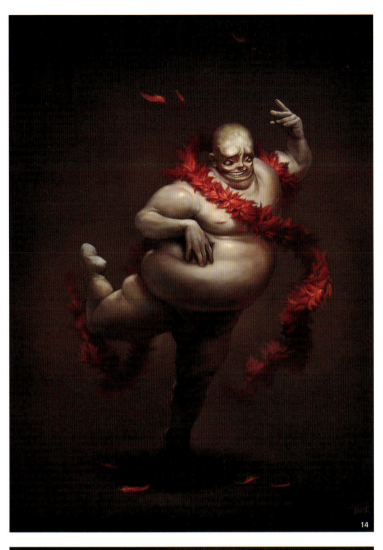

14

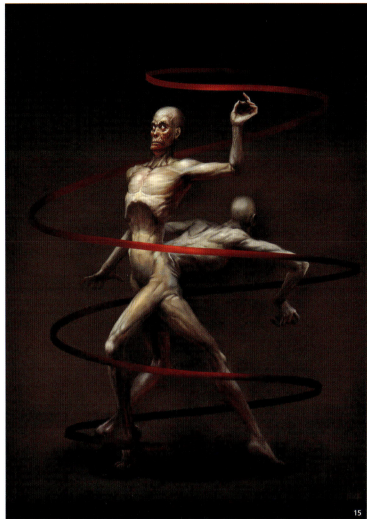

15

16

⑬ Father and Son

⑭ Dancing

⑮ Twins

⑯ Joy

-- What was your fantasy when you were young? And how far away do you think you are from that fantasy now?

-- I fantasized that I could be taken away by aliens so that I could live on other planets, wearing a skin-tight, silver-colored union suit. But now it seems that that fantasy has been shattered.

Name: Ya Lee (Lee-337)
Profession: Key Animator at Possibility Space
Homepage: www.lee337.net

Radius of Age 30
A Special Interview with Ya Lee, Game Concept Artist

When a man is 30 years old, the length of the radius of his life determines whether or not he can draw an annual ring wider than those of the past. Here at Possibility Space Company, the project quality determines the radius of his life; market competition also determines it; and the launch of a new project and even change of responsibilities determine it again. Everybody here is doing what they have not done before. And even those things they were doing in the past are now marching, under the guidance of a model, to a different drummer.

Talking with each member of Possibility Space, we feel inspired by their joy of achievement and their confidence in the current project, which we hope will also determine the radius of his life. At age 30, Ya Lee is starting all over again. Full of pride and enthusiasm, he is sure to have a successful and productive year.

Interview

-- *What do you think are the biggest challenges facing you with this project? And is your work this time in any way more productive than in the past?*
-- I think the first challenge is to stay the course, haha, and to learn to schedule all kinds of 2D tasks, and to press on regardless. My biggest headache is UI. I also have problems with designs and illustrations, but things will change for the better as the project goes on. For a technologist, there's no more enjoyable experience than making technological progress, so I find doing games really interesting now. In the past, however, game designing used to be very conventional, since most of the work involved was just patching together various existing programs. Now we measure up different requirements here. I still remember that as soon as Feng Zhu, the Warrior Epic designer, joined Possibility Space, he urged me to work out unique designs that would set us apart from the rest. That made me feel quite comfortable, for a long time. But eventually he spurred me to success. My greatest achievement at Possibility Space is, of course, in game design, which made me realize that my previous work out there had been tinkering around the edges.

2

3

WARRIOR
EPIC

WARRIOR EPIC

4

WARRIOR EPIC

5

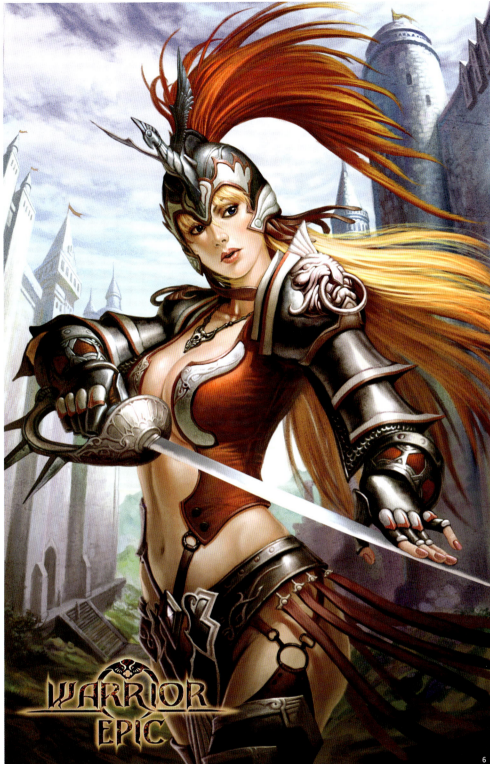

WARRIOR EPIC

6

To keep your company's projects going takes up too much of your own time. Do you sometimes have to suppress your own ideas, only to find yourself longing for freedom of creation?

You said it. I have a lot of plans and ideas, but have to hold them back at the moment. I can only draw a little while for myself on weekends or at home after work every day, and the finished paintings leave much to be desired since none of them was accomplished in one fell swoop, which left me all the more eager to draw pictures for longer hours. The two subjects that I want to work on most are science fiction and magic realism, to relive those experiences of the past, and to fashion bold and dynamic forms and to furnish compositions with fine details. Well, I won't mention specifics here.

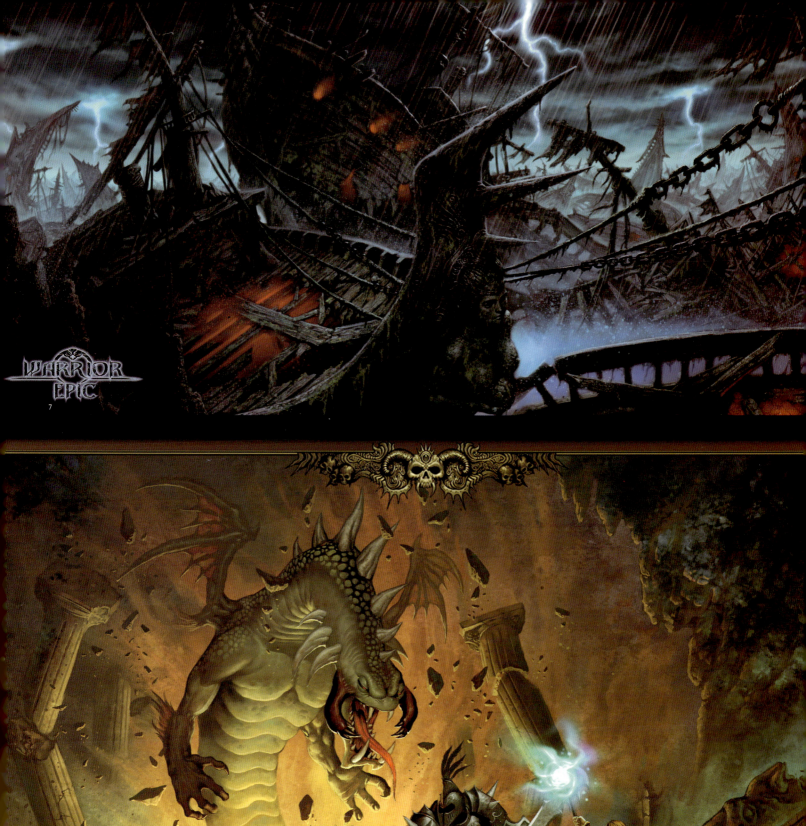

9

11

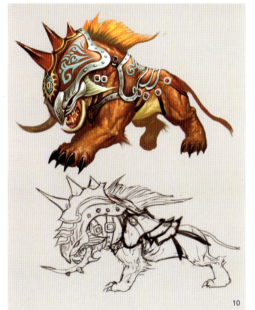

10

❼ Ship Tomb

❽ Guarder

❾ Aberas-bones

❿ Aberas-dog

⓫ Aberas-boss

⓬ Game Characters Setting

-- And what is your plan for the future?

-- I'd like to have my own comics published, and that is a long-held dream. If the company does well, I may combine my personal plan with the company's development programs, which I aspire to do most.

12

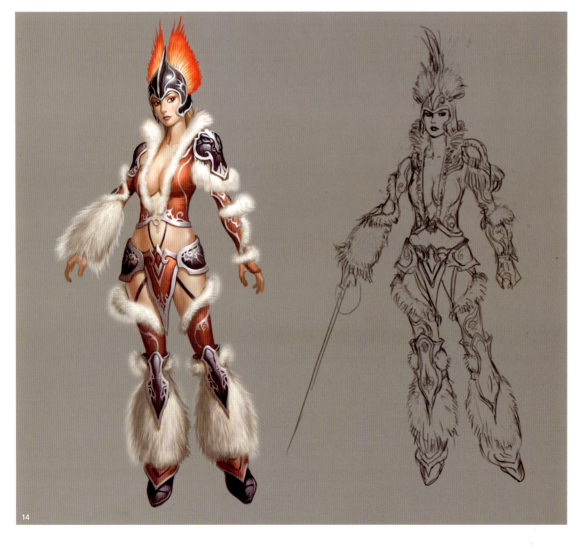

13

14

15

⓭ Warriorgirl
⓮ Warriorgirl
⓯ Pit-fighter
⓰ sexgirl-3b

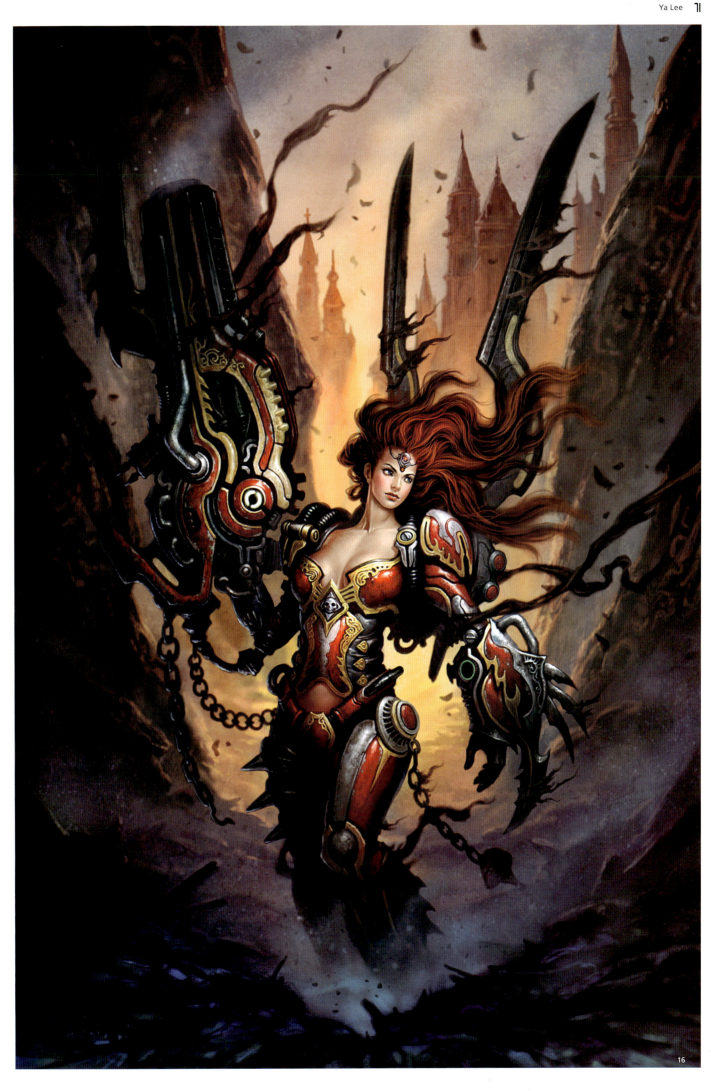

-- What was your fantasy when you were young? And how far away do you think you are from that fantasy now?
-- I used to have many many fantasies, haha, but the only worth mentioning here is: I hope my comics will defeat America Hero Comics. How far away? Anyway, I'm still preparing for my first step in that direction.

Yongjie Lee

Name: Yongjie Lee
Profession: Key Animator at Object Software

Hero on the Way

A Special Interview with Yongjie Lee, Game Concept Artist

There are many different definitions for "hero," but not everybody can become a hero, not even on their way to the Hero Totem in their mind. For children, their intuition tells them that a soldier or a police officer must be a hero, but when old enough to think independently, many of them decide not to follow their hero's footsteps.

Our interviewee, Mr. Yongjie Lee, has his own definition, believing that a hero is just an extraordinary person, clearly in the broad sense of the word. He started out painting as a kid, and those artists and painters in his mind, naturally enough, have become his own heroes. Before he was about to graduate from high school, he decided to give up everything for art, so he continued on his way to becoming an artist. In fact, ever since the first day he got to know those heroes, he has been on the way.

Interview

-- *Since you have been doing character designs, what do you think are the important elements for a successful character? And what's your own rule of thumb, if any?*
-- I think it is important for a concept artist to focus on character traits, to breathe life into his images depending on game design requirements or personal preference. My general rule is to strive to set my products singularly apart from the rest.

-- *How long does it take you to complete a piece of artwork? And how do you work on that?*
-- Perhaps 4 to 5 days, usually with PS. I learned quite a few approaches to work from some master painters, for example, to produce 10 to 20 thumb-nail sketches first, and then develop 4 to 6 into mockups or templates. The whole process is repeated several times in a pyramid fashion until all the designing, matching and coloring work is completed. Finally, all that's left is detailing and texturing.

-- *I noticed that the costumes you designed for your characters are very distinctive. They are national folk costumes, aren't they? And suppose you are asked to create a game with the background of your ethnic group, what plots do you have in mind? And what ethnic elements will you infuse into your work?*
-- Ha ha, yeah, I did design some national or ethnic styled costumes and ornaments, just to make my images look unique. As to the game concept, well, any folk-tale involves a conflict, if not an ethnic conflict. And the conflict between the Chinese from the central plains and the frontier ethnic groups had lasted from time immemorial, which might have resulted in a couple of alliances. My game concepts are usually associated with some fairly distinctive ethnic groups, such as the Miao, Mongolia, and Yi minorities.

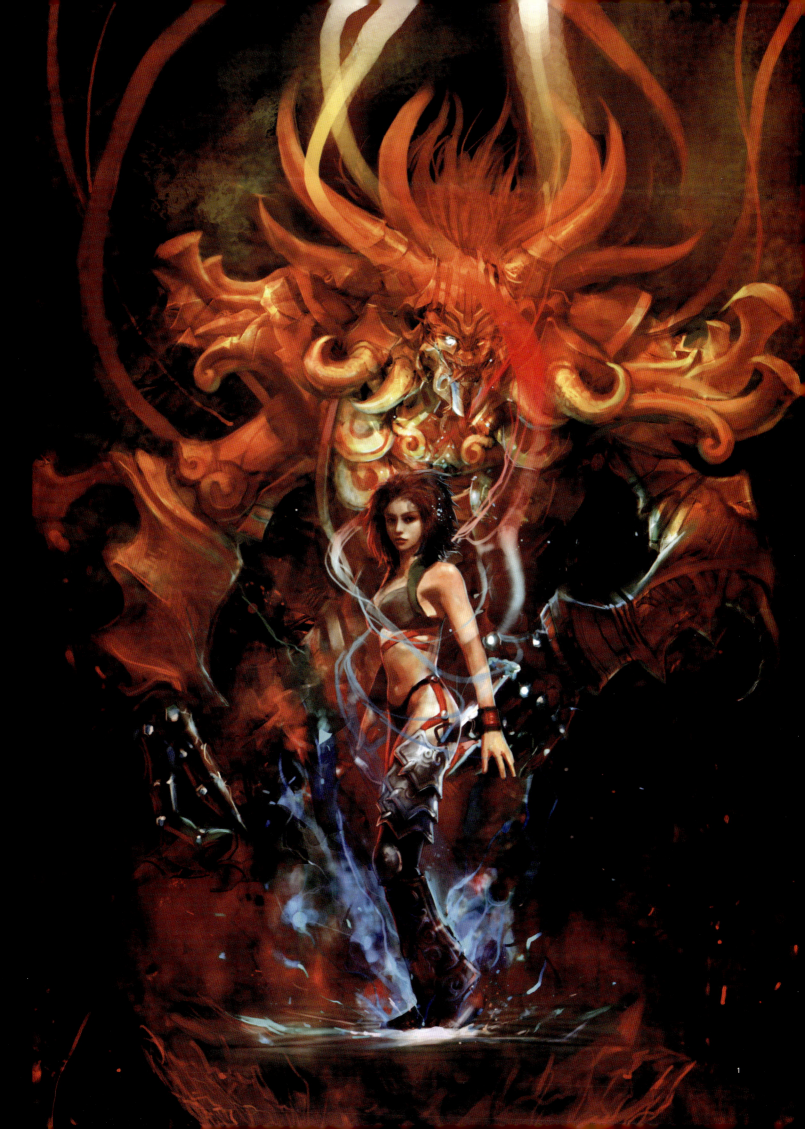

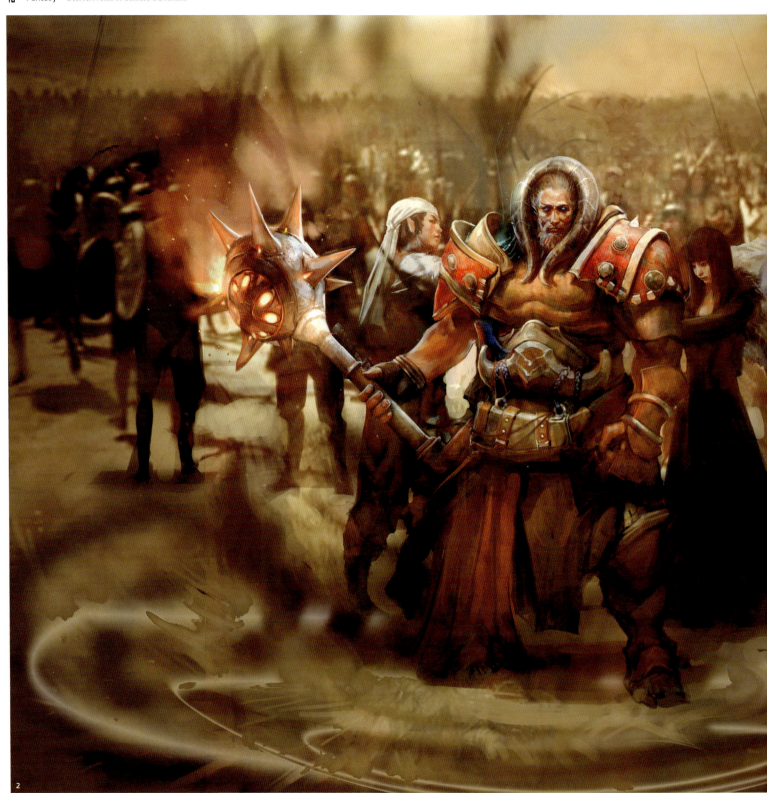

2

-- And what is your plan for the future?
-- First of all, I'm planning to release a game. Plus, I'd like to learn more, to paint more pictures, to make myself known to more people, and to have more experiences. I think what I'm good at is probably character design, but I have so many things to learn, like scene setting and concept designing. I hope more communication and exchange of ideas will broaden my horizon. Honestly, I don't think I will be living to do games. So it's likely that I will learn animation, but that's just a personal preference because when I have heard a song sometimes, or read an article, or seen a picture and scene, I usually conjure up images in my mind, to flesh them out, and to paint them on canvas.

❷ Go out for a battle

❸ Go

❹ Untitled

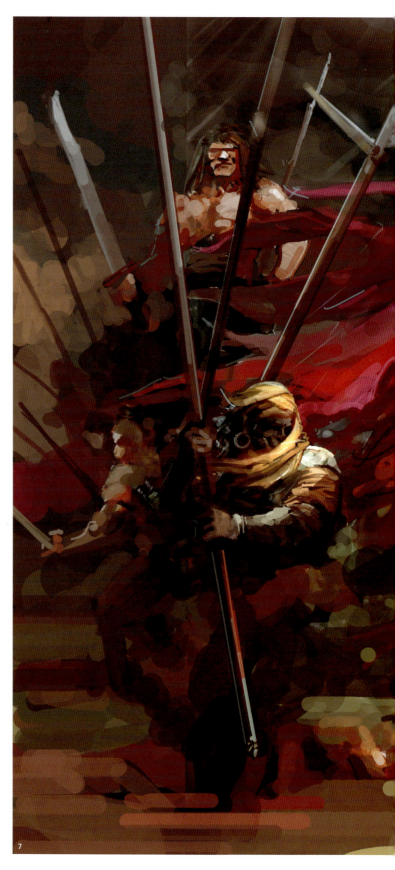

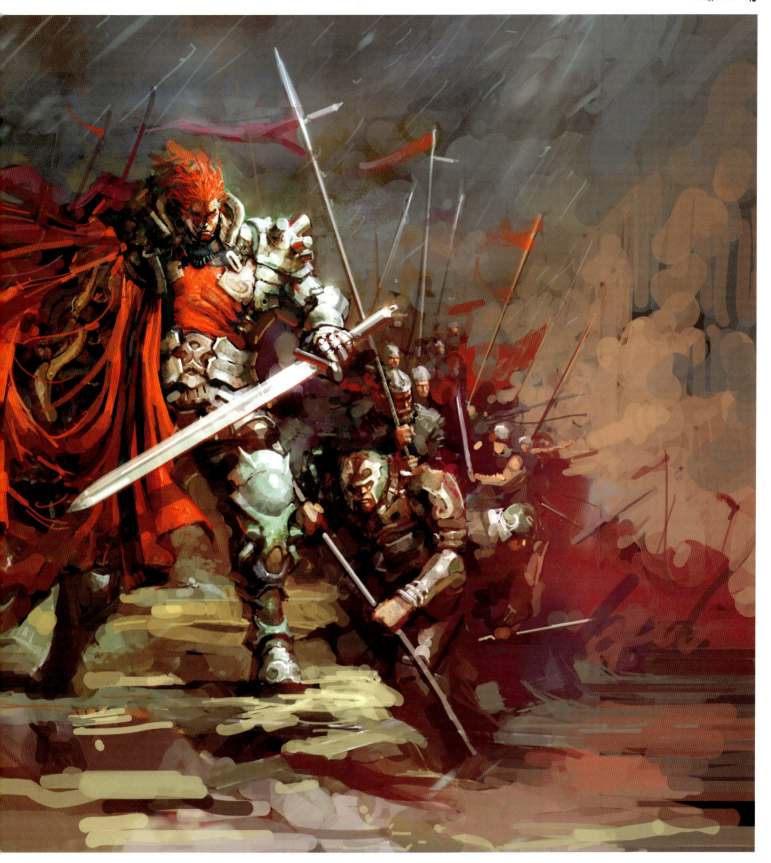

❺ Military Attaché

❻ Mecha Design

❼ Winners are made, not born

-- Did you have any fantasy in the past? If yes, how far away do you think you are from that fantasy now?

-- My fantasy was nothing but a fantasy: to be a hero like Frazetta or Rockwell, but now it seems I am further away from that goal, haha. I probably need to work harder to close the hope gap.

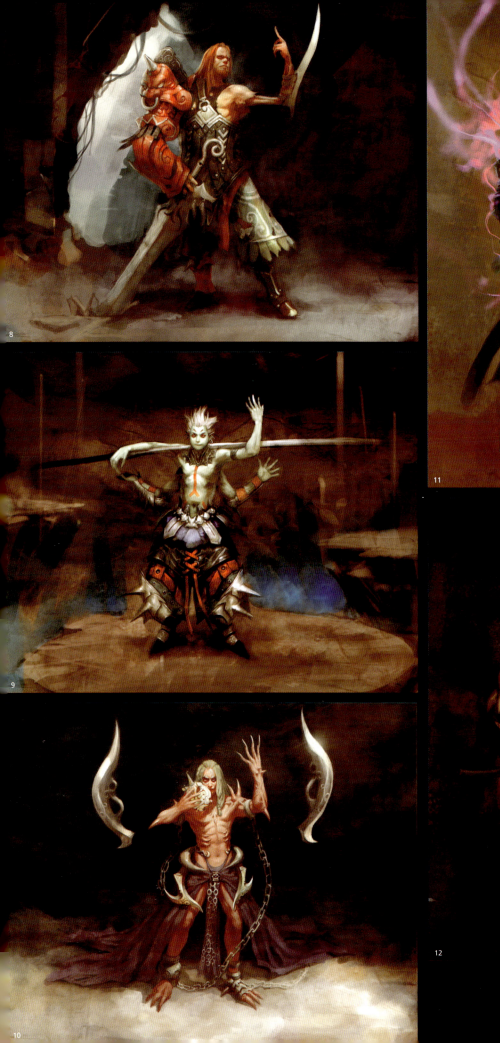

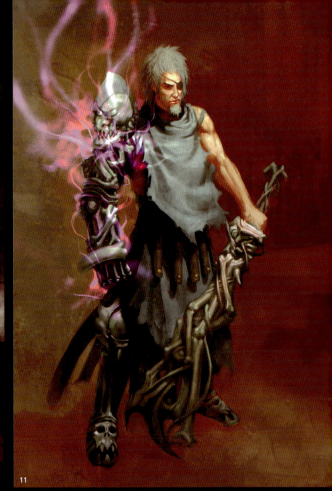

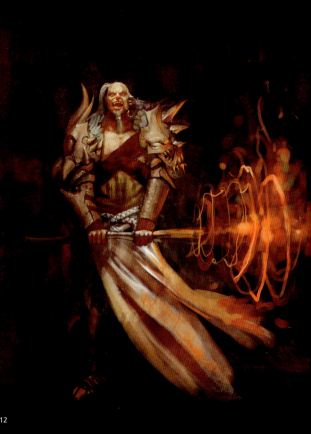

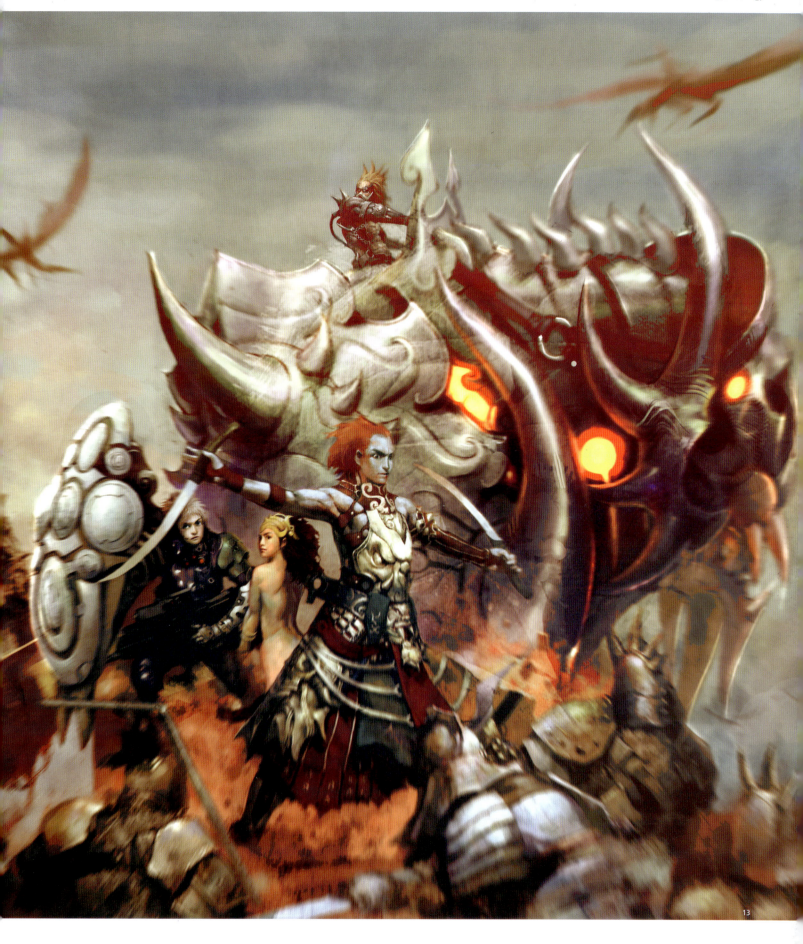

13

14

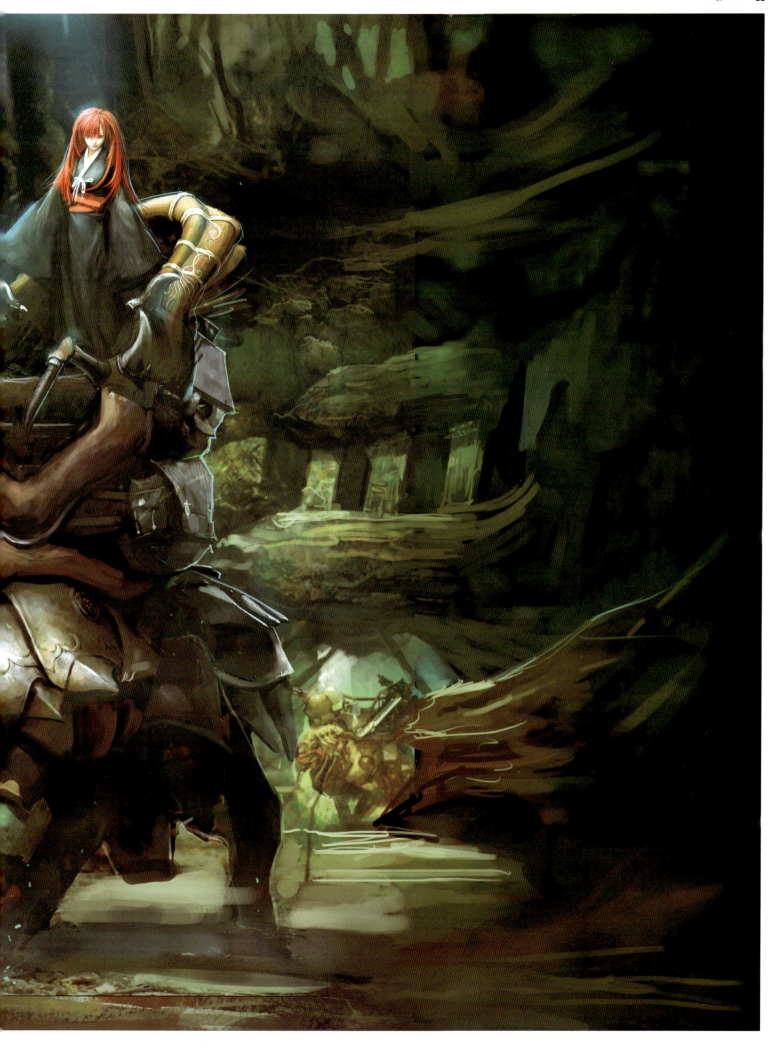

Yi Liang (Crystal)

Name: Yi Liang (Crystal)
Profession: Key Animator at Possibility Space
Blog: http://blog.sina.com.cn/hellbb2007

From New Era to His Own
A Special Interview with Yi Liang, Game Concept Artist

For the past seven years, Mr. Yi Liang has worked with seven companies in three cities. Many of his contemporary artists either started their own businesses or faded out of this community, but Liang, drawing his own pictures as usual, has never taken a single step away from the gaming world. With one of his books published, he believes that his new era lies in this industry, a starting point for his career development. The new era, in his eyes, means the recognition of both individual achievements and corporate values.

At the end of 2007, Yi Liang, realizing that personal development is most important, joined Possibility Space together with many other fans following the footsteps of Feng Zhu, founder of Possibility and robot concept artist on Transformers Movie. Seven years' hard work has made Crystal (Liang's online name) a worthy game concept artist, who is now marching into his own new era with a new goal in mind—to be an all-round gamer.

Interview

-- *We have so many games today, and what do you think are the worthy games, leaving nothing to be regretted?*
-- First, I think it's essential for a game to run perfectly on gamer PCs. Next come the interface and playability. Having said that, I would consider programming and designing the most important elements for a worthy game. Teamwork, of course, is equally important. If each member of a crew has contributed something to the project, we are most likely to have satisfying results, leaving nothing to be regretted.

-- *What are your achievements at Possibility Space?*
-- Since I came here, Feng Zhu has been urging us not to base our work on those programs already developed by our competitors, since good concept designs require that you have your new ideas, and programs developed means programs used, or they're someone else's products, not yours. To create your own designs, you need to observe fundamental, real-life objects more often, or more specifically, to combine all possible things into entirely new images. This approach is justifiable in that all creations are based on the most essential elements of life. Indeed, the creation process is fun and engaging.

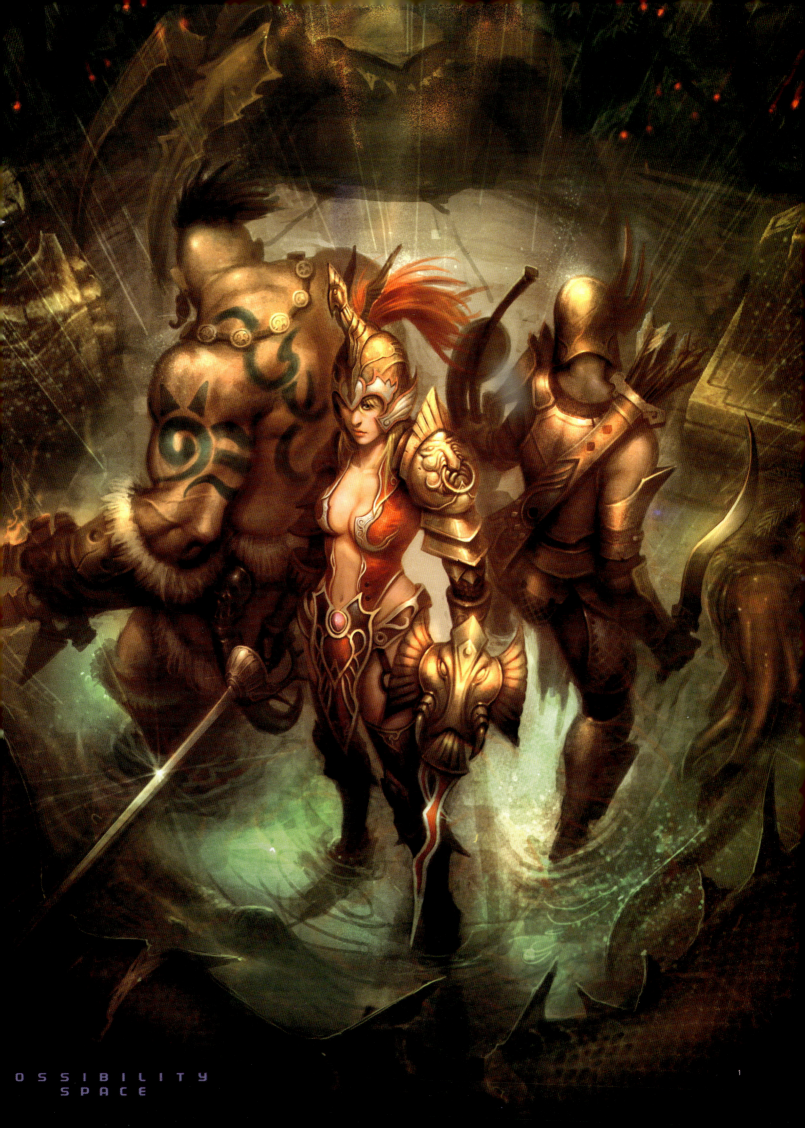

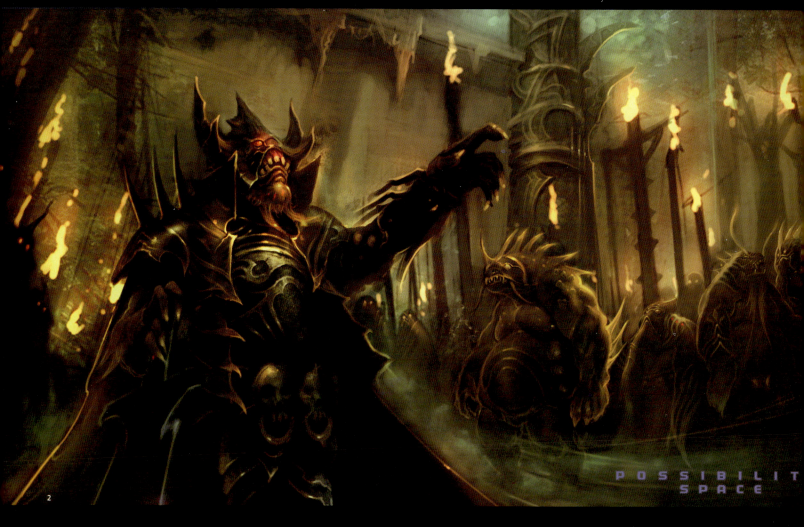

2

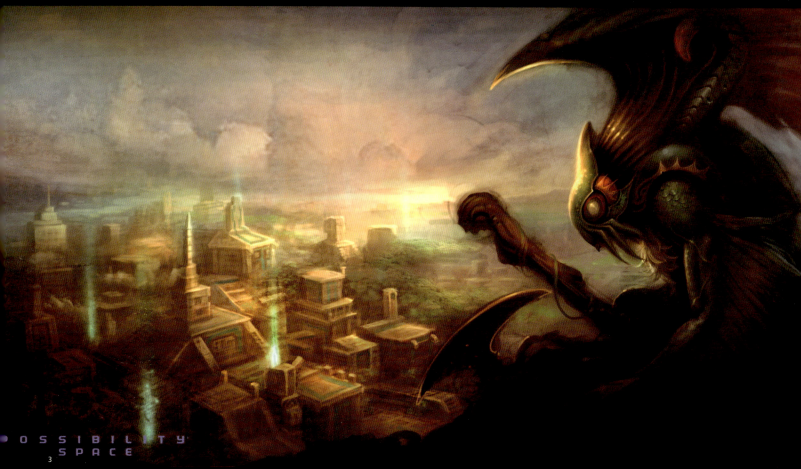

3

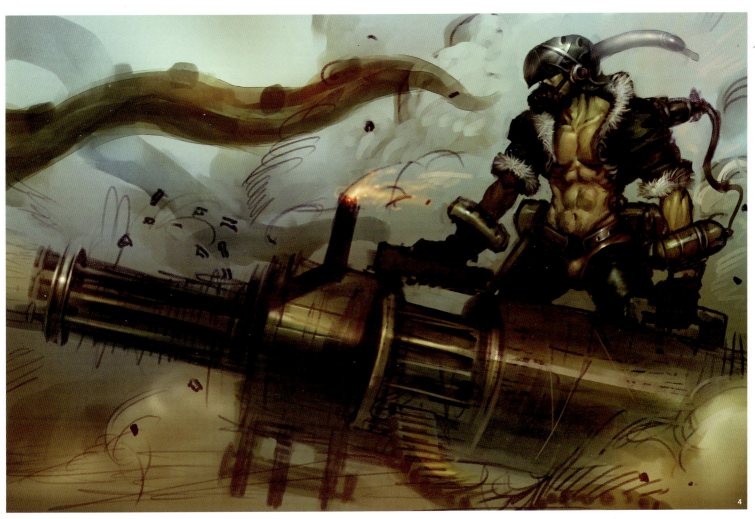

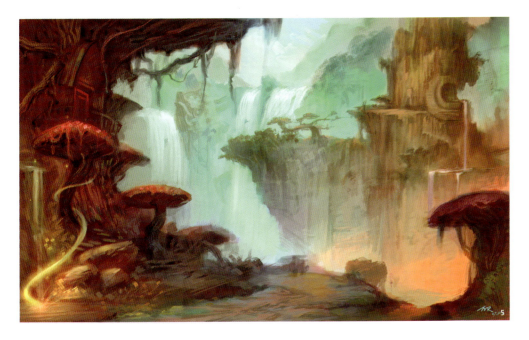

❷ Campaig-story

❸ NR-story

❹ The Lost Planet

❺ Holy Land

-- Why is it that you seem to prefer classical themes? Do you fear such preference may result in limitations?

-- Ever since I entered this industry, I have been working on classical things, ha ha. I love trying new things but I should say, from the bottom of my heart, I prefer ancient Chinese mythological elements. In fact, that won't result in limitations, for art knows no boundaries. As long as it is necessary, I will infuse any culture into my creations, be it Occidental, Oriental, or whatever.

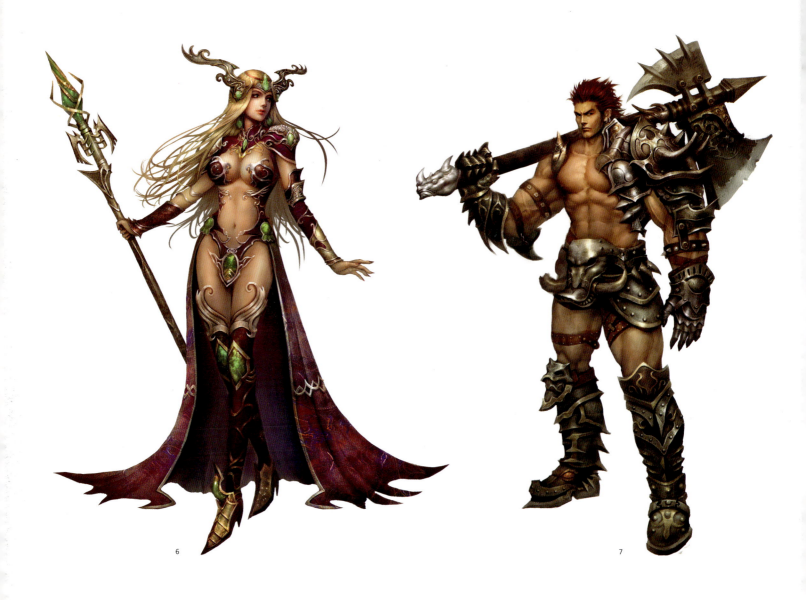

6

7

-- *What was your fantasy in the past? And how far away do you think you are from that fantasy now?*
-- Shortly after I graduated from high school, I dreamed to be a comics artist. My today's fantasy is not such much a fantasy as it is a goal—to be a top-notch game design artist and game project manager.

❻ Sorceress

❼ Berserker

❽ Warrior

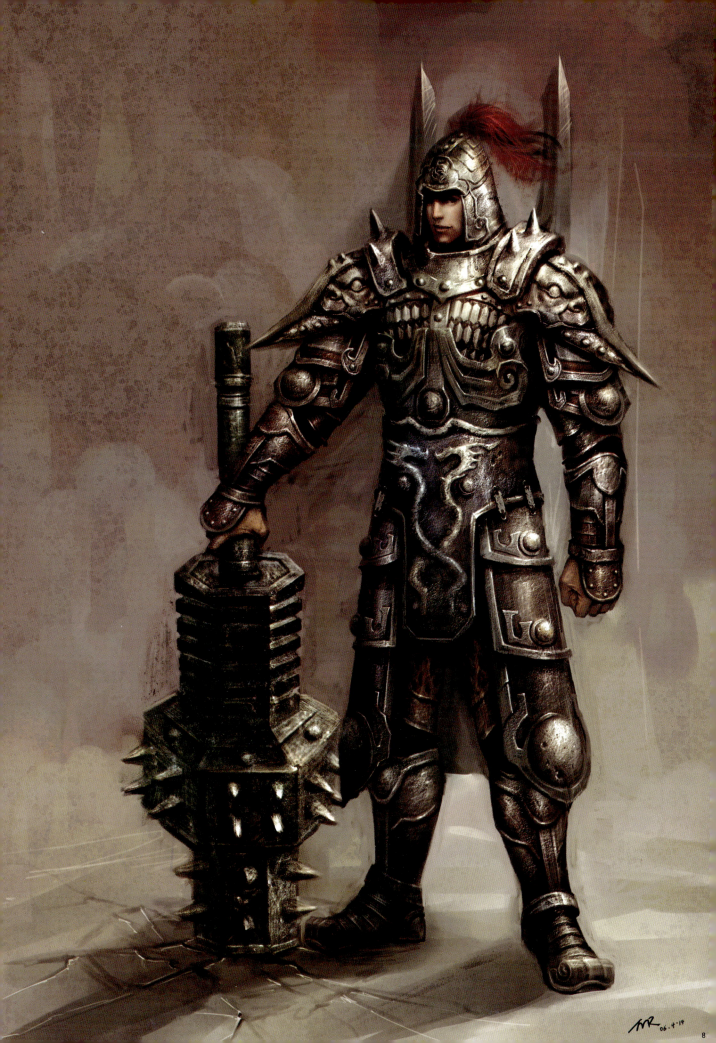

8

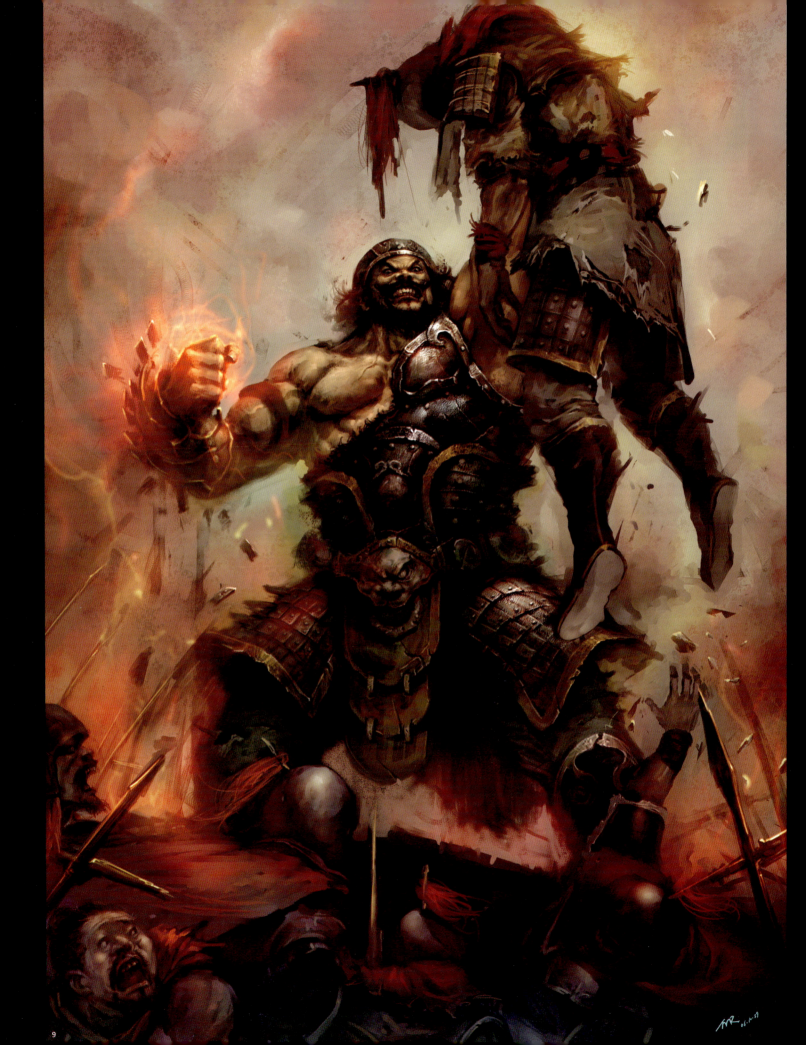

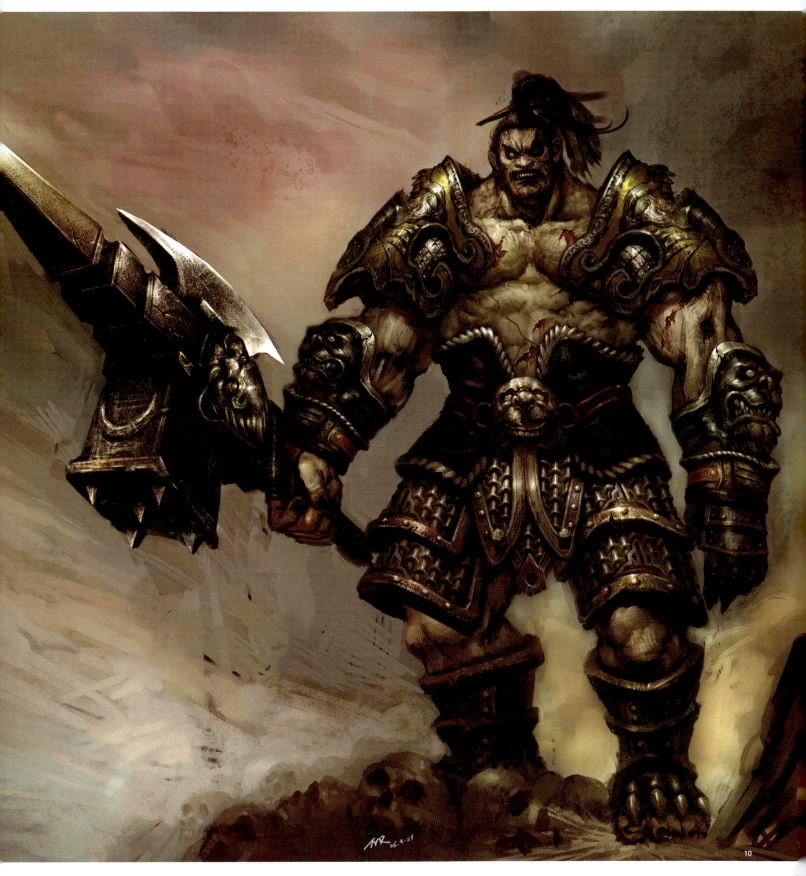

10

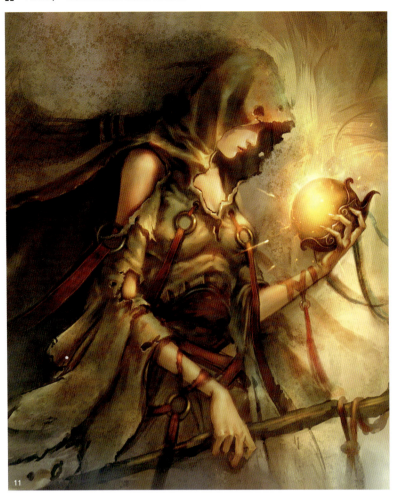

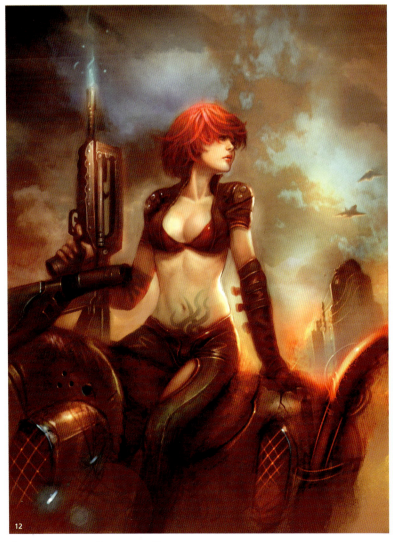

⑪ Huang Yueying ⑫ Gun Girl ⑬ Guan Yu

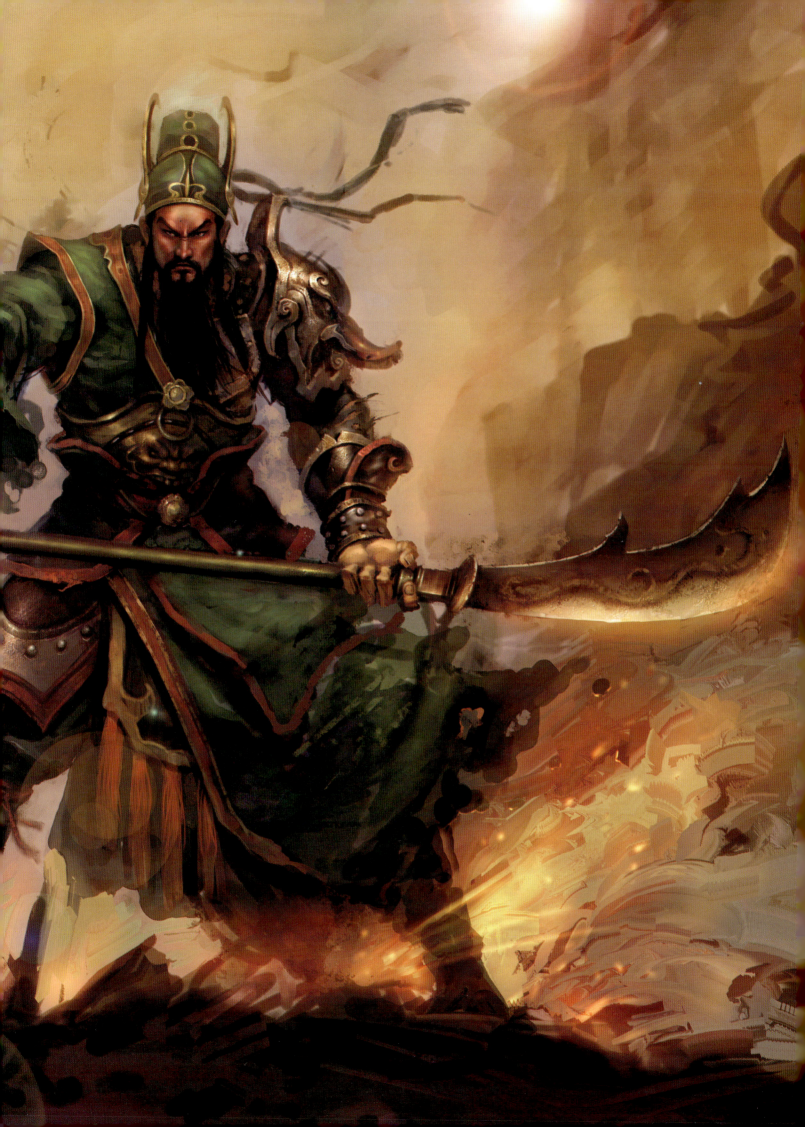

Name: Chen Lin (Wanbao)
Profession: Game Environmental Artist
Blog: http://wanbao3.spaces.live.com/

Environment is the Name of the Game
A Special Interview with Chen Lin, Game Environmental Artist

Chen Lin has strong conviction that the environment of a game counts, which probably explains why he's so sure of his career direction and environment creation. The artworks created by Wanbao (Lin's favorite online ID, literally "Night Leopard") help us visualize the experiences that have shaped his life. Lin's style is fairly international, intended to convey the realness of expansive environments and provide full information on almost everything, from the whole disaster to the whole prosperity to the whole fantasy.

Techniques, to use his words, are but flashy gimmicks, and the name of the game is to understand the game environment you are in, a mirror of life and work in the most fundamental and straightforward way. Lin has drawn a lot of ready-to-take-off spaceships and, when the moment comes he himself is about to take off, he clearly knows that environment is the name of the game, which we believe will be immeasurably rewarding.

Interview

-- It seems that most of your creations are environmental artworks, with very few characters and a particular inclination toward environment designs. Why is that?
-- Ever since I started my career, I have been more of a specialist, partly due to my work because I am responsible for the environment stuff. In my case at the moment, I want to be more of an all-rounder, and not to concentrate solely on one particular field.

-- Why is it that your works seem significantly related to science fiction? Do you find it hard to manage that classical or fantasy style stuff you did in the past?
-- Personally I just prefer subjects like science fiction and mechanics, and I have a lot of such models in my cupboard at home. Honestly speaking, I'm not good at the classical stuff, in many ways, not just the expressiveness. However, it does not matter much now that I am a concept designer, and what's important for me is to be a professional design artist.

-- How do you work on creative concepts? And how long does it take you to complete a concept design picture?
-- Generally, the way I do it is to examine more. I tend to hold on to my pictures whose concepts I appreciate, even though some of them are poorly drawn. Sometimes, when an idea occurs to me, I put pencil to paper and sketch out rough outlines. Although many of those drafts are never used, I'd rather like to see them as an accumulation of experiences. To scribble a rough design would take no more than two or three hours, but to create an original animation would need probably two weeks. The creations of Craig Mullins, I hasten to add, are my favorites, which have inspired me in more than one way.

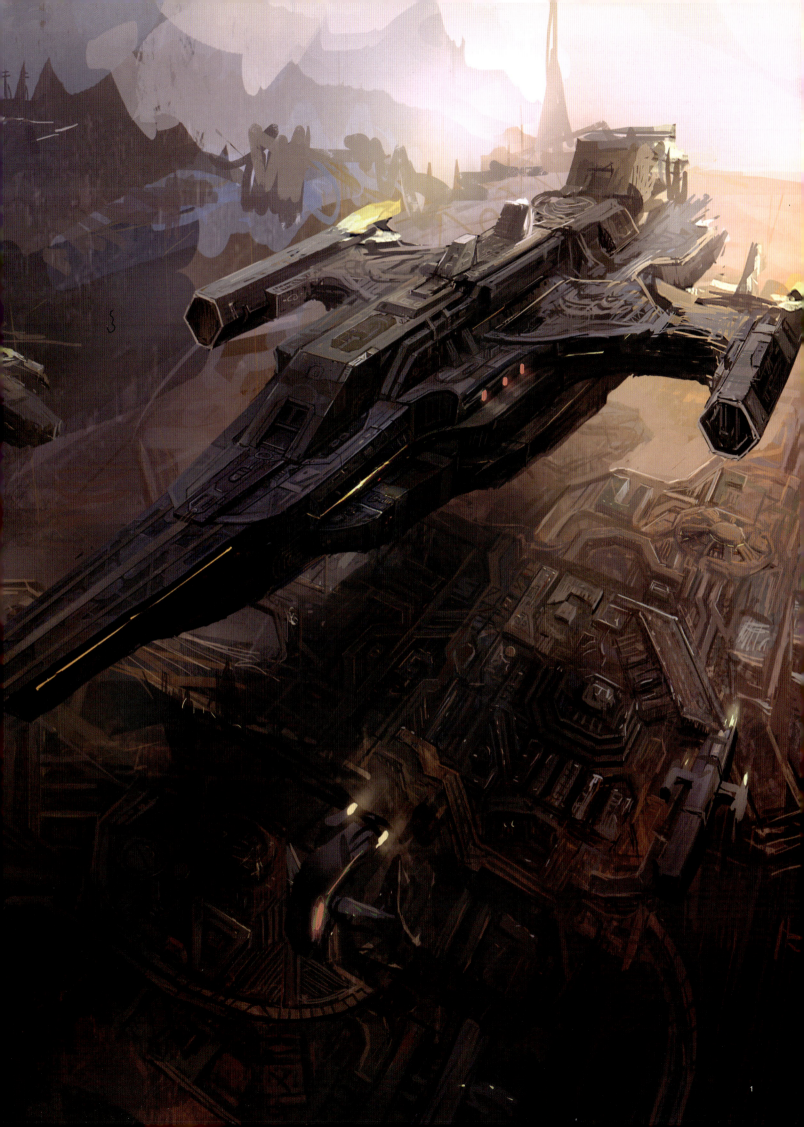

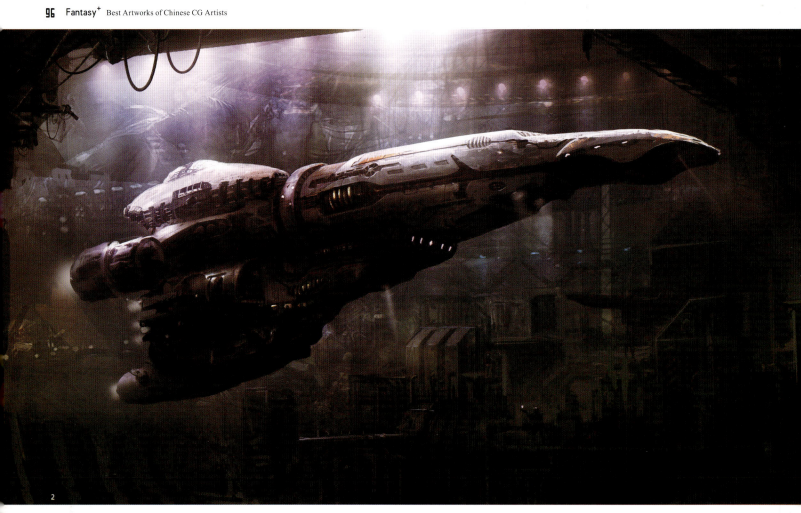

2

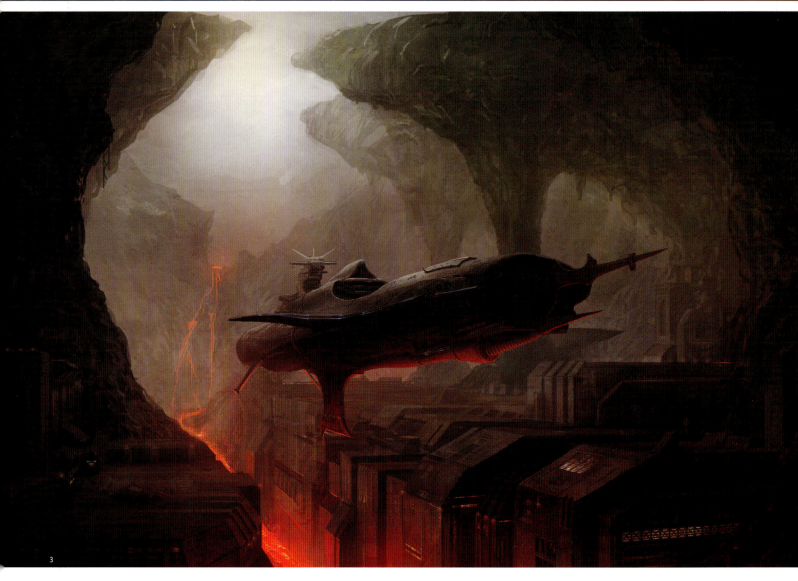

3

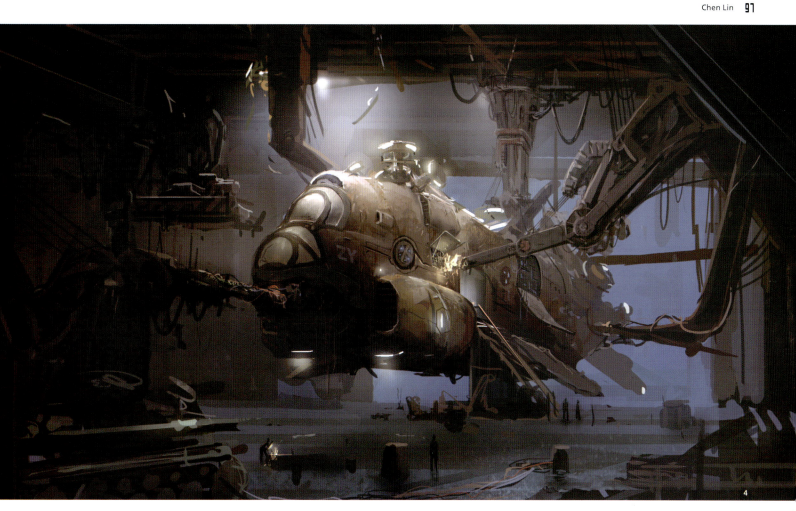

4

❷ Airship

❸ Grotto Base

❹ Repairing Plant

-- What do you think is your own style of creation? And, as far as the concept design is concerned, what's your own rule of thumb, if any?

-- I have never tried to give a definition for my own style, and what I've been trying to do is to get across my thoughts in a simple manner. As to the design work, I would say that concepts are concepts, so any approach that clearly expresses complete ideas is fine. For painters, it is essential to express themselves effectively through pictures, and it is the only and most important language.

-- What fantasy did you have in the past? And how far away do you think you are from that fantasy now?

-- I aspired to be a CG master, to have so many people worship me and follow me. To achieve that goal, however, there's still a long way to go.

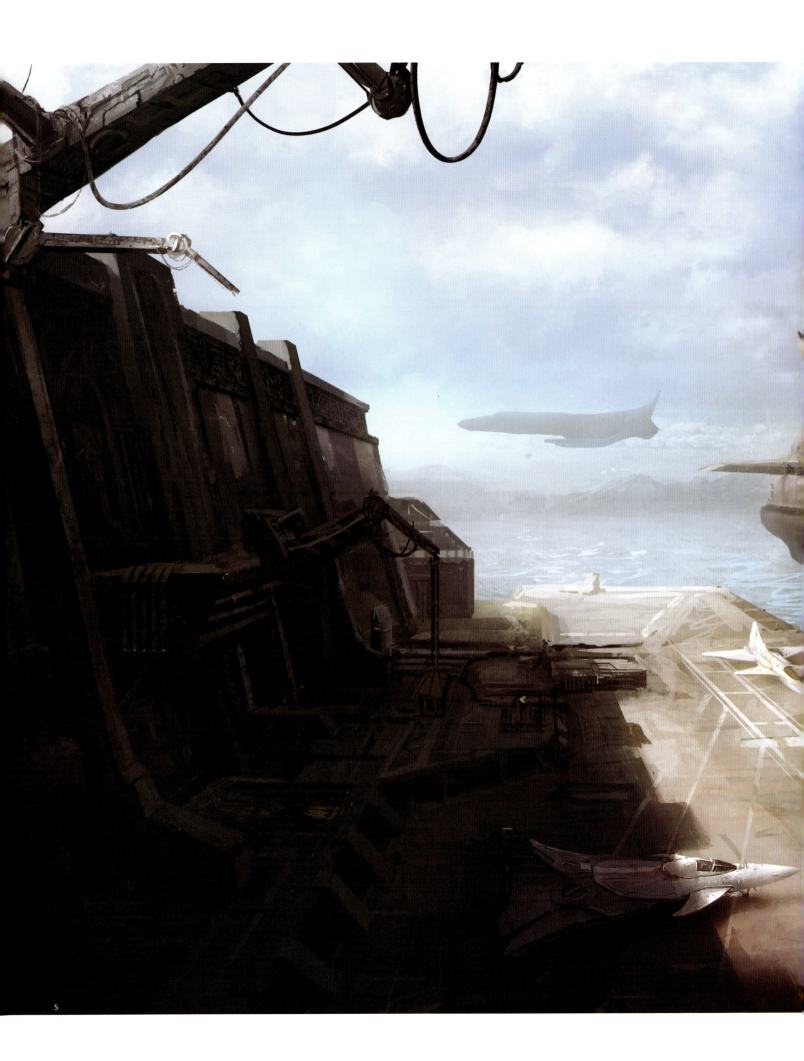

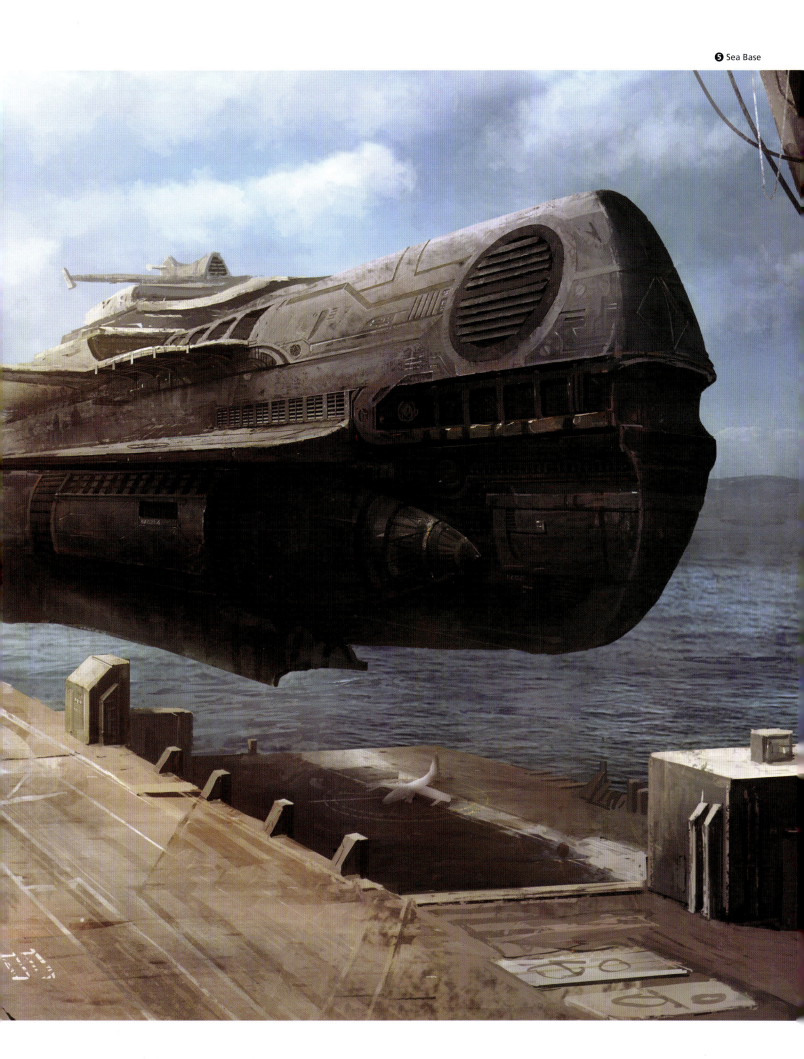

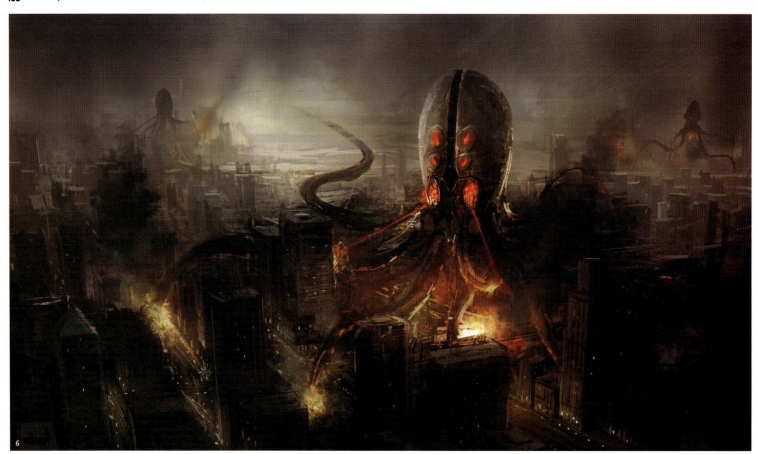

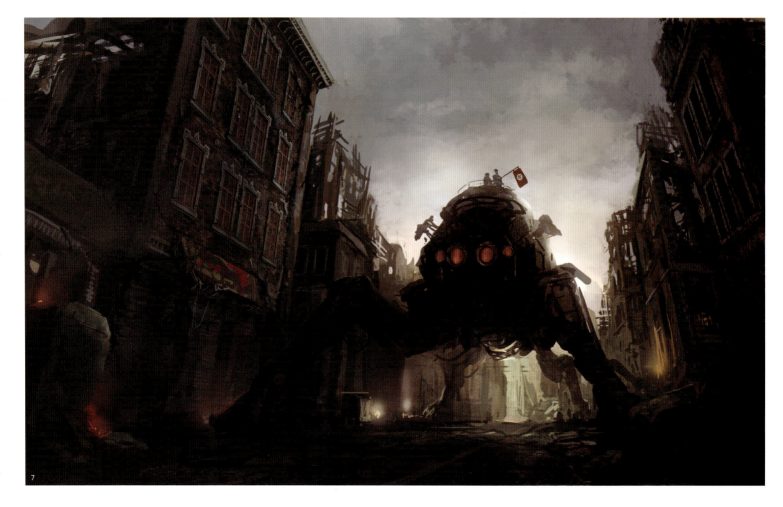

6 Invasion 1 **8** Future Base

7 Invasion 2 **9** Future City

 10 Jungle

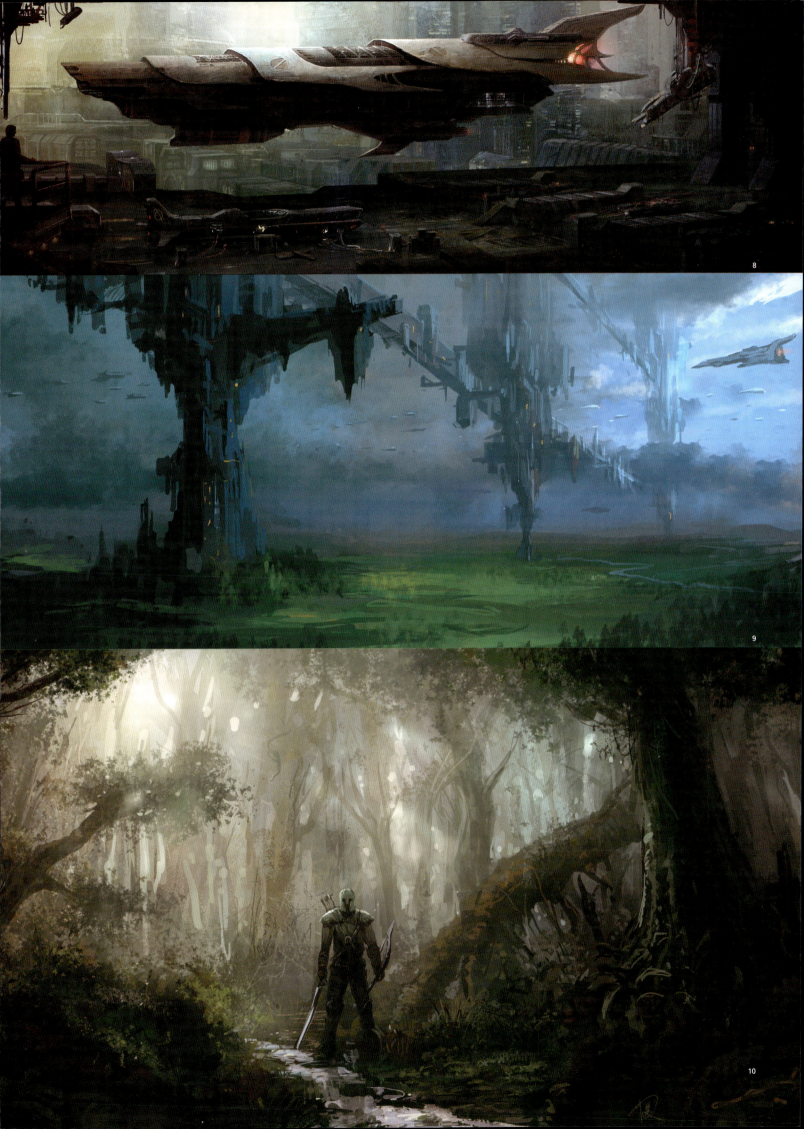

8

9

10

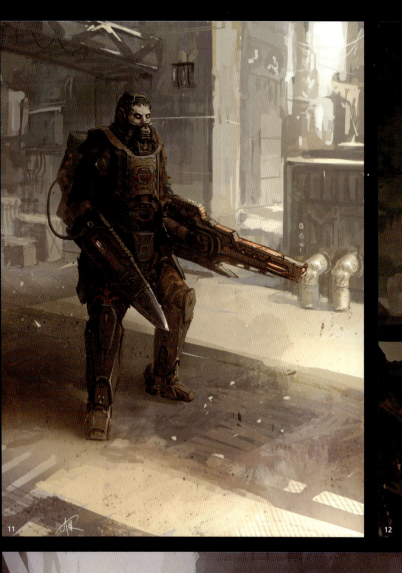

11

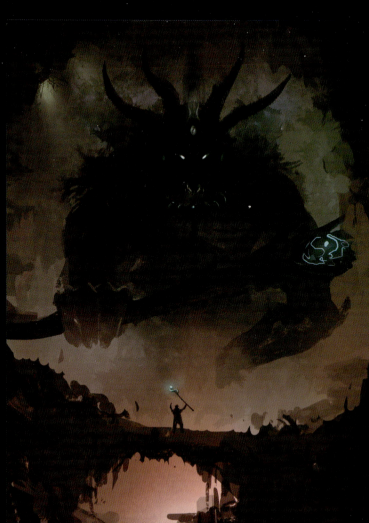

12

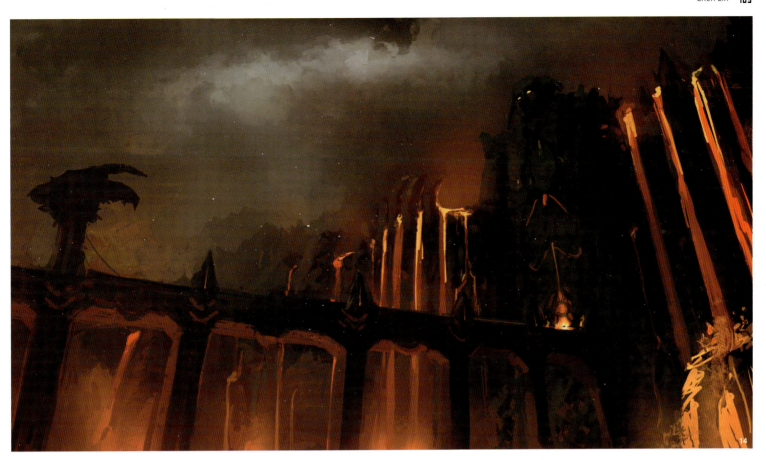

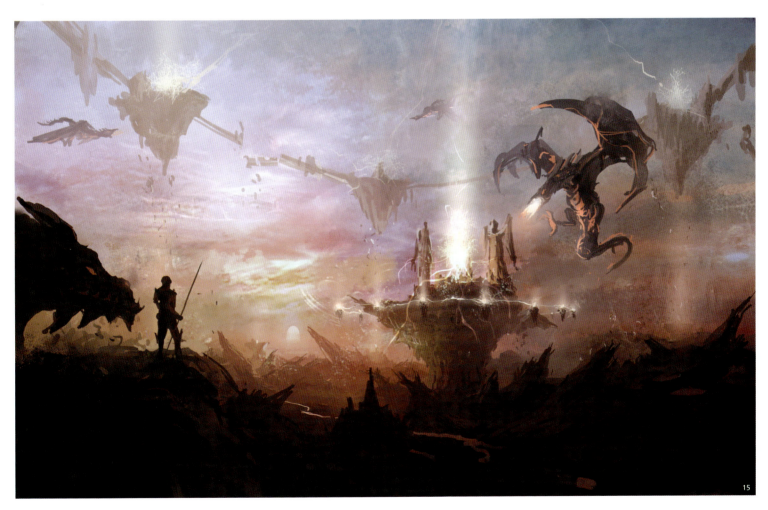

⑪ Iron Soldier ⑭ Devil Land

⑫ Call ⑮ Transmitting City

⑬ Tank Soldier

Name: Hui Ling (mamax)
Profession: Game Concept Artist at Electronic Arts Computer Software (Shanghai)

Time as Rare Metal

A Special Interview with Hui Ling, EA Concept Artist

Two years back, my first interview with Hui Ling was to express the feelings accumulated during the past months and to make up for the chances missed over and over again. Hui, then a fresh university graduate, was so fond of robot models that he would even fall asleep beside the machine tools. In my eyes, the boy was like a piece of lustrous white titanium, firm, simple and easy-going.

Currently, Hui Ling heads a concept designing group at EA. I'm no less amazed at his progress than at the thought that the project with a long history and strong reputation has eventually met this talented concept artist who was born for it. In my eyes, Hui has dropped his toys and grown into a professional game player, ready to devote himself to the game industry.

Every responsive and effective team is made up of individuals, like any metallic chain which is no stronger than its weakest link. As far as Hui Ling is concerned, he acts as the titanium link and tends to view his own time as a kind of rare metal, which should be carefully divided and wisely used so that any sparkle of inspiration can be noted down in any brief intermission.

Interview

-- Why are so enchanted with mechanic design?
-- Well, it might traced back to my childhood. As a little kid, I was fond of such extraordinary things as the monsters, UFOs, robots, and dinosaurs; even now, I am still crazy about them, particularly robots.

-- Is there any change in your concept design?
-- I used to adopt marker techniques for the industry effect chart, but later switched to oil painting and watercolor painting techniques for common mechanic design. In general, the marker technique works well for highlighting images and gains advantage in speed and effect since there are not so many materials

or colors available. The mechanic design is, relatively speaking, more complicated since it must take into account such things as light and shade, the atmosphere, the blending of colors as well as textures. Nevertheless, I stick to the oil painting broken color technique because it works best for producing desirable effects to viewers.

-- Then, how long does it take you to complete a concept design picture? Do you have any requirements for your work speed?
-- Well, in case I'm not familiar with the image, I would spend about an hour collecting the related material and then start to work on the first draft, occasionally adding some new and

neglected ideas. Generally speaking, I have a quantity requirement for my work speed and hope to perfect my skill as much as possible. It is my common practice to express the concept with simple but effective techniques.

-- What fantasy did you have in the past? And how far away do you think you are from that fantasy now?
-- As a kid, I fantasized to be a scientist; as a university student, I fantasized to produce a physical model designed by myself at 30 something. And then, I did produce one, together with my friends, so I think my fantasy is fairly close to reality.

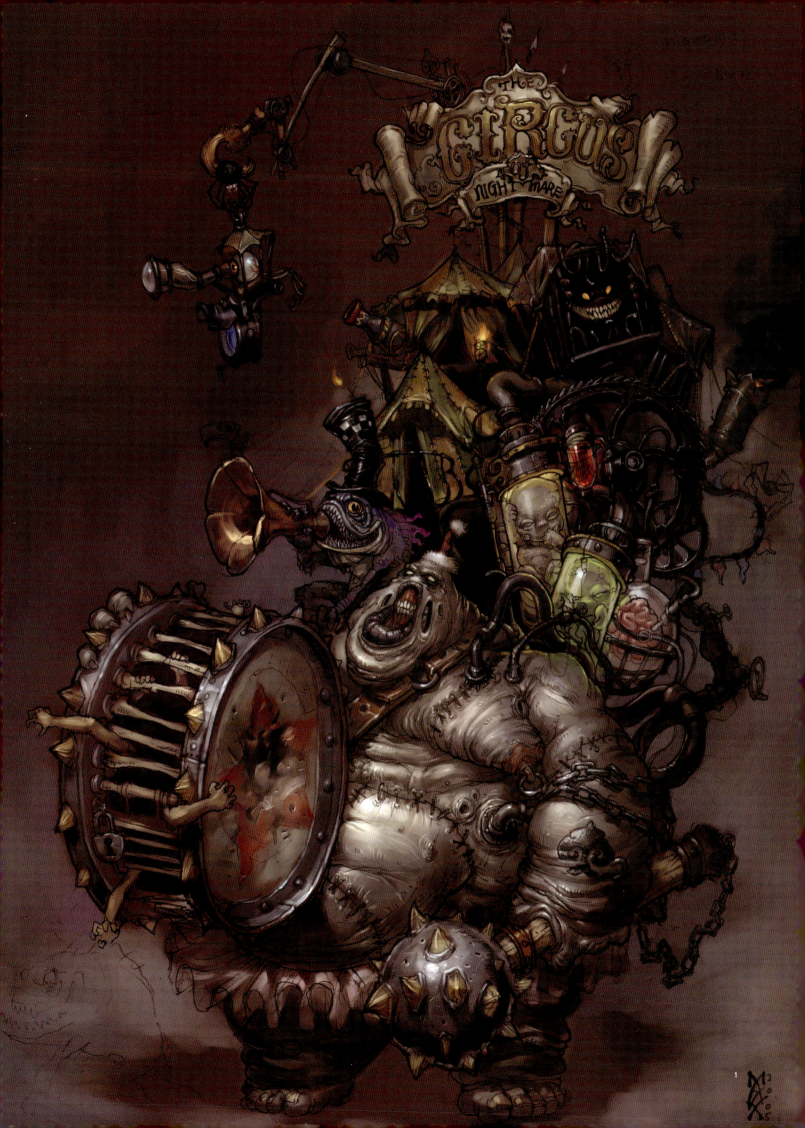

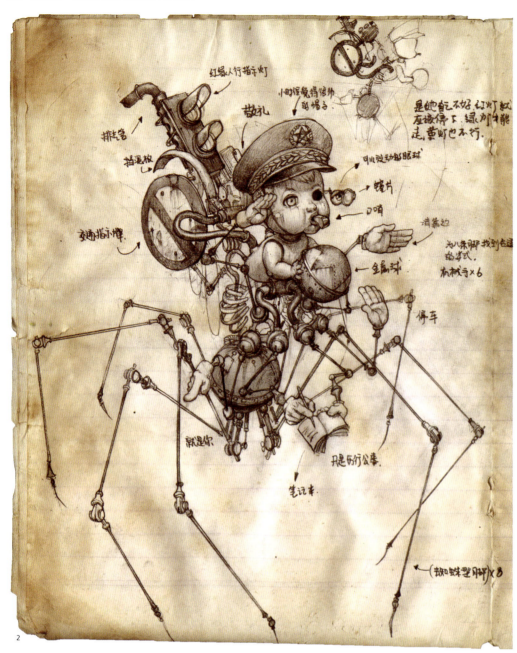

2

❷ Ouija Board---Octal-foot Cop

❸ Ouija Board---Decomposition Chart of the Octal-foot Cop

❹ Ouija Board---Head Chart of Nimmanarati

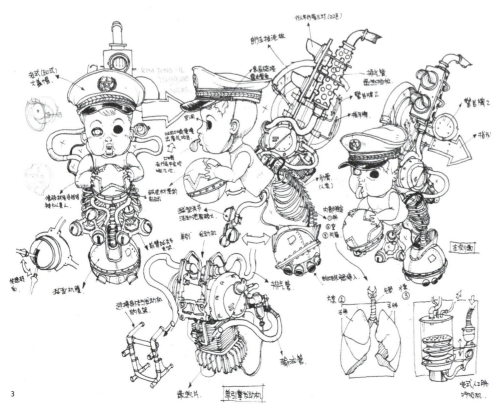

3

4

5

5 Ouija Board--- Candy Making
Machine Faery Bugs

6 Ouija Board---OUIJA

貔

7

7 Ouija Board--- Nimmanarati

8 Ouija Board--- Decomposition Front Elevation of Nimmanarati

❾ Red Escort

❿ Meat Mincer

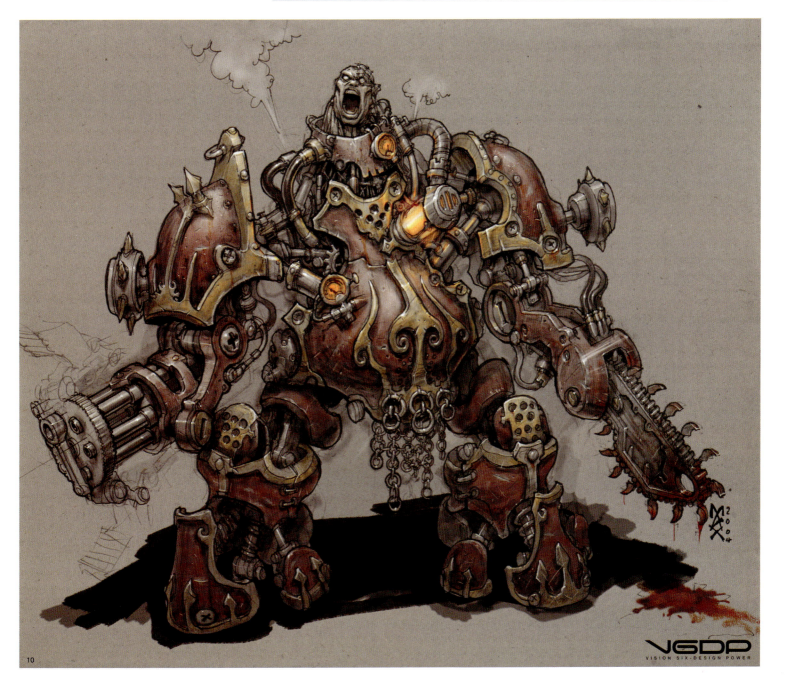

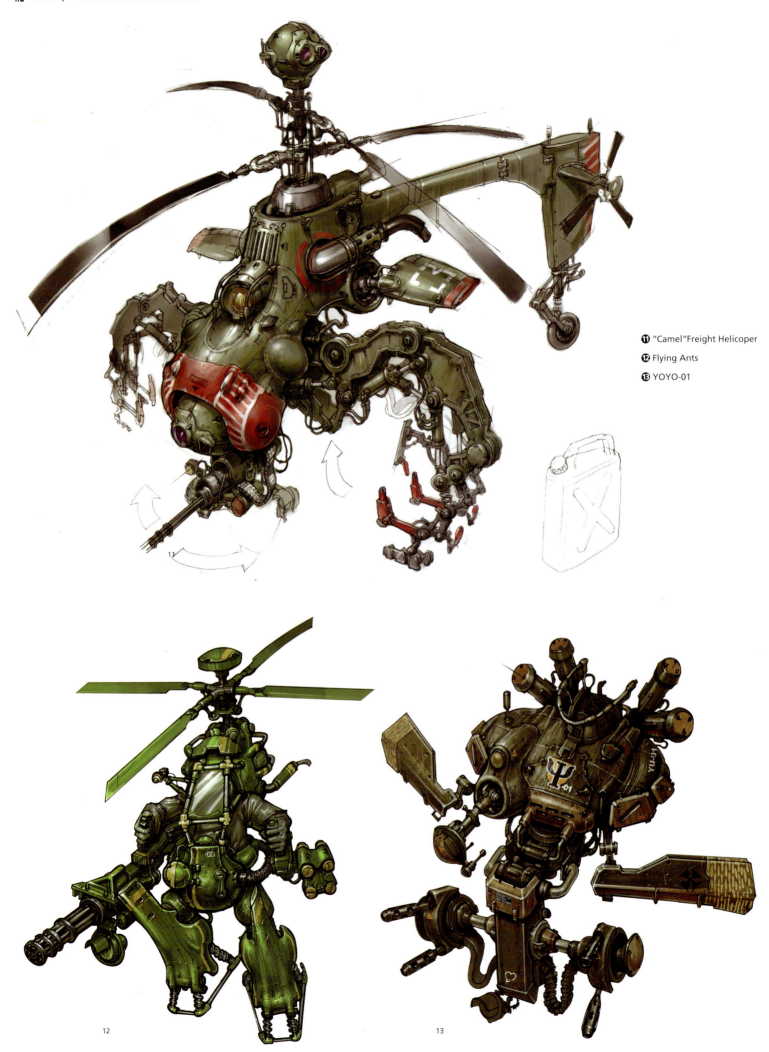

⓫ "Camel" Freight Helicoper

⓬ Flying Ants

⓭ YOYO-01

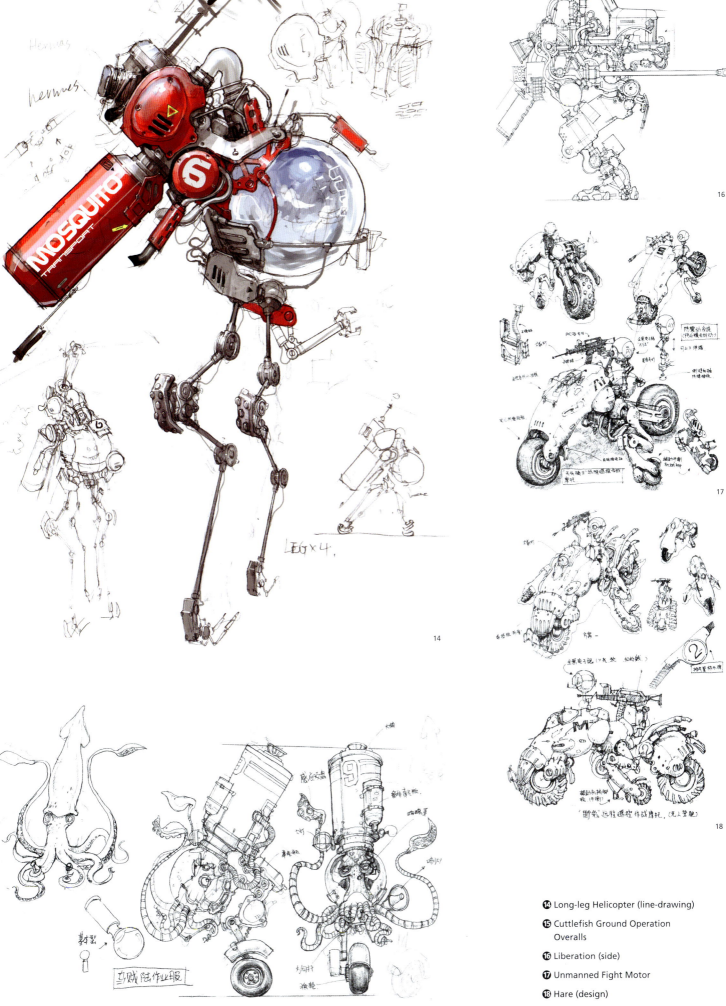

⑭ Long-leg Helicopter (line-drawing)

⑮ Cuttlefish Ground Operation
Overalls

⑯ Liberation (side)

⑰ Unmanned Fight Motor

⑱ Hare (design)

Name: Dongzi Liu (eastmonkey)
Profession: Freelance Illustrator, Scene Artist
Homepage: http://eastmonkey.blogcn.com/index.shtml

Looking for Monkey King
A Special Interview with Dongzi Liu, Freelance Illustrator

Dongzi Liu named his online ID "Monkey King" after his idol, which explains why we find in him so many characteristics typical of the mythological figure in the classical Chinese novel Pilgrimage to the West: traditional, strong, unyielding, cynical, and daring. A lot of his creations feature "Monkey King," including illustrations, comics, and water colors, and more importantly, he is currently working on a new edition of Pilgrimage, responsible for the character and environment design work. Since he was a kid, Liu has loved Monkey King, but he admitted that he has been trying in vain to sketch out the Monkey image in his own mind, and fantasizing to see his idol anytime soon.

His long odyssey in pursuit of Monkey King will lend more significance to this character. Just as we see in a movie, the pursuit itself is a rewarding journey that helps make the crusaders better than what they are.

Interview

-- As a freelancer, what do you think you should do to get recognition from your client?
-- Well, honestly, I haven't given too much thought to this issue, but I do know that if my pictures are awesome, everything will be OK.

-- What, in your view, should an awesome picture or design look like?
-- As with a meal, the color, flavor and taste must all be excellent before it can be considered "awesome." Suppose a painting portrays Europe in the Middle Ages, then whatever we see in the painting should best fit the atmosphere of the corresponding period, including such features as the character's mental states and settings. Personally, I think we should collect all the necessary data, find more clues and explore more thoroughly before starting work on the intended theme.

-- Your digital works resemble the hand-drawing style to a great extent, and at the same time your own hand-drawn creations are brilliant. Why are you so hooked on this particular texture?
-- I knew this early on when I was into water colors: Computer generated digital drawing is substantially different from hand drawing in that the latter shares the creator's mood and feelings. So when I do digital creations, I persist in my efforts to restore the hand drawn textures.

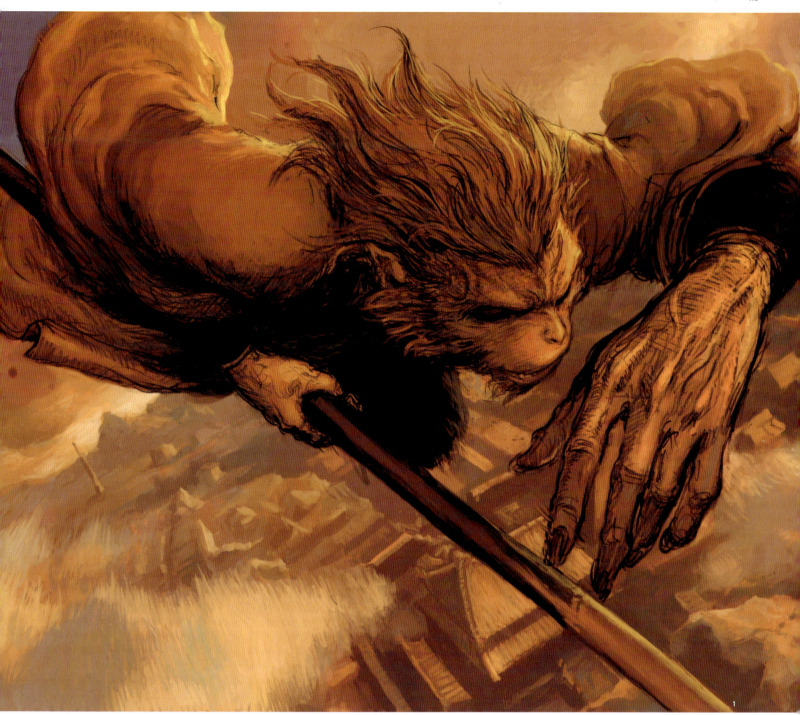

❶ The Monkey King Returns

-- Talking of Pilgrimage to the West, why do you love Monkey King so much?
-- Many people do. I'm just one of them. When I was a kid, I was always brandishing the "Golden Cudgel," the weapon used by this mythological hero. Over the years I have seen him not only as my idol, but as my talisman as well. Whenever I have troubles, I know that Monkey King, or Great Sage Equal to Heaven, is always by my side. And that's why I'm inclined to produce the image of Monkey King in my mind.

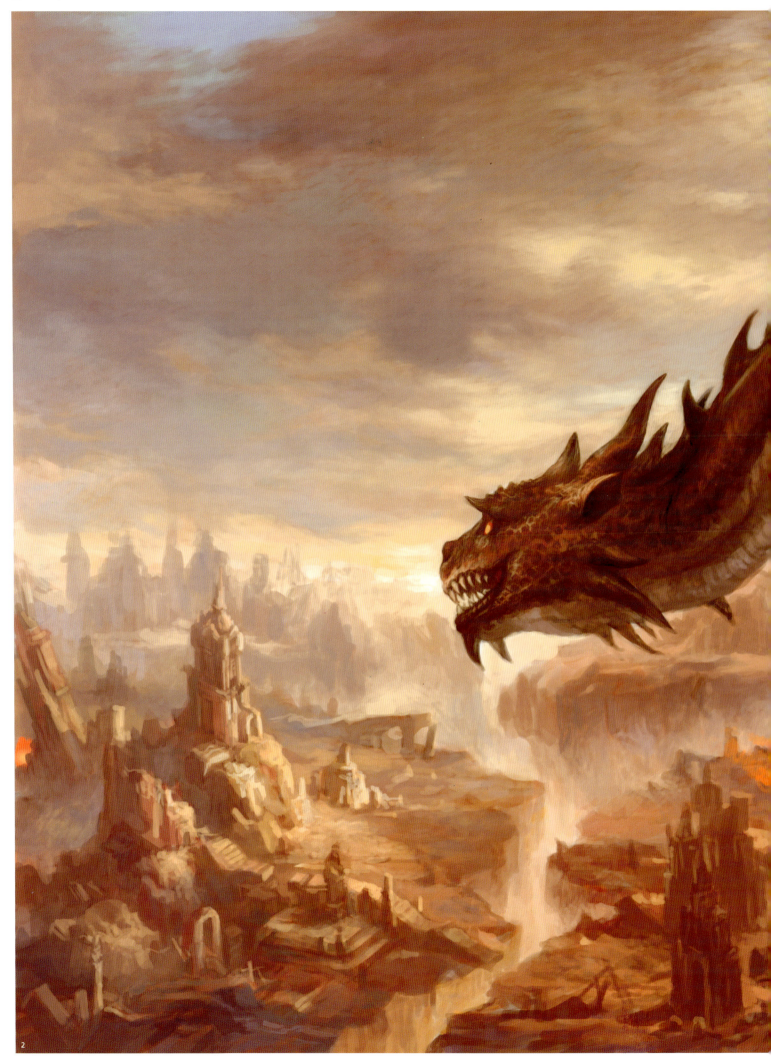

❷ The Pale Knight

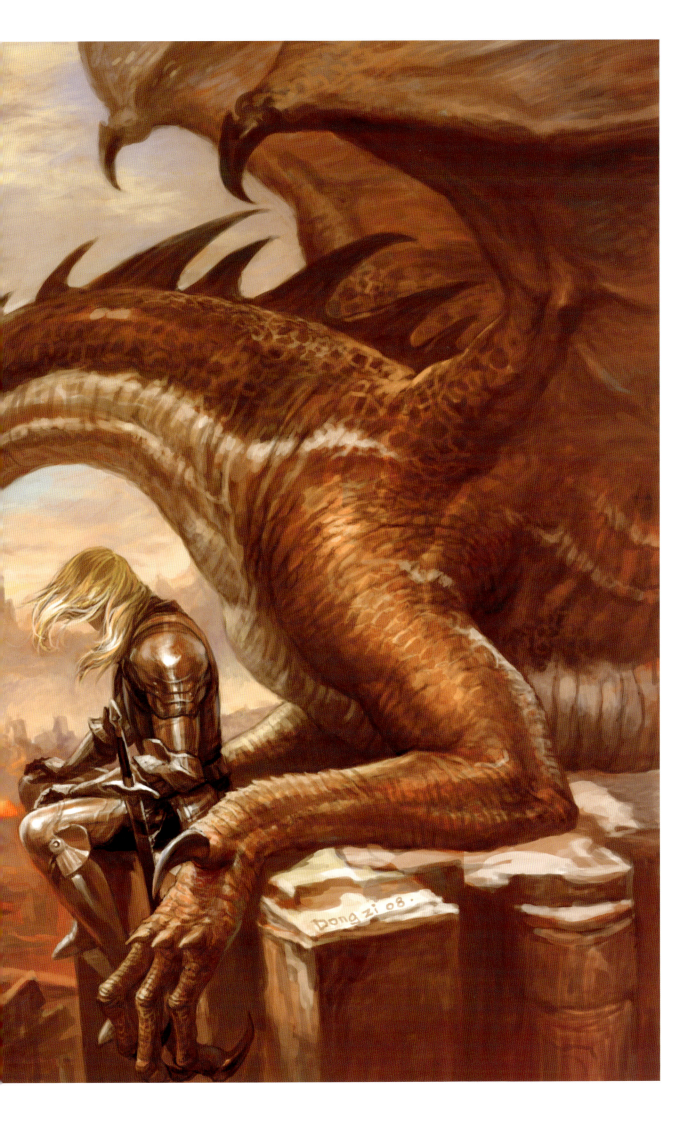

That means you have been Looking for the Monkey King in your mind. Do you think you can make it in today's era?
-- Monkey King is our Chinese mythological hero, and all generations need such an idol, like each American has a Superman in their mind.

-- What fantasy did you have in the past? And how far away do you think you are from that fantasy now?
-- Only one fantasy: I would kill to see Monkey King in person.

❸ Fox

❹ Congratulations to *Ya San*

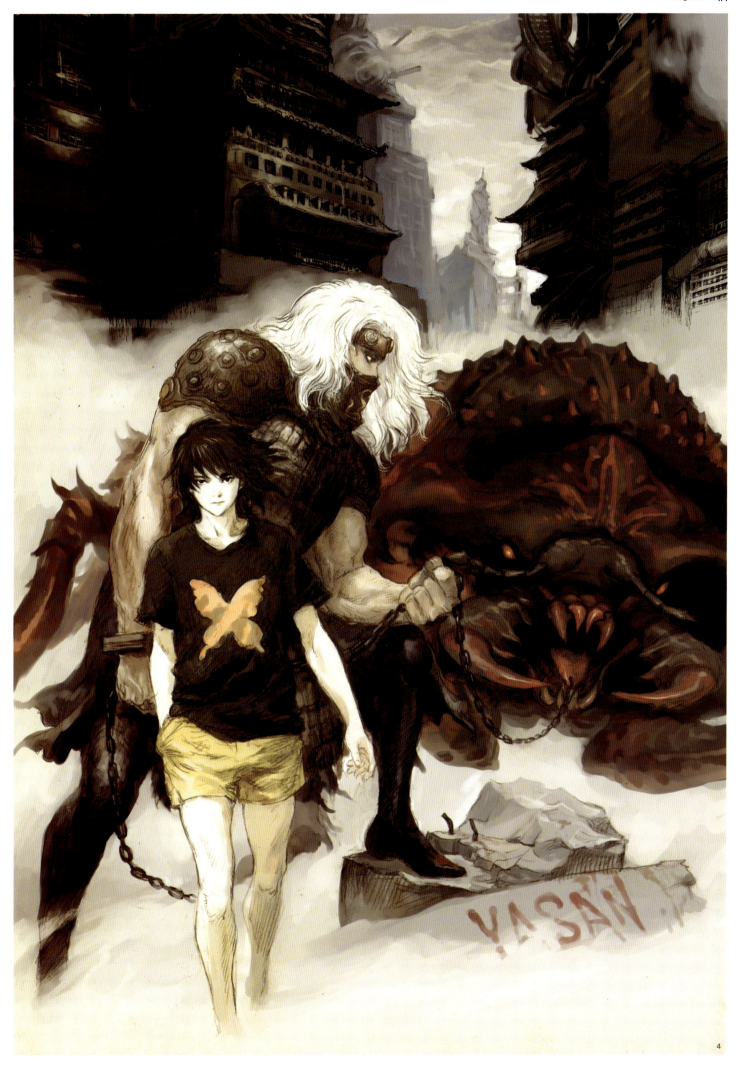

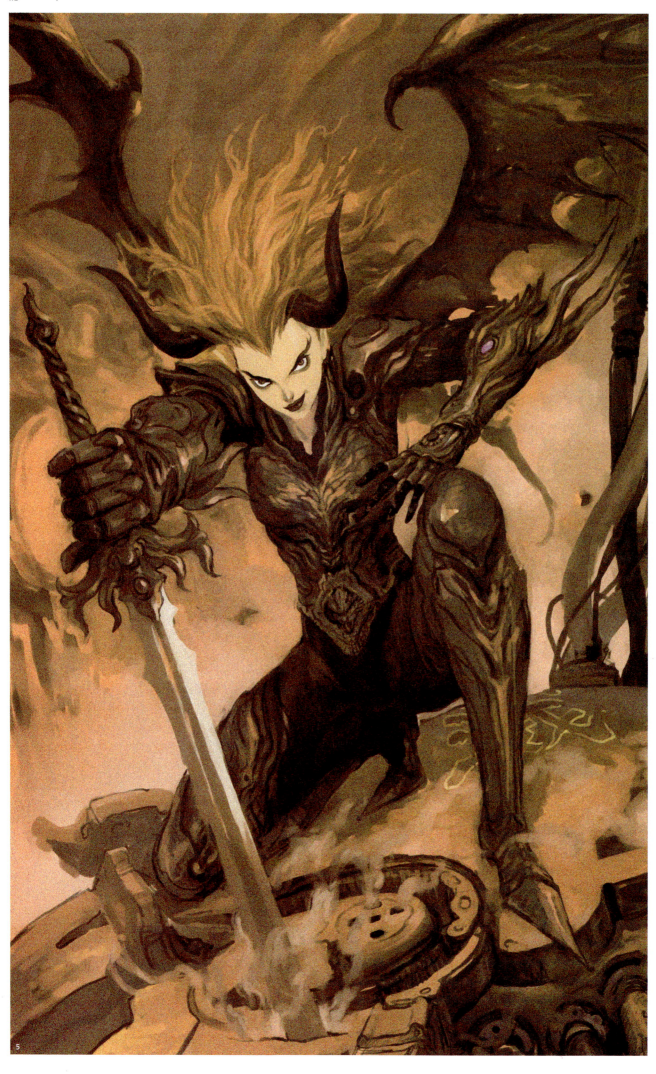

❺ Fire-fiend
❻ Possessed
❼ Pig girl 1
❽ Pig girl 2

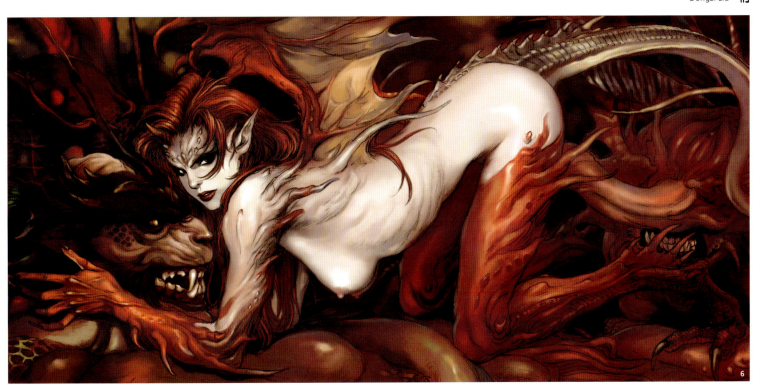

9

10

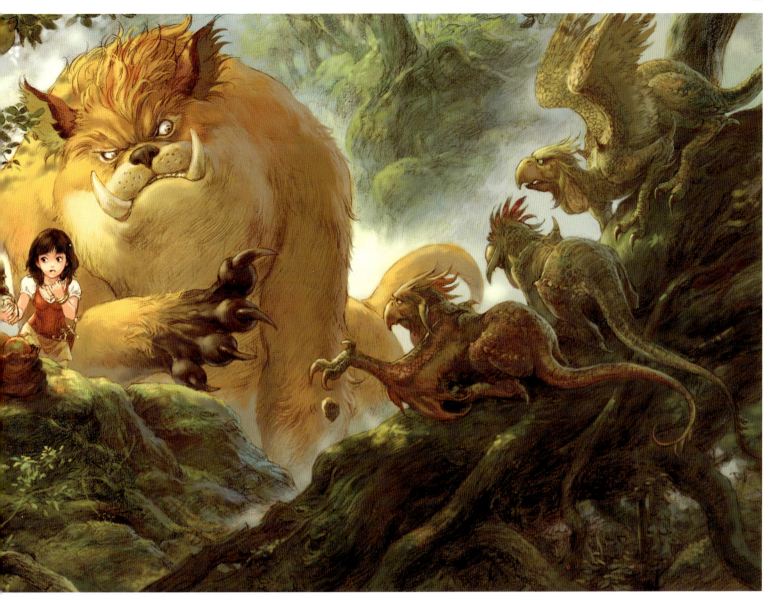

9 Zi-Xia
10 Street King
11 Pumpkin

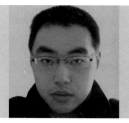

Name: Yang Liu (Darklord)
Profession: Freelance Illustrator, Concept Artist
Homepage: http://liuyang-art.com

Yang Liu (Darklord)

Seems Juvenile, But It Works

A Special Interview with Yang Liu, Freelance Illustrator

Just like his peers who behave in the "juvenile fashion," Yang Liu loves freedom, takes things as they come, believes in his ability, and controls his own destiny. A 22-year-old artist, Liu is currently a university student majoring in English. While he is having a headache right now over his graduation thesis, Liu is, in my view, very cool because he lives a life wearing two hats—on the one hand, a grouchy student of the English Department who is always ready to play hooky; on the other, a budding illustrator in the international digital art community.

Presently, Liu is actively involved in CG creation, but not far enough into this industry yet. More recognition comes from foreign institutions, while the huge market of this industry in China is waiting to welcome our big boy. Liu, however, hopes to work as a freelancer so that he could maintain his young heart and his youthful interests.

Interview

-- I feel that your works are very mechanical, or extremely futuristic, and you usually add a smile to them. Why do you prefer this style of design?
-- Well, honestly, I love tactile things and science fiction ideas. Fantasies about mechanics and futuristic world, in my view, may be categorized as manly romance, and you can see the smile as a symbol of romantic playfulness. A big boy's romantic visions should not, anyway, be the same as a girl's crystal fantasies.

-- To draw futuristic and mechanical illustrations, the artist must have his own concept

design principles. What's your own rule of thumb, if any?
-- Personally I prefer the ancient robots, or the Steampunk mechanical design. When it comes to systematic robotics, I don't have any specific ideas, but I'm planning to infuse some elements of ancient Chinese architecture into my works, not just a cheap copy of the traditionals, but a blending of some structure, form and layout into the futuristic style. I think it would be a lot of fun to do so.

-- What advantages do you think freelance positions have over permanent jobs? And

why is it that you're looking to continue your freelance work?
-- Freedom. The best part about being a freelancer is that it allows you to wake up naturally every day, and you don't have to squeeze onto the subway to work. And if you wish, you may well go to the coffee bars or the countryside to work with your laptop, no longer concerned about the unreasonable house prices in big cities. What's more, you can make a nice income that way.

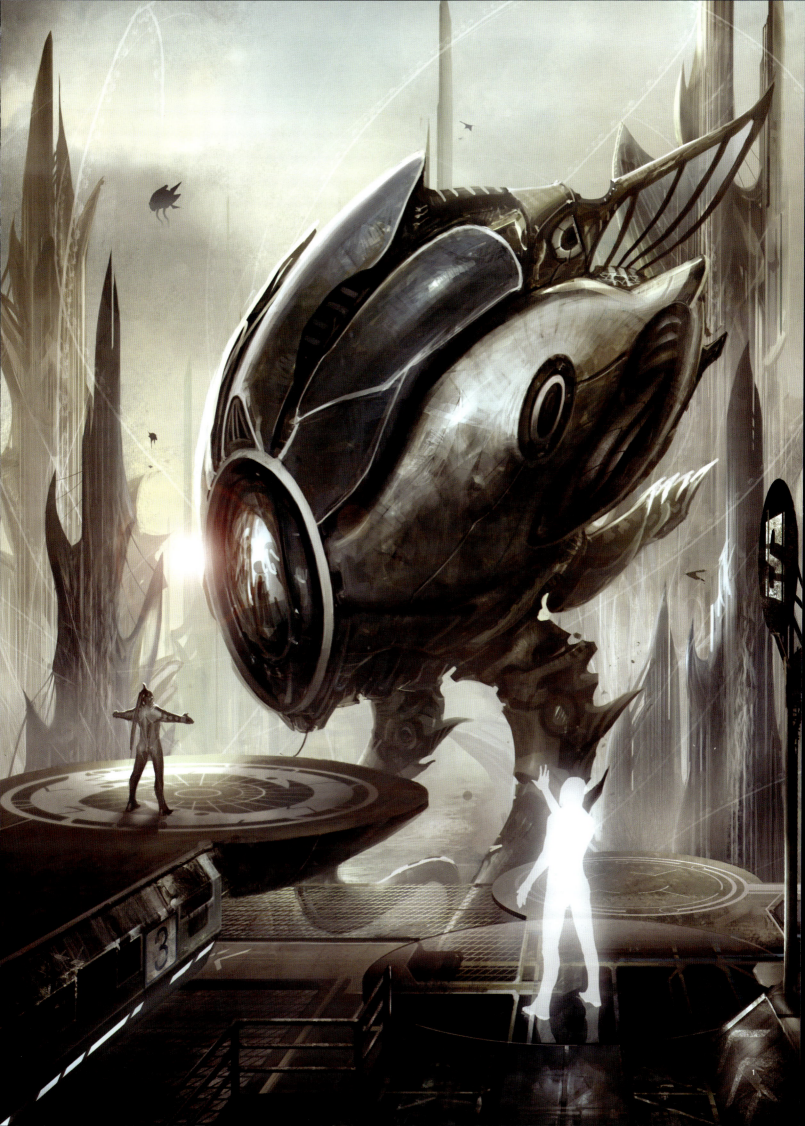

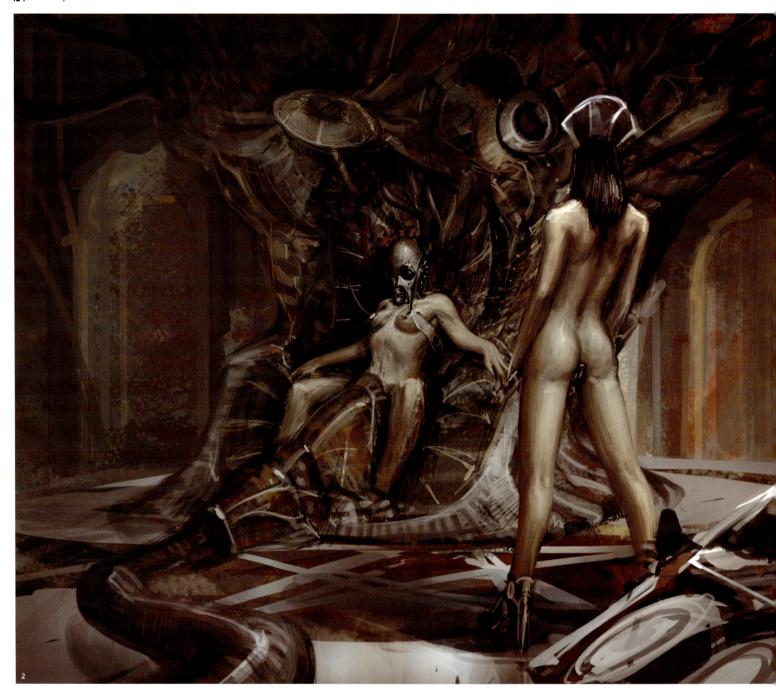

❷ Interesting Experiment

❸ Robot Samurai

❹ Marketplace

❺ Street

-- What fantasy did you have in the past? And how far away do you think you are from that fantasy now?

-- To live a comfortable life, to draw whatever I like, and to be successful as Craig Mullins. I've no problems with the first two, but the third one, I should say, is my future goal. Probably I'll never be as good as Mullins, but I will try, haha.

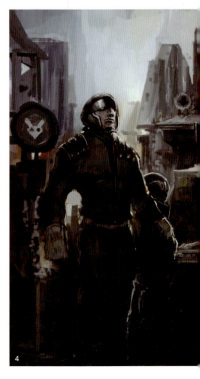

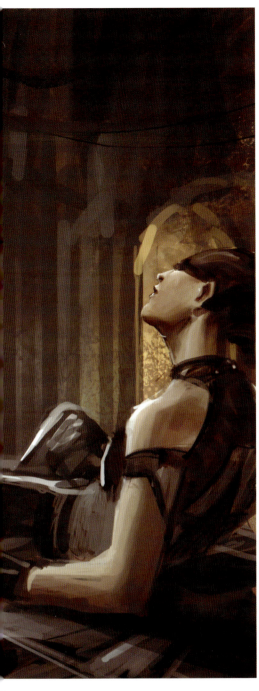

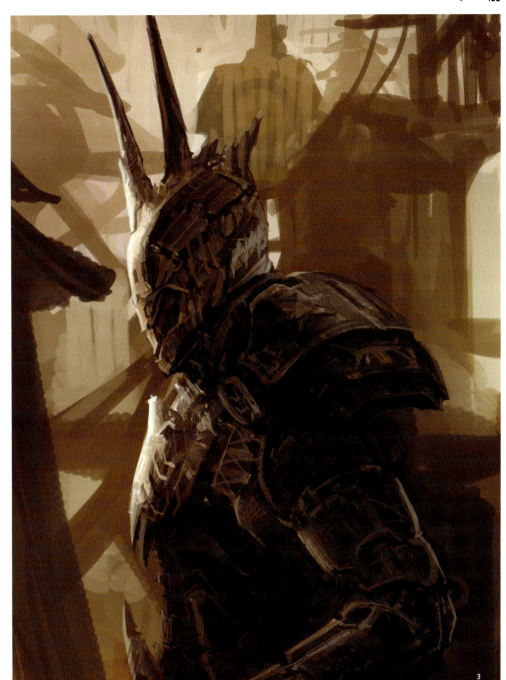

3

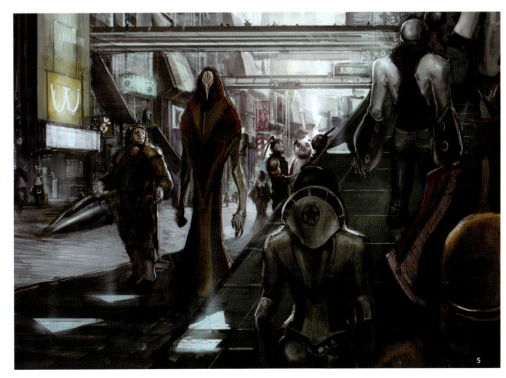

5

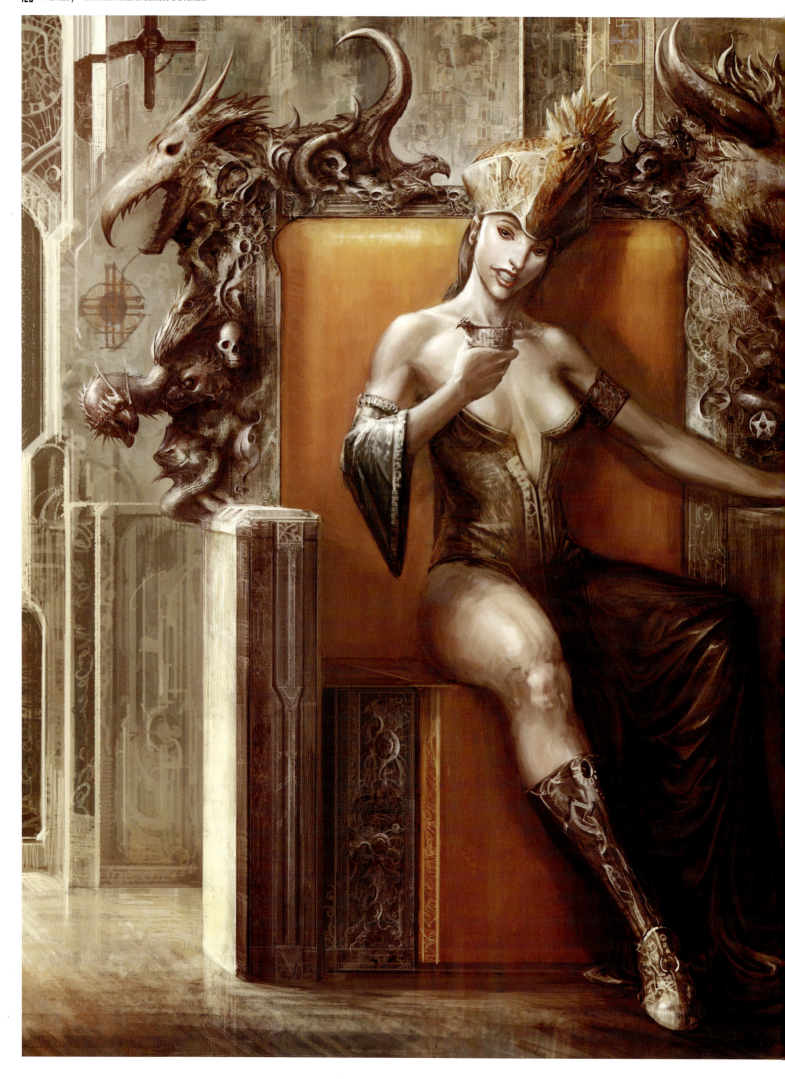

❻ Drinking

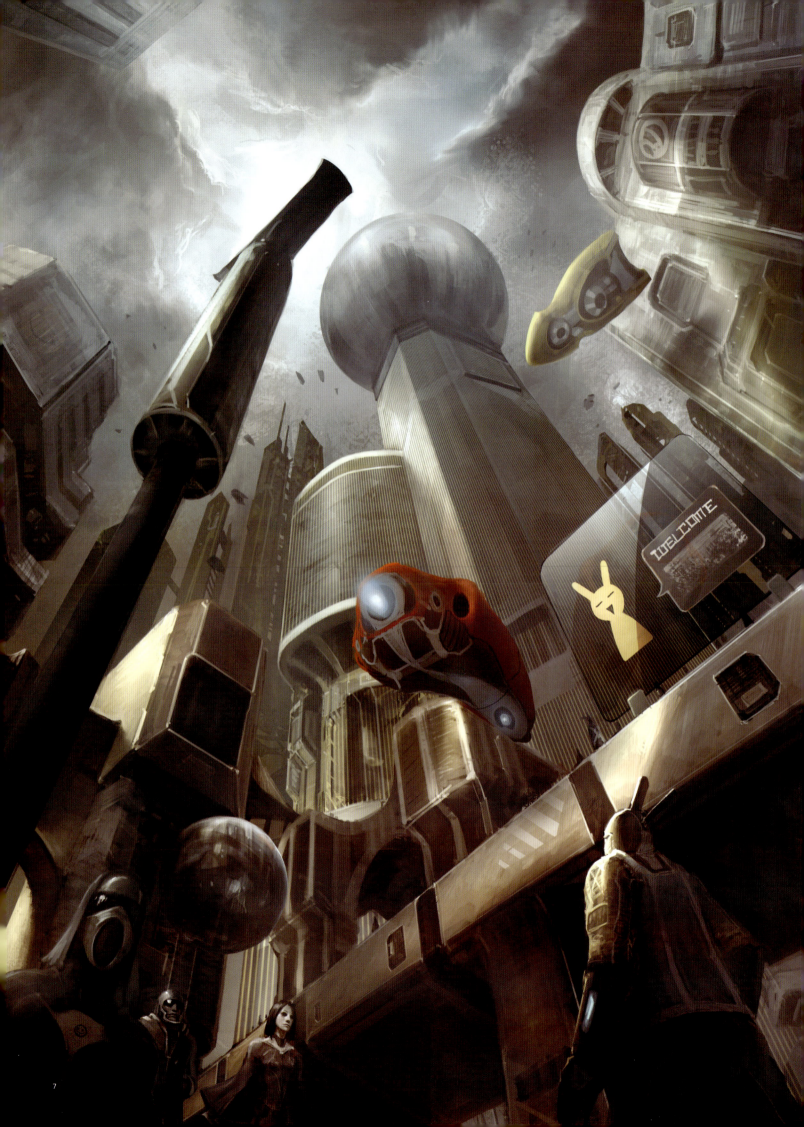

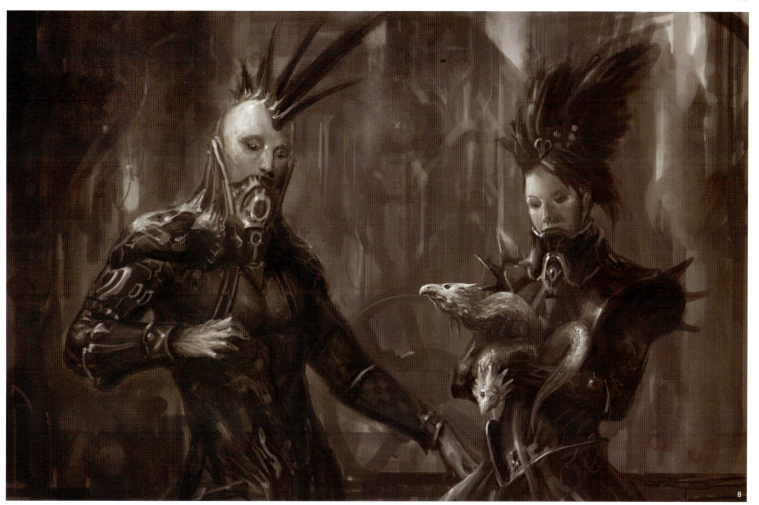

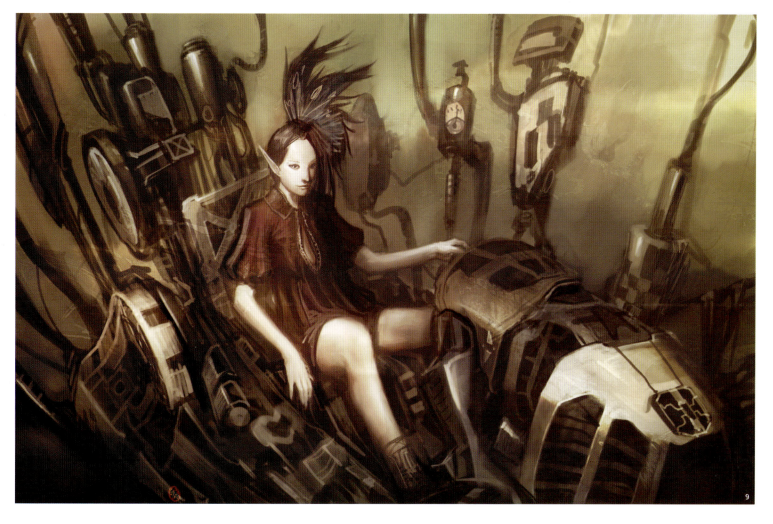

❼ Welcome to the Rabbit City ❽ Pets ❾ Steam Punk Robot

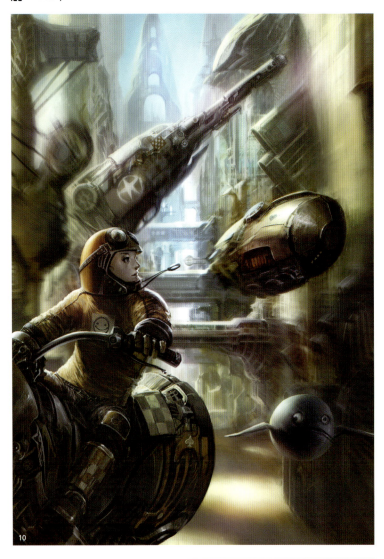

10

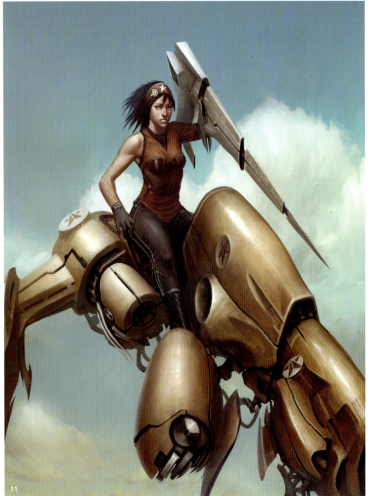

11

12

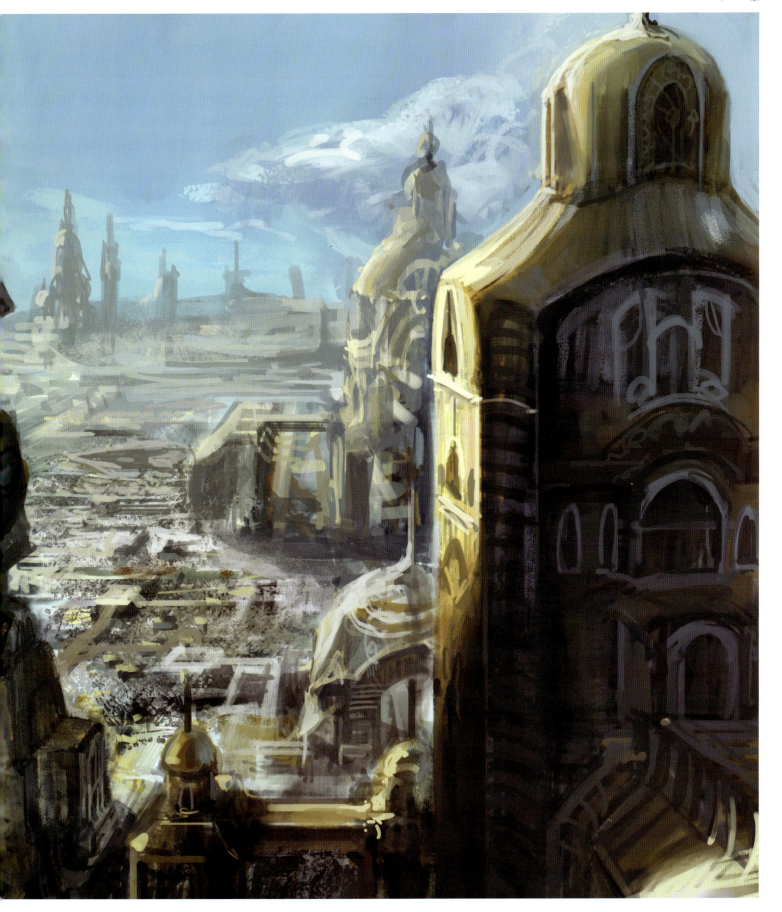

10 Blur

11 Knight

12 Kingdom

Yong Liu (Yohn)

Name: Yong Liu (Yohn)
Profession: Art Director at Coslight Tiancheng Interactive Software
Homepage: http://www.yohn.cn

Building a World in Two Years

A Special Interview with Yong Liu, Game Artist

Yong Liu has been living a life different from most of us in the past two years, or at least it is different from what he was until he disappeared from my view. Two years ago, he left Beijing for Shenzhen. From then on, I have not seen many of his works, nor heard from him, as if he had walked into another world.

By "another world," it means that he is having a different time schedule from ours. When we are looking back, Liu has, for the first time, taken on responsibility for a project team. As an art director, he has devoted much of his time to his work, the meetings that fill his calendar, and the most labor intensive and around-the-clock work on his creations, which, taken together, have plunged his world into an era where time drips with gold.

For the past two years, Yong Liu has placed himself in a different world, to build a new one of his own.

Interview

-- It seems that you've been bent on creating classical works. Why do you prefer this particular style?
-- Well, ha, during my learning process I've spent almost all my time and efforts on Chinese cultural traditions and styles, simply because I'm interested and find it hard to forget them. All I want is to study, to understand, and to make the best use of these traditions.

-- You put so much into your present work, with a little time left over for your own creation. What do you think you have got out of it?
-- Both my present work and my own creation have been focusing on what I love to do and my own academic interests. While I'm developing an actual project plan, I'm developing myself, trying to know more about game designs, and creating more opportunities to acquire and use more knowledge, which helps me to work more efficiently.

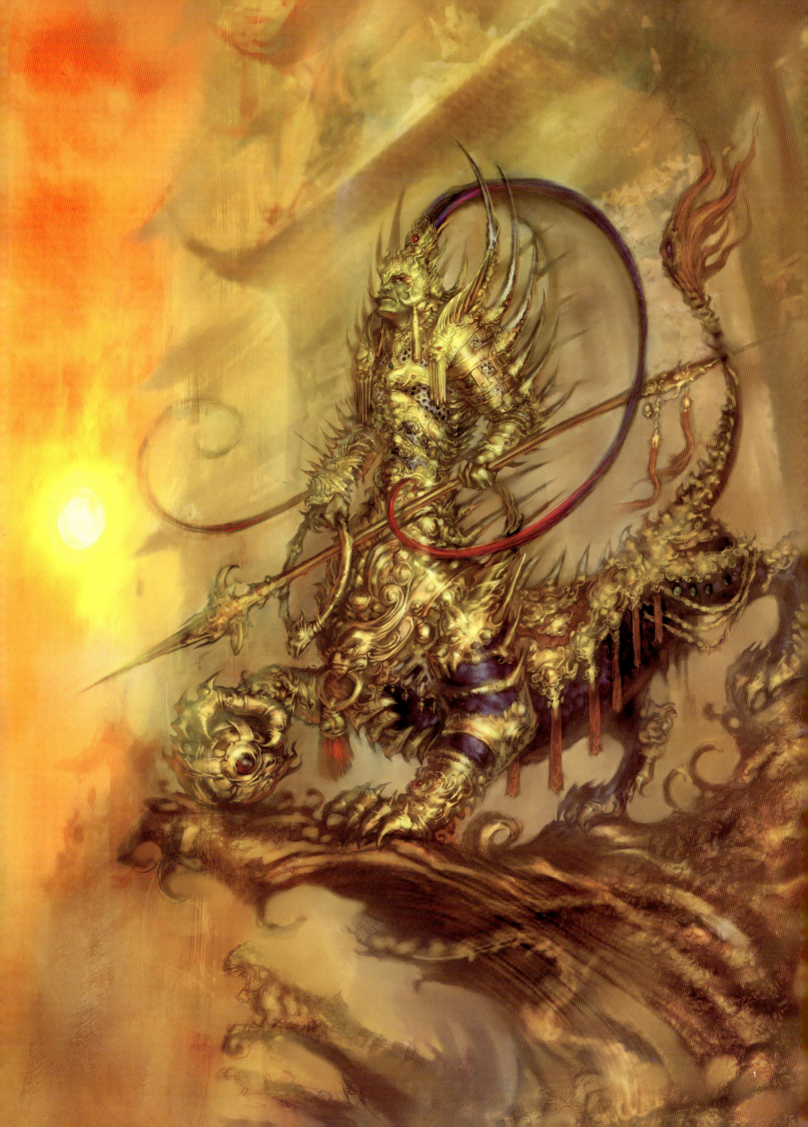

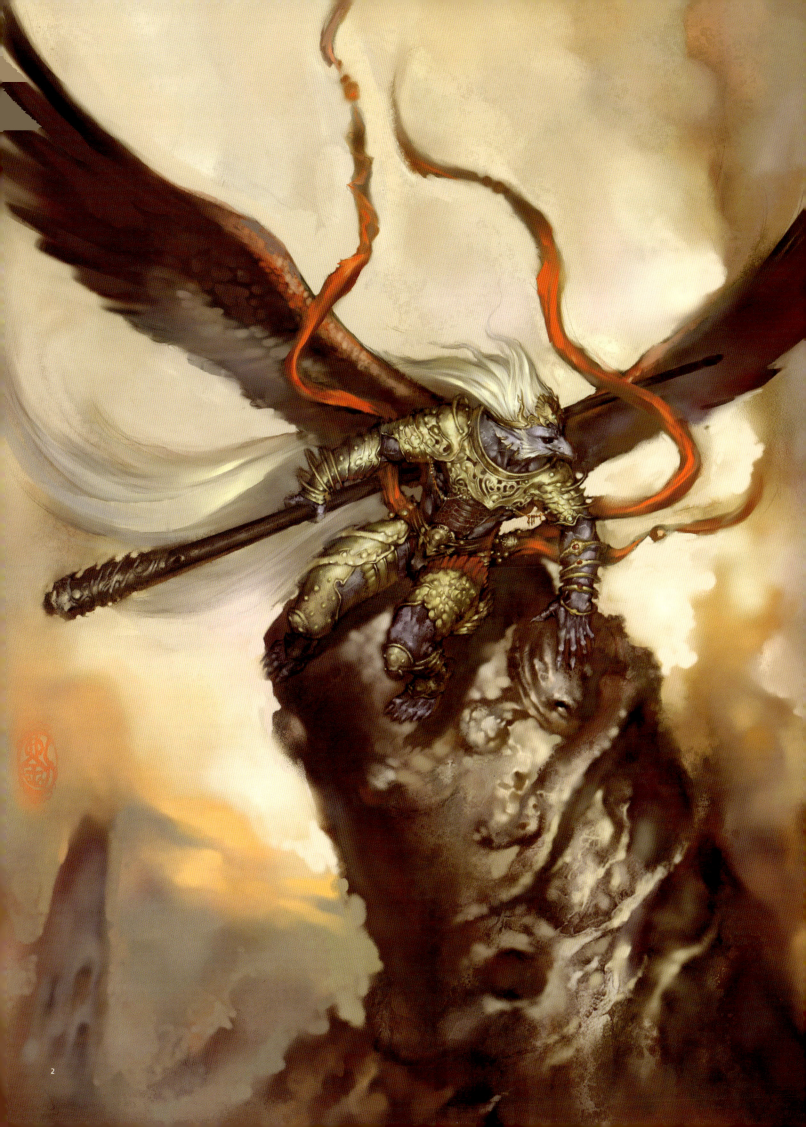

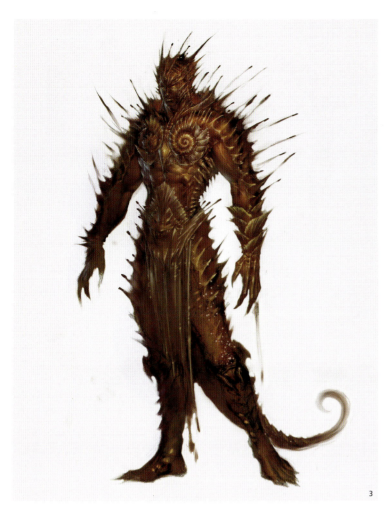

3

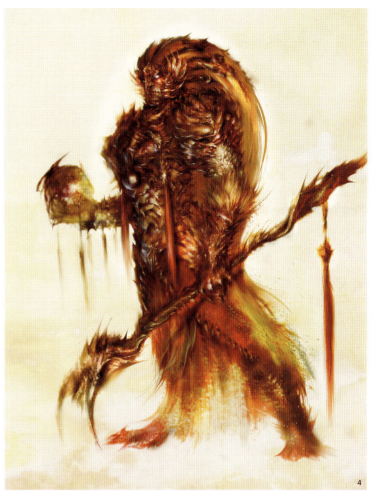

4

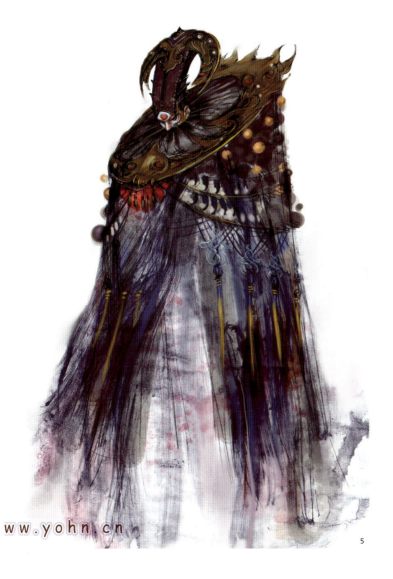

5

❷ Thunder God
❸ Sea Knight
❹ Lion Man
❺ Opera

-- What is your understanding of concept design? What's your own rule of thumb, if any?
-- Concept designs reflect the subjective views of the designer, but they're not blind expressions of personal feelings. It is important to know that when you reconstruct or restructure your subject matter, you should allow most viewers to experience the intended cognitive response very soon. Before a qualified concept designer sets to work on it, he is supposed to update and expand the relevant knowledge, to learn and use information transmission channels, and to know the major response generation rules and principles.

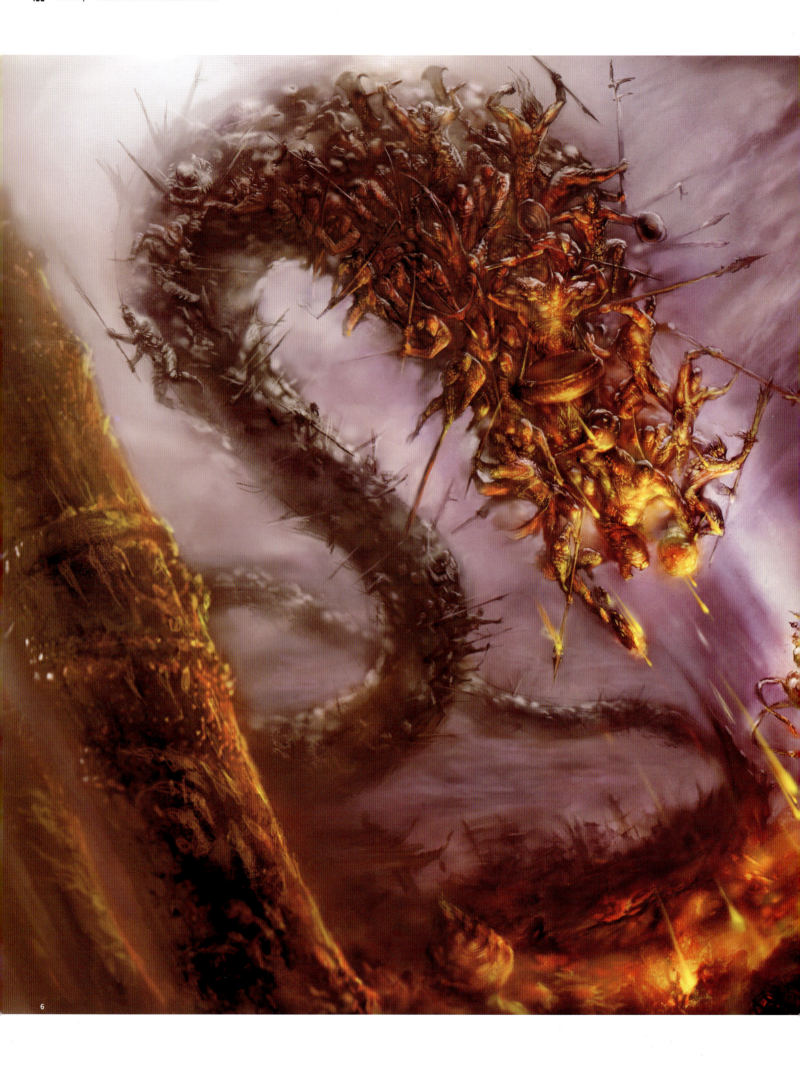

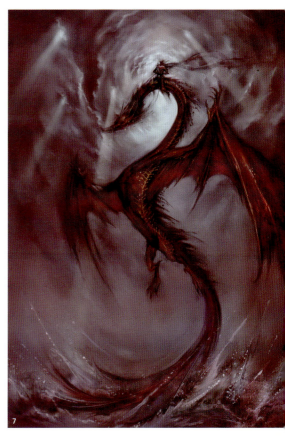

6 Capture

7 Dragon

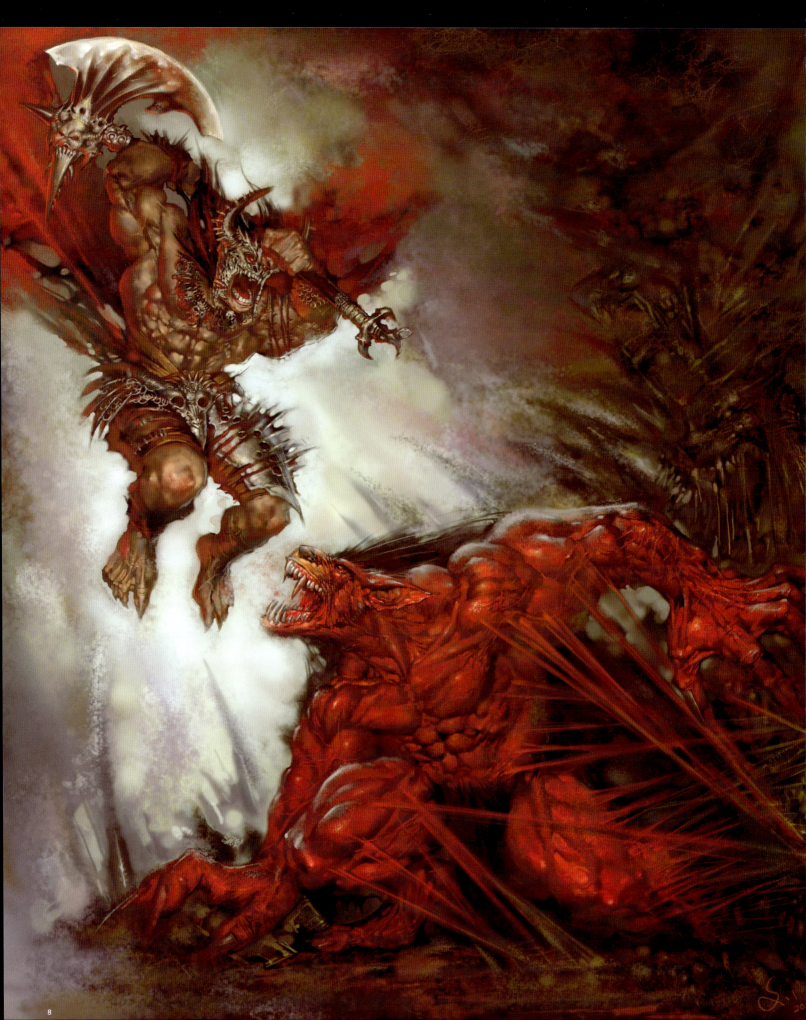

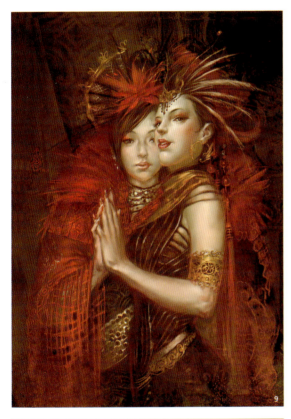

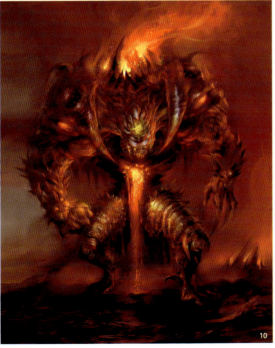

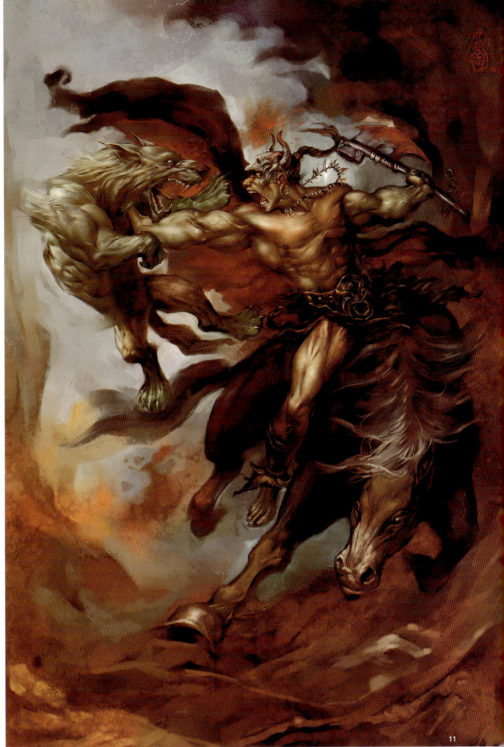

8 Warrior 1

9 Twins

10 Scorching

11 Warrior 2

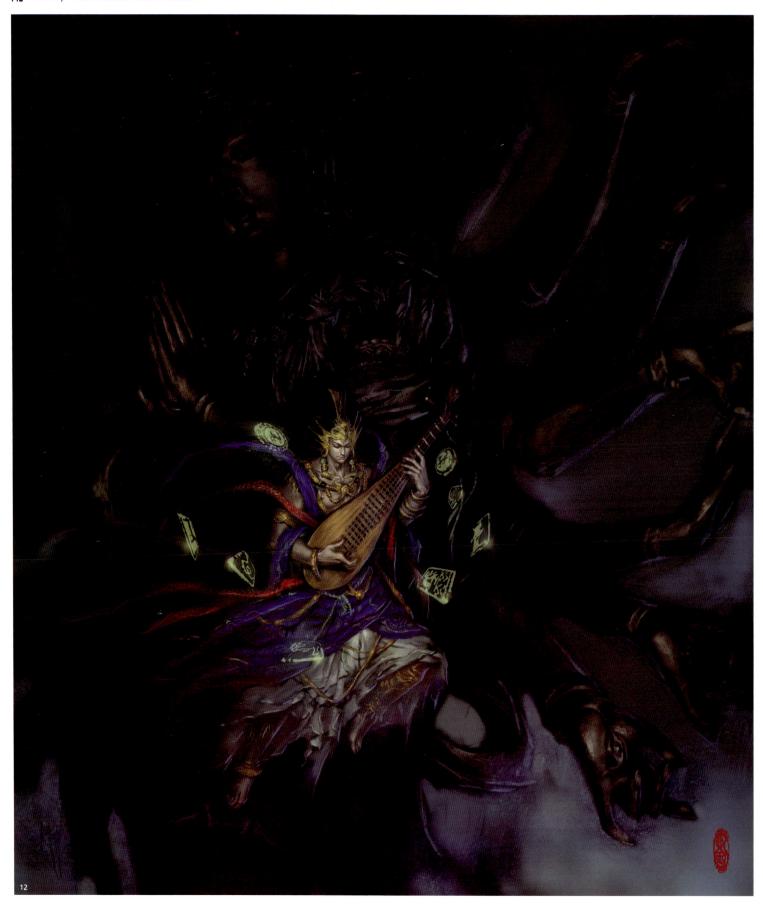

12

⑫ Lute God

⑬ Tower God

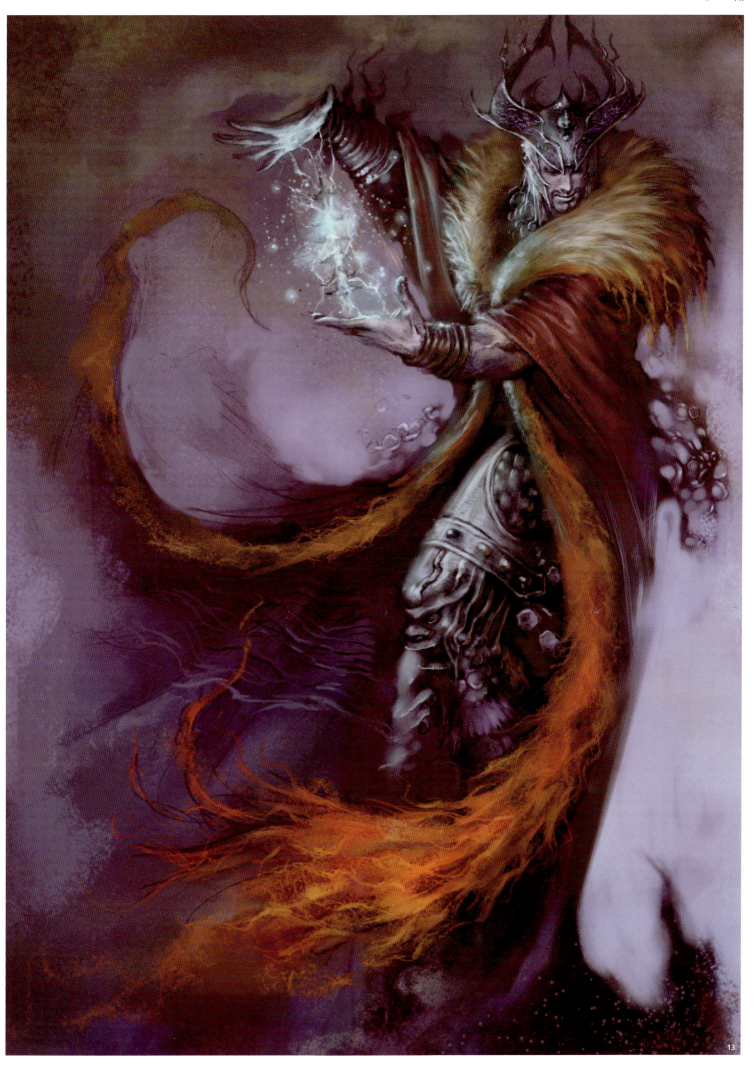

Guoliang Sun (Dalian Newconcept)

Name: Guoliang Sun (Dalian Newconcept)
Profession: Concept Artist at Spicy Horse Games (Shanghai)
Blog: www.banhatin.blogspot.com

孙国梁

Everything Starts Somewhere
A Special Interview with Guoliang Sun, Game Concept Artist

In an outsourcing company, nothing is impossible; everything happens for the first time; all staff members have to force themselves to move forward, to do whatever they can to develop personal skills, and to welcome their own new beginnings.

Guoliang Sun is never afraid to start a new life, or start using a new technique. Dalian is perhaps his familiar hometown, but it's not the heart of the game industry. Matte painting is perhaps not his familiar concept design technique, but it's a must-have tool for today's technology. Mr. Sun has grown up in the web world, in an outsourcing company that tests and builds character, and in an era before he was 30 years old, when he would have tried everything. After that, however, he would have to shape his style by drawing on experiences from his earlier attempts.

Interview

-- You're a good example of a concept designer who has found himself by "getting lost" in the cyber technology. Do you think it has become a fashion to be a professional through self-education?
-- Well, it depends on who you are, but I'd rather believe that a new era of self-made men is coming. Powerful Internet technology facilitates resources sharing, and we're entitled to enjoy such a privilege to learn from each other through the Web.

-- During your own self learning process, what are important factors in improving your skills?
-- Obviously it's important, first of all, to change your way of thinking. Repeated frustrations and failures often lead me to try new techniques. Sometimes, of course, before progress is actually made, I refrain from painting for an extended period to reflect on what I have been doing. And after that, I usually make satisfying progress until the next cycle begins.

-- Some people out there want to become professionals through Internet. What advice would you give these new illustrators starting out?
-- First, plunge into an environment of creation. They should know that the more they put into it, the more they get out of it. In my case, I would surf the web first, looking for graphic design forums and artists' personal homepages to get a good start and develop my interests. It really does me good to draw preliminaries and rough sketches more often. When it comes to computer design, you can have full confidence in PS, and enhance your skills by reading more textbooks and learning more about software before going to web sites to download illustrations you admire most. Those illustrations, of course, should suit your interests. What I have said boils down to this: practice more, observe more, and think more.

❶ NAKARDY Warrior

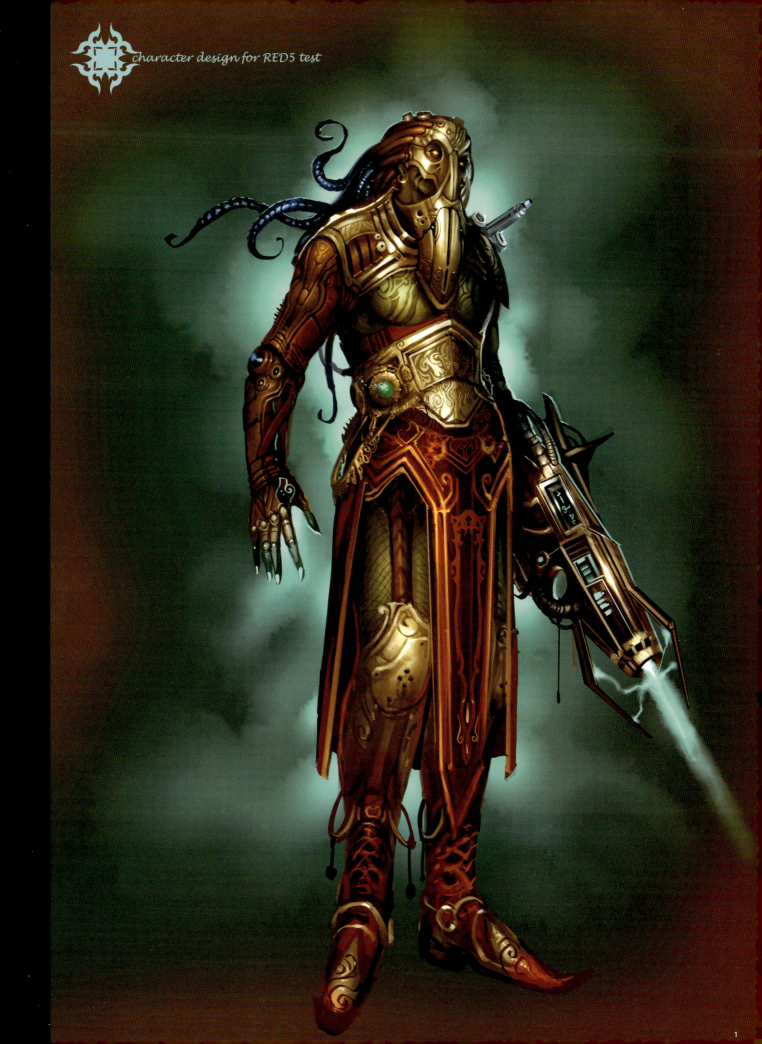

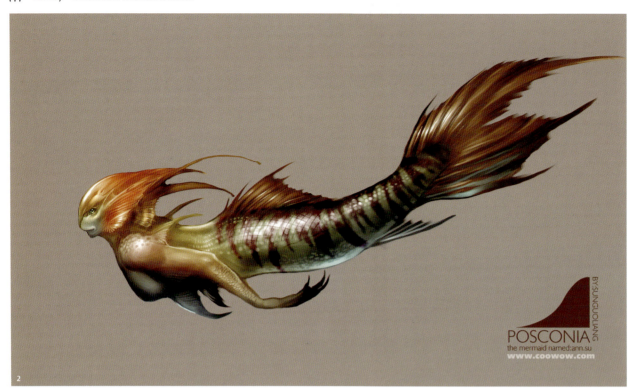

POSCONIA
the mermaid named:ann.su
www.coowow.com

BANHATIN
THE WORLD AMAZING CREATURES

❷ Mermaid

❸ Hoe Water Monster

❹ Angels and Demons

❺ Huge Alien

THE
INSECTCRAFT

6

THE
INSECTCRAFT

7

THE CREATURE REMIX DESIGN
Deep creatures

Creature one

Creature two

The mix creatures called deep leasoner

9

8

MEDIAC
The character design

10

❻ Bugs1

❼ Bugs2

❽ Design of Fitness for Creatures

❾ Design of Barbarian Autan Giants

❿ Biochemical Machinery

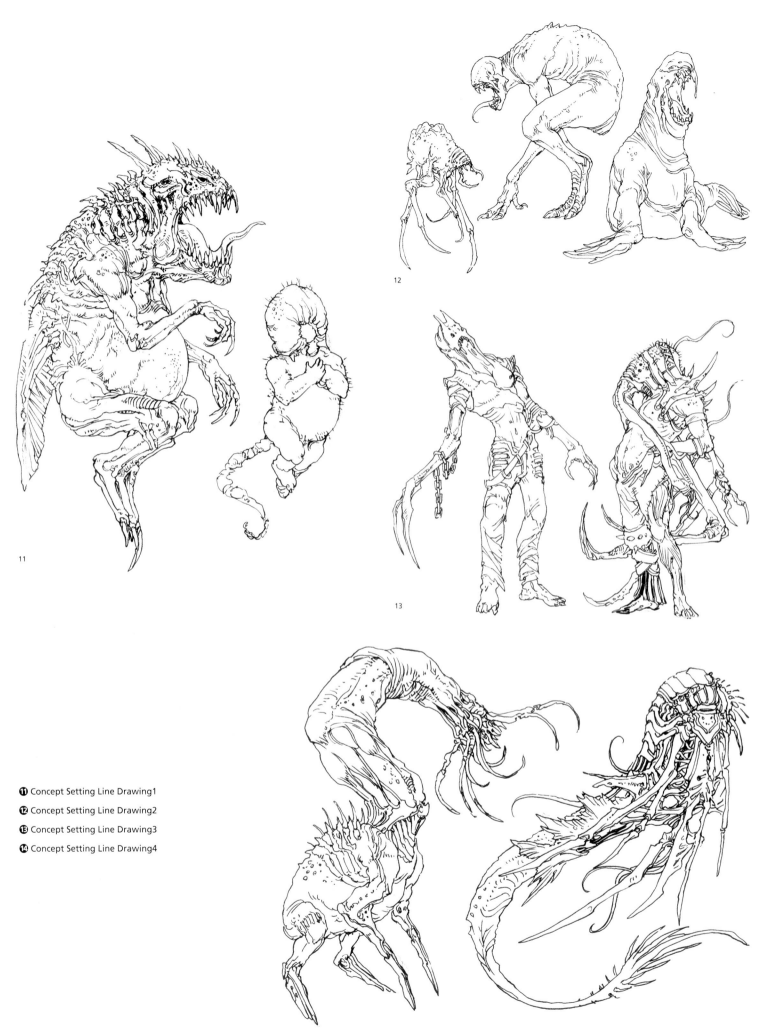

11 Concept Setting Line Drawing1
12 Concept Setting Line Drawing2
13 Concept Setting Line Drawing3
14 Concept Setting Line Drawing4

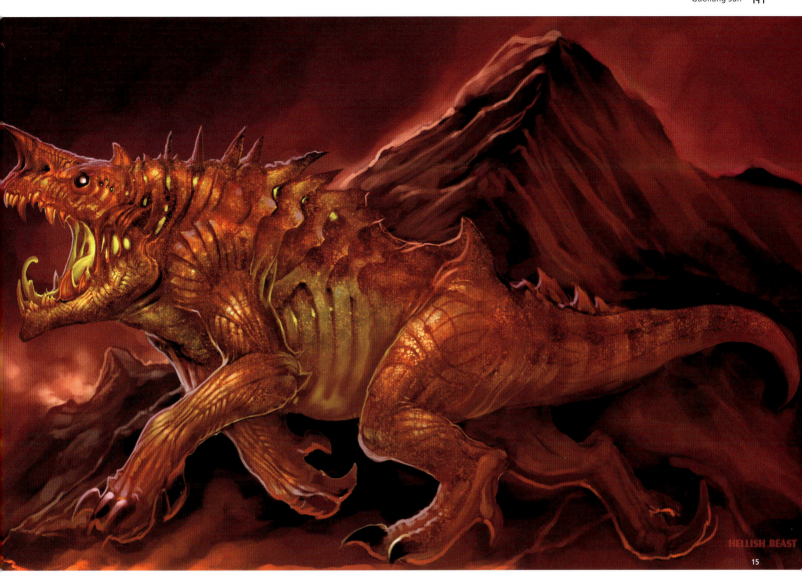

HELLISH BEAST

15

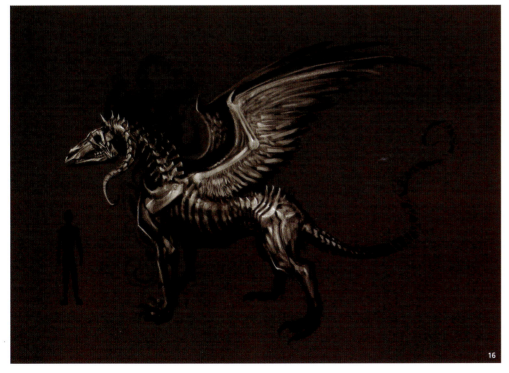

16

-- Which category of creations do you appreciate? And which category of products are you looking to create?

-- In fact, I appreciate all the creations by those artists who are better and more progressive painters than I am. Personally, I like the strong subject matters of science fiction and magical realism, particularly the dark style such as the Brom's. I hope I might follow Euro-American style, setting concept design and illustration as my goals. I also hope to draw more illustrations that feature Chinese style. In any event, there's no harm trying different styles.

⑮ Growl from the Hell

⑯ Night Kylin

Denny Hey!

17 Sea parrot

18 Fox

19 Cheetah

20 RingTail Lemur

21 Chameleon Jackson

-- What fantasy did you have in the past? And how far away do you think you are from that fantasy now?
-- I would replace "fantasy" with "dream", and "dream" with "goal." My goal, then, is to create opportunities to work with some major international companies as a concept artist. Right now, to realize that glorious goal, I'm saving up for "travelling."

22 Cat
23 Marmot
24 Secretary Bird

Name: Man Qin (Carbon)
Profession: Concept Artist

Passion Rekindled
A Special Interview with Man Tan, Game Concept Artist

When its "veil of commodity production" is lifted, the game industry is a good example that shapes and defines one's values. It is for this reason that many people who love thinking and painting have thrown themselves, without the slightest hesitation, into the waves of the game world. Even though their projects were once frozen, their products failed, and their teams eventually broke up, their passion

for creation would be rekindled anytime soon.

During the past year, Man Tan experienced a project failure, switched to the film industry for a short while, and finally returned to the game world. I learned from our conversation that he sees the game industry as one that satisfies his very basic to showcase needs and allows him ample opportunities showcase his talents. Carbon

(Tan's nickname) exists in many forms, and burns at a temperature between 300 and 700 degrees Celsius. When he got frustrated, it was the game industry alone that provided enough heat to rekindle his passion, to make him extraordinary, to inspire him to press on, to allow him to present his brilliant concept designs to the public, and to polish him into an ever-shining diamond.

Interview

-- *While you're creating artwork, do you think that attitude is everything?*
-- Attitude is an important prerequisite for success. In fact, we often refer to our creations as our "children." I don't doubt the importance of good working conditions, but when we depend too much on objective conditions, we often neglect ourselves and turn into their victims. In addition, it is also very important to know where you stand as an artist, and par-

ticularly so if you work in a team.

-- *Concepts grow out of one's heart and life experiences. Is it less important to satisfy your desire to express yourself? And how do you get yourself into, in your own words, the "concept design state of mind"?*
-- The desire to express is VERY important. In case a concept artist lacks the desire to express himself, it's fair to say that he is as good

as "dead." What I've said does not go against the idea that concept designs grow out of life experiences. And, in my view, two prerequisites have to be met to get into that particular state of mind. The first is motivation, keeping your minds set on the designs, concepts, film scripts, design proposals, or even your own ideas; the second is life experiences, and that's why I called concept design "posture practice" in one of my earlier posts.

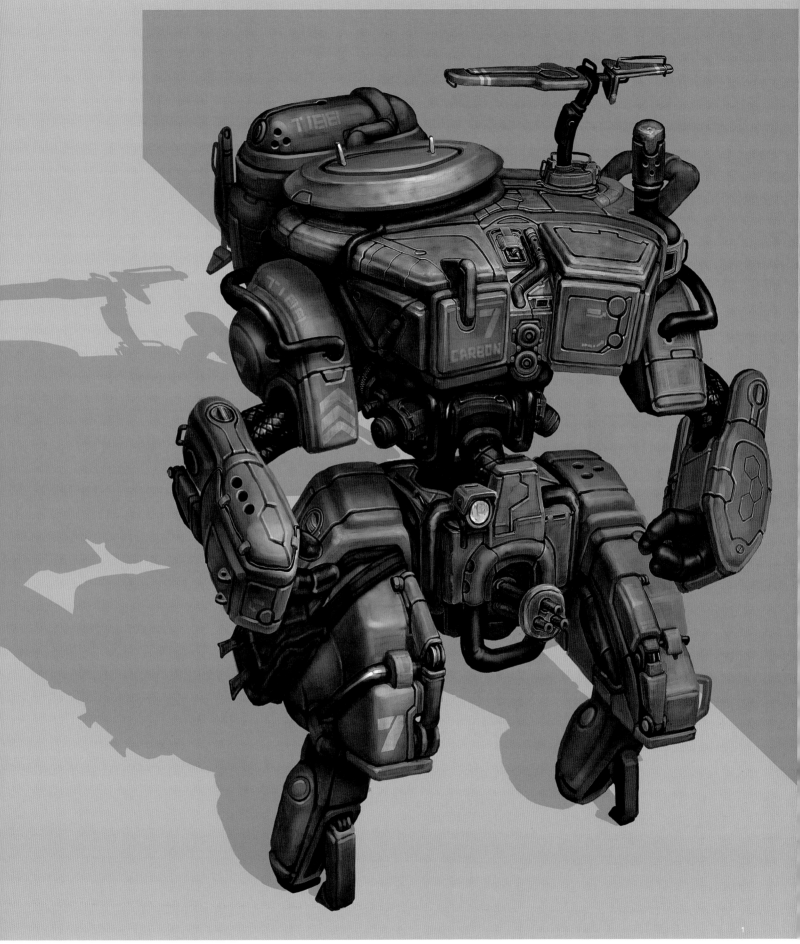

1

❶ Hellcat

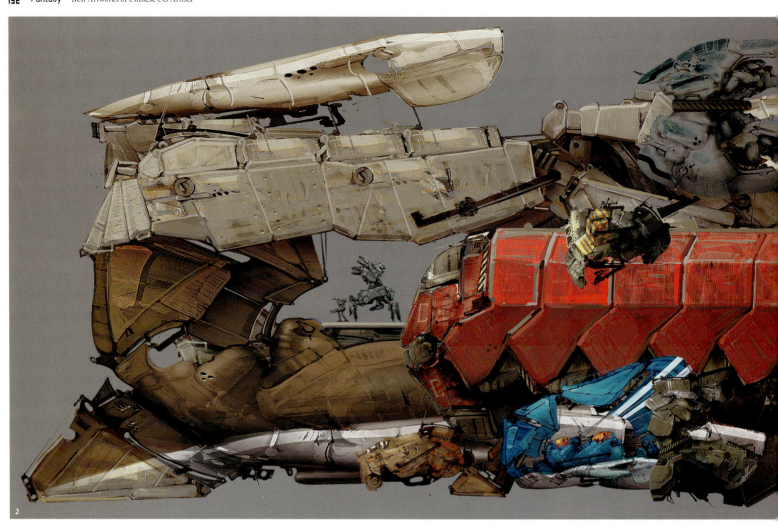

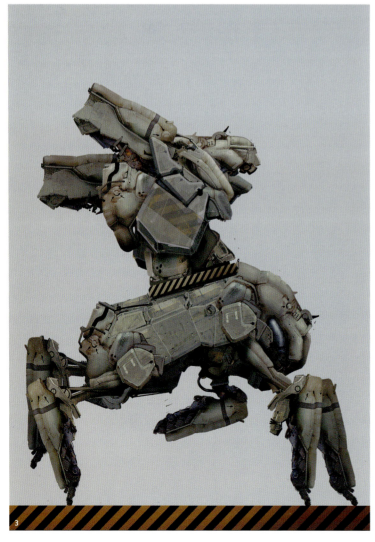

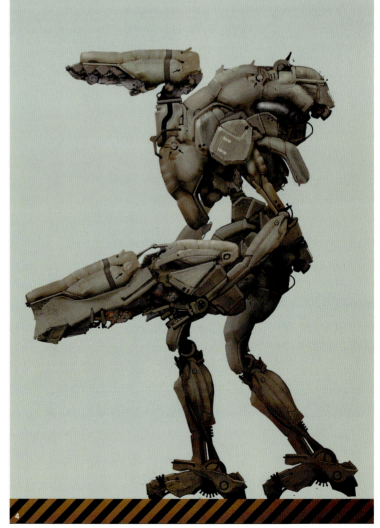

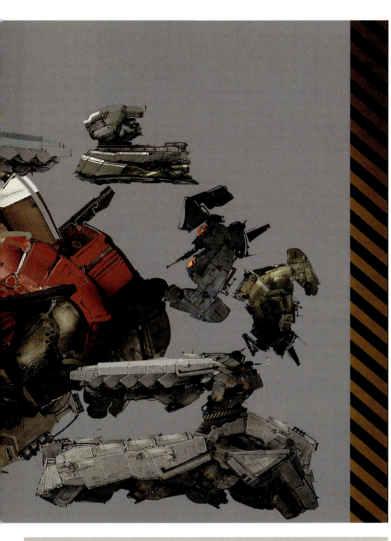

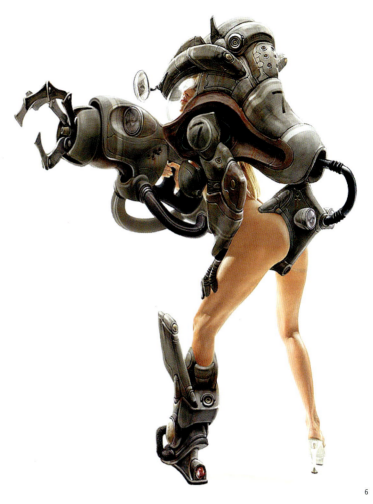

6

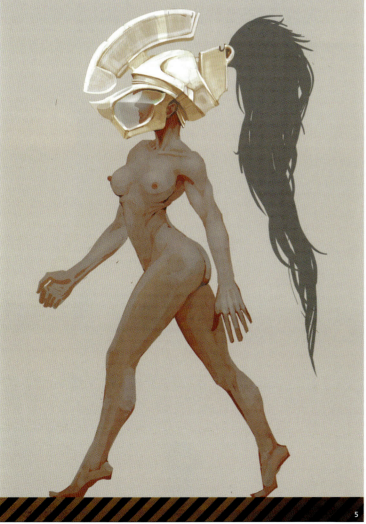

5

❷ Machine 1 (exercise)

❸ Machine 2 (exercise)

❹ Machine 3 (exercise)

❺ Helmet

❻ Sample

-- *According to what you said, concept designs grow out of life. That said, where do you think the meaning of concept design lies?*
-- The meaning lies in not losing our childlike heart, which inspires our imagination that is fading over time and work. What's behind concept design is nothing but "fun." Taking on forms of different periods, the designs are transformed into funny images that fuel our imagination.

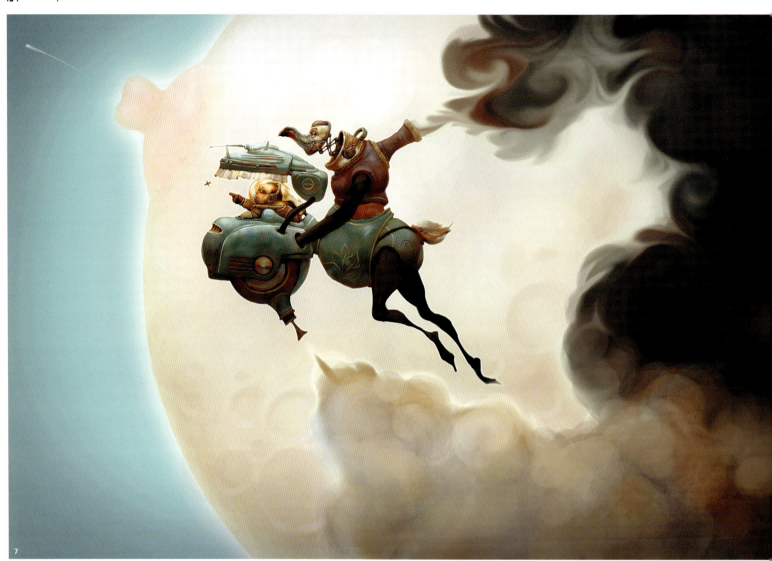

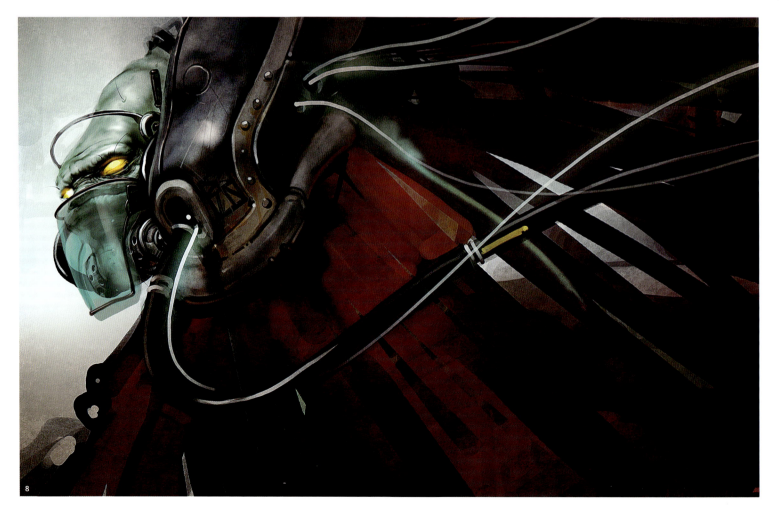

❼ E.T.
❽ Priest
❾ Rencountre

-- Then, how to get started on thinking about designing a new concept?
-- Ordinarily, when I take a rest after tiring work, I prefer to scribble something or escape into fantasies, just to relax myself for a while. I've scribbled a lot of notes about what I heard, saw, and felt. In most cases, I would give some thought on how to incorporate those impressive ideas into my artwork.

-- What fantasy did you have in the past? And how far away do you think you are from that fantasy now?
-- To build a wooden house on a huge tree, haha. But at the moment it seems that my wish is well and truly a fantasy.

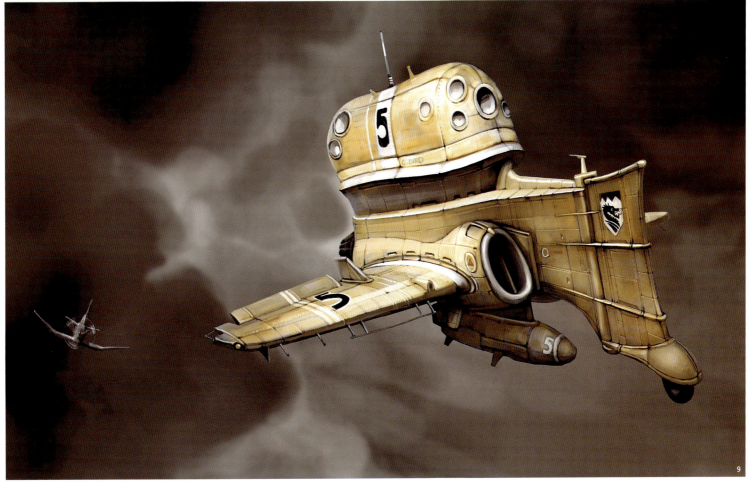

9

⑩ Chracter 1 (exercise)

⑪ Chracter 2 (exercise)

⑫ Chracter 3 (exercise)

⑬ Chracter 4 (exercise)

⑭ Beast

⑮ Garrison

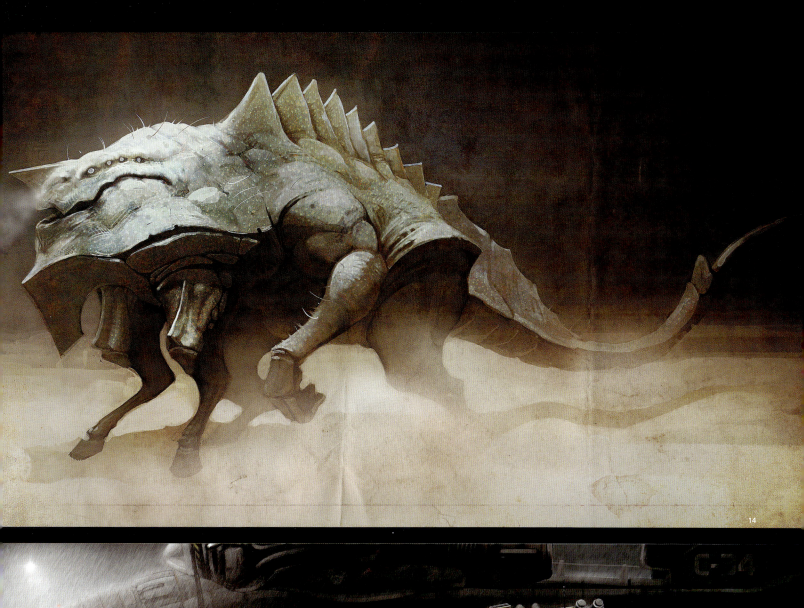

14

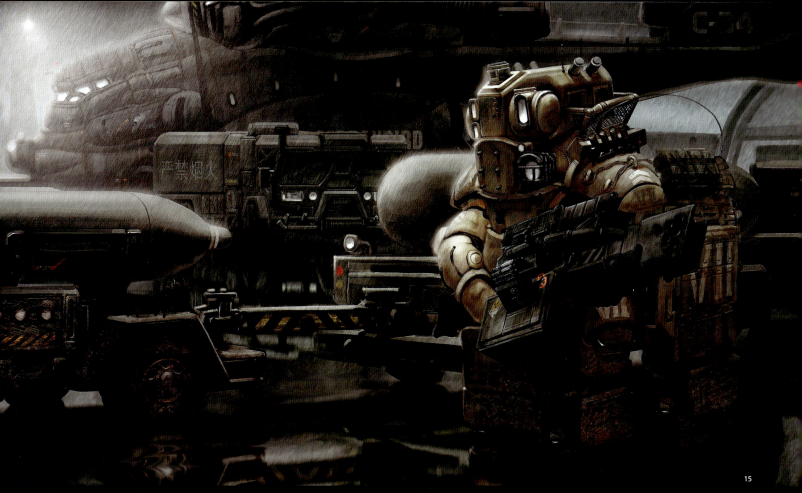

15

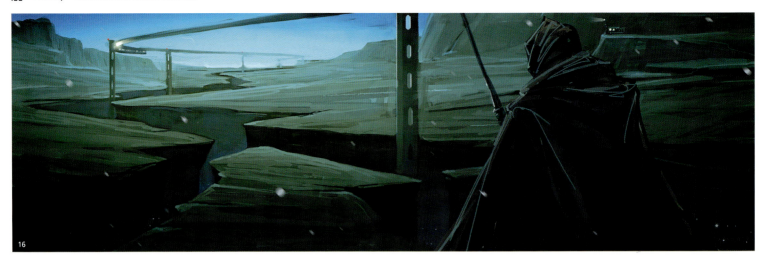

16

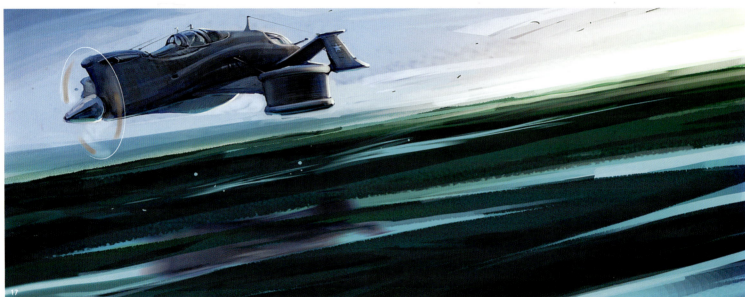

17

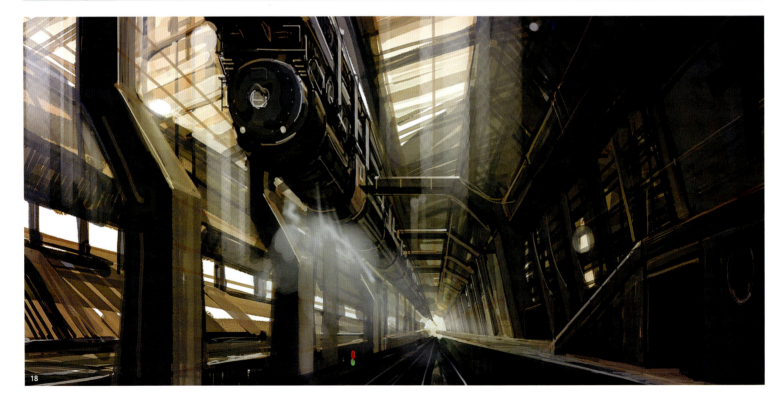

18

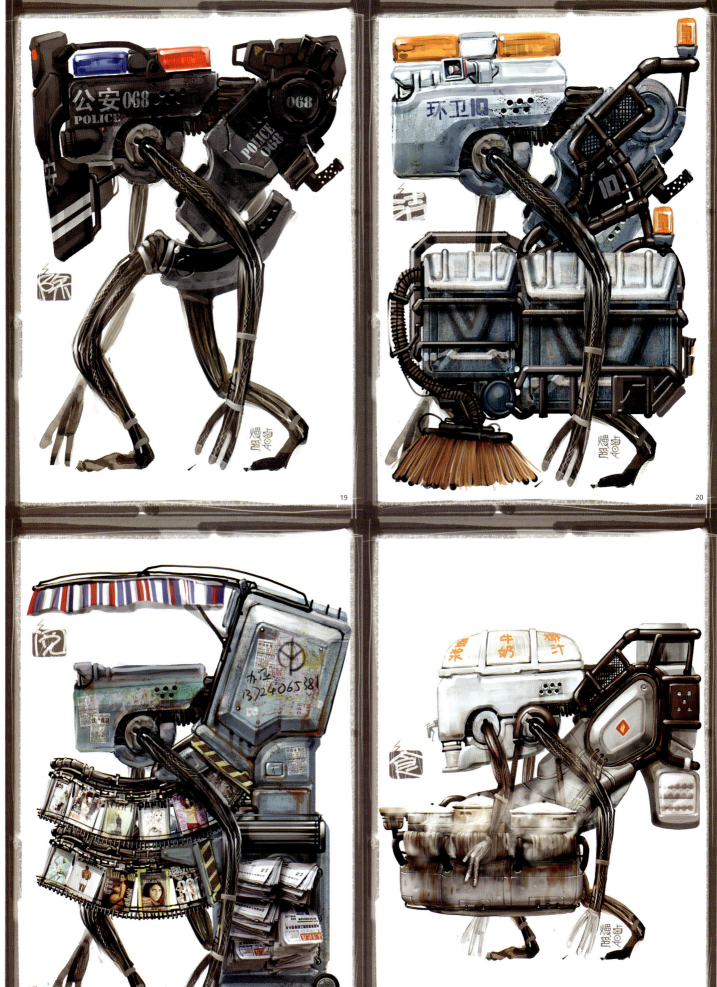

Name: Linning Wang (Apipe)
Profession: Concept Artist
Blog: http://apipe.blogbus.com/

Linning Wang (Apipe)

Creative Aerobics
A Special Interview with Linning Wang, Game Artist

New ideas generated by we Chinese have been few and far between, leaving the impression that we are so intrinsically poor at producing ideas that specialized concept companies must be established to make up for it. Since getting back from Canada one year ago, Linning Wang has felt the remarkable growth of Chinese game industry, now on a par with the international competitors in terms of market development. However, the game companies in China, to use his words, "lack creative aerobic exercise." He argues that Chinese game artists tend to shut themselves indoors, reluctant to walk out of their companies, not to mention "from cells and galaxies."

Over the past year, Mr. Wang has been carrying his sketchbook with him as usual, jotting down his random thoughts. Inevitably, the best ideas are born from passion, dedication, and past experiences, but we also need to be daring to make them come true. We need to exercise for better health as much as we need to generate creative ideas for better products. Probably, the resulting changes would not be so drastic as to constitute a revolution, but it is high time for us to take action.

Interview

-- In your view, where does a good game concept come from? And what is it that discourages the creation of new ideas?
-- First of all, the target of a game company CEO makes a big difference. Is he trying to seek maximum short-term returns, or to make the most fun games? If the CEO is thoughtful, he would accept good game concepts, and invest to fund them. Generally speaking, fine concepts come from those game design professionals who are knowledgeable, dedicated, enthusiastic, familiar with most of the games on market, able to predict the future of the industry, competent in writing, and with strong team spirit. The requirements are so demanding that I believe we have only a few such designer candidates. Simply put, if a designer has played no other games than MMORPG (massively multiplayer online role-playing games), he can by no means produce innovative designs. Regrettably, however, such professionals are more than necessary, and that's part of the problem, discouraging the creation of new ideas.

-- It seems that the character images in some of your designs and sketches are not good looking enough. Why is that? And how do you make character designs?
-- Indeed, not all people in the real world are good-looking, and "ugly" is in the eye of the beholder. Personally, I dislike the Japanese and Korean aesthetic styles. That's why I choose to paint realistically, and why you see more uglies than beauties in my illustrations. What's really important are the physical features of your characters such as costumes, weapons, and knife scars, or the psychological traits like persistence, weirdness, cowardice, and generosity. As far as character design is concerned, I strive to highlight the key character traits by infusing similar elements into a series of designs. In another series, however, I intentionally make them different from the previous images in order to enhance their uniqueness. And that, I think, explains why I prefer to design ugly characters.

❶ Egyptian 1 (sketch)

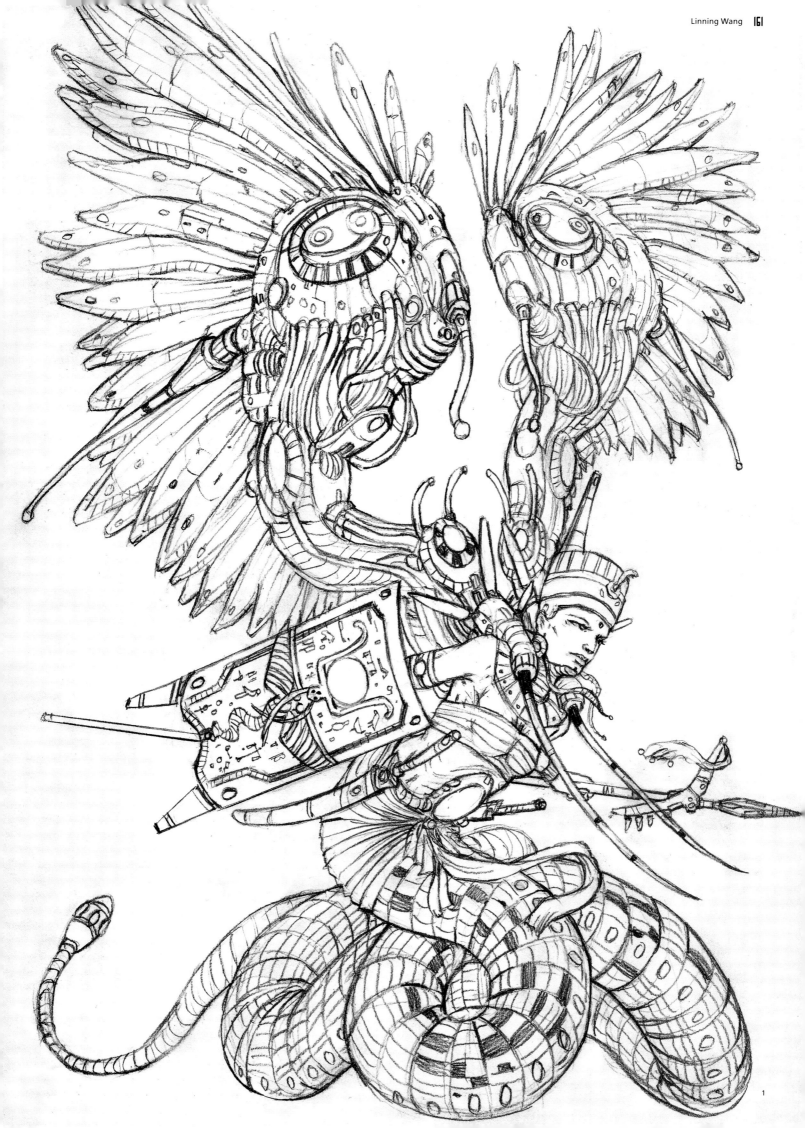

1

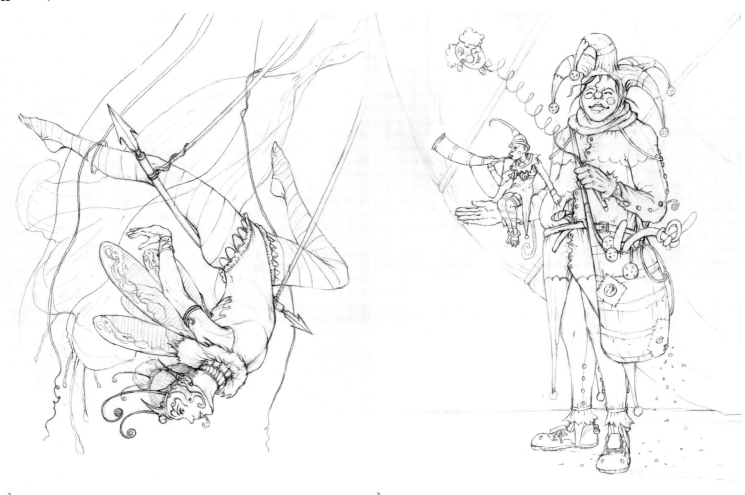

2

3

❷ FlyingTrapeze

❸ Clown

❹ Egyptian 2 (sketch)

❺ Egyptian 3 (sketch)

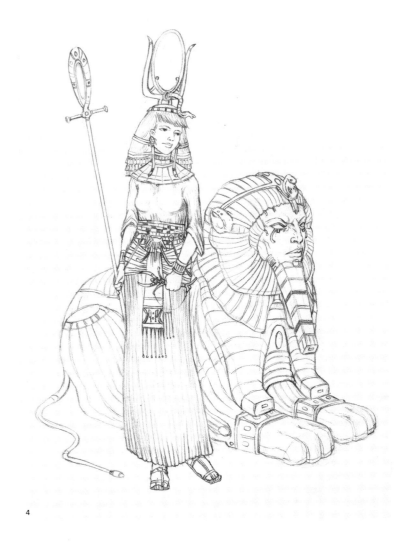

-- The Euro-American style is fairly realistic. Is your current style in any way related to your life and work in Canada?
-- Canada allows me more access to Euro-American cultural traditions than China. Knowing that an ounce of preparation is better than a pound of fixing it later, I would go to the libraries and stay there reading while sketching for three or four hours. If I stumbled on some books that I particular liked, I would take them home for a good read.

4

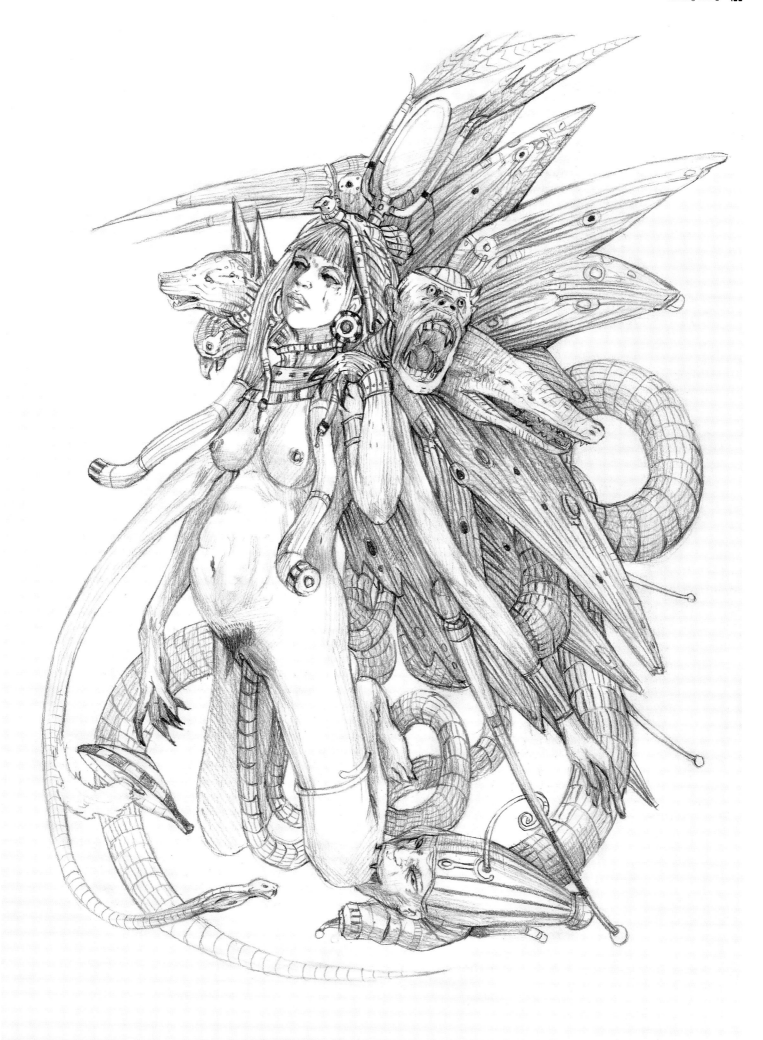

6

7

8

9

10

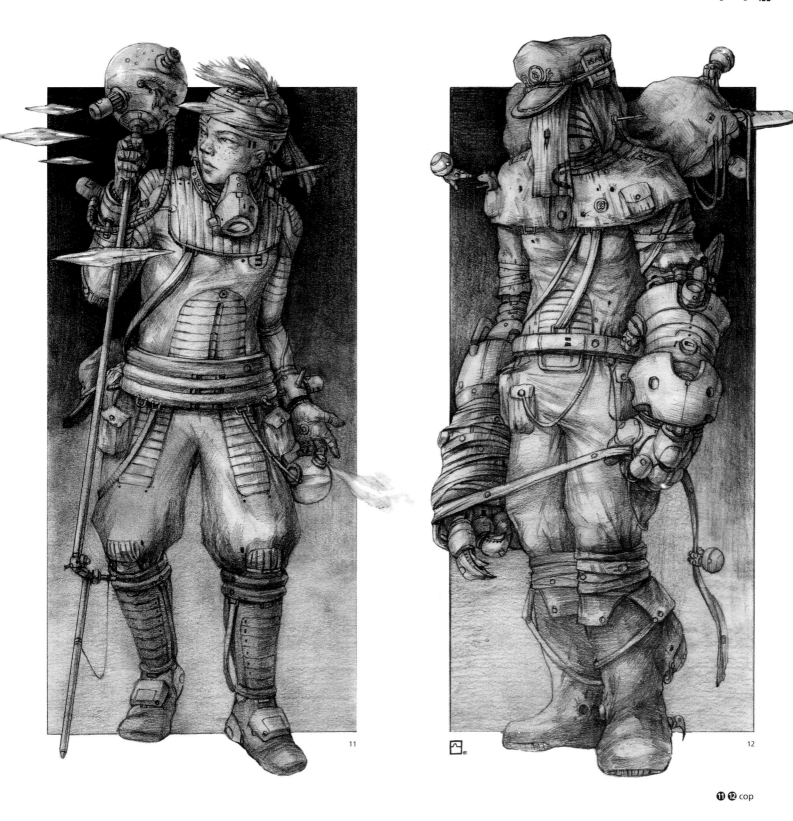

11

12

-- Now that you produce more line drawings than color drawings, is it to save time to produce more pieces?
-- In my opinion, even if the sketch looks a bit rough, it doesn't matter much as long as the final draft is clear and the general impression is positive. Regrettably, most of the pieces are expected to look neat and tidy, so I have to do the line drawing in the thumb-nail sketch, but I do it no more than once since the more I draw, the fainter the "feel." Also, I normally leave the coloring to the texture artists. In fact, many of my creations are colored, but I do find line drawing more enjoyable.

-- What fantasy did you have in the past? And how far away do you think you are from that fantasy now?
-- I fantasized that in our generation human beings would become extinct so that I might see what the world would be like. And it seems that I am getting closer to that fantasy.

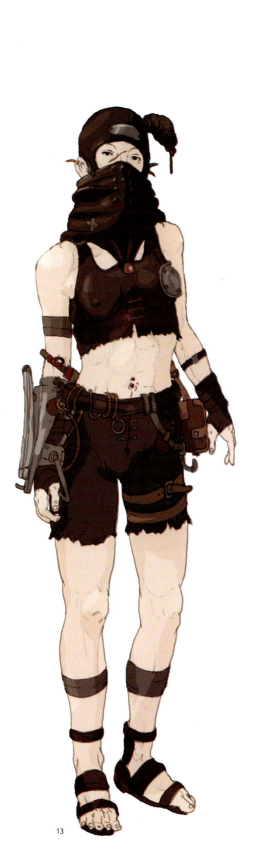

13

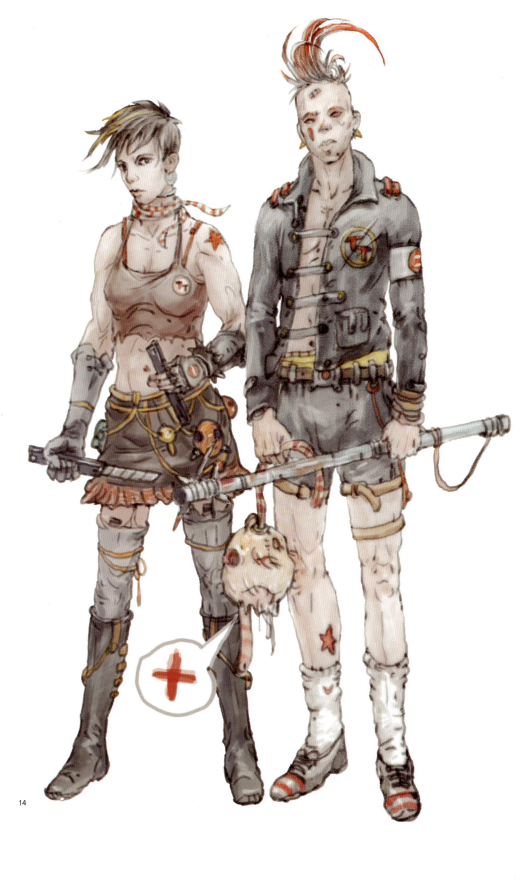

14

⓭ Ninja ⓰ Jetstrip

⓮ Soldier ⓱ MBrainGirl

⓯ Baby,Don't Cry ⓲ Oldgun

15

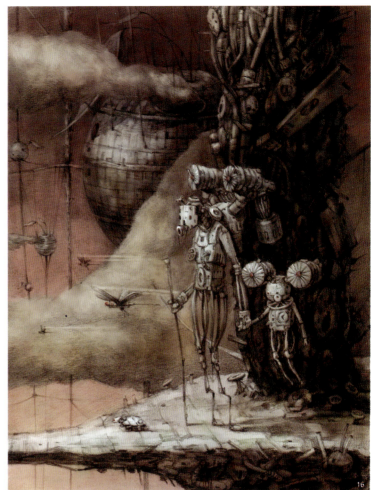

16

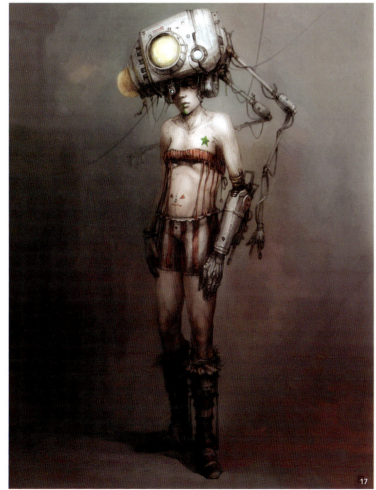

17

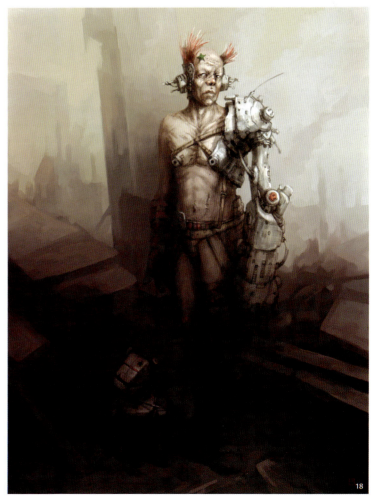

18

Name: Feng Wang (Haosha)
Profession: Concept Artist at Guangzhou NetEase
Blog: http://blog.sina.com.cn/haoshacg

Outgrowing the Fairy Tales
A Special Interview with Feng Wang, Game Concept Artist

Feng Wang, also known as Haosha (his online name, literally "Vast Sand"), has walked out of his fairy tales, where the nostalgic mechanical designs blend with their declining grandeur. Having produced scores of "hats" and "masks," Wang decided to close the fairy-tale book and leave it at that for the time being.

The publication of his two art books, The Hat Kingdom of Haosha and The Mask World of Haosha, has made a huge difference to his future. As the culmination of his years of hard work and his fairy-tale complex, these exquisite designs made him realize that he still has a long way to go. As a result, the past year has seen him planning for more "sophisticated" creations, rather than holding on to his own style. In addition, he has been responsible for the training of new staff members, expecting them to be productive more quickly. What he's been doing boils down to this: he is outgrowing the fairy tales.

In our heart of hearts, everyone has a fairy tale, and our colorful dreams and the desire for those dreams in our memory never fade with time, even if we are growing up, even if we have finished reading the tale.

Interview

-- In the past you seldom did realistic illustrations, but now you have many. When and why did you switch to this style?
-- When I was doing concept designs for The Hat and The Mask, I found I was rather weak in the realistic style area, including human body in motion, muscle description, tension between real and unreal. This is my new target for the new year, which will help me greatly in my personal development.

-- Can you tell us something about your plans for the future?
-- Plenty of plans, such as Fishcg and Designs for Cube Toys. I was working on them with passion, but some of my thoughts were extremely personal, and some others not well developed enough to be worthwhile. Plus my work schedule is so tight right now that I've set them aside for further consideration. Currently, I'm looking to do some special research on mechanical concept design that I'm interested in. In any event, I have to prepare enough manuscripts before trying to get them published.

❶ Mask

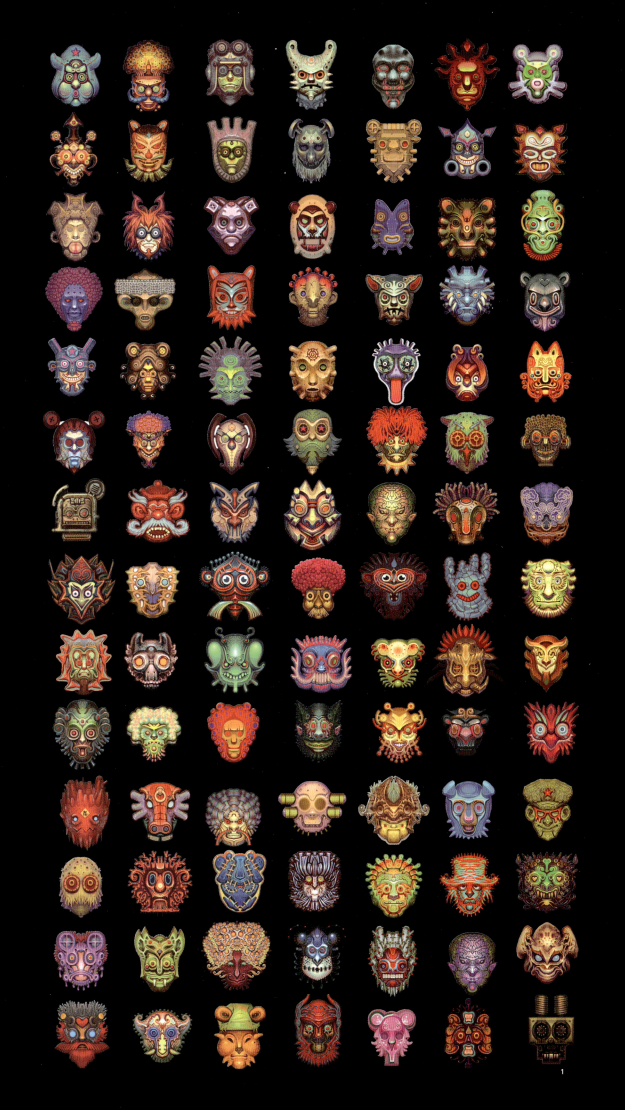

1

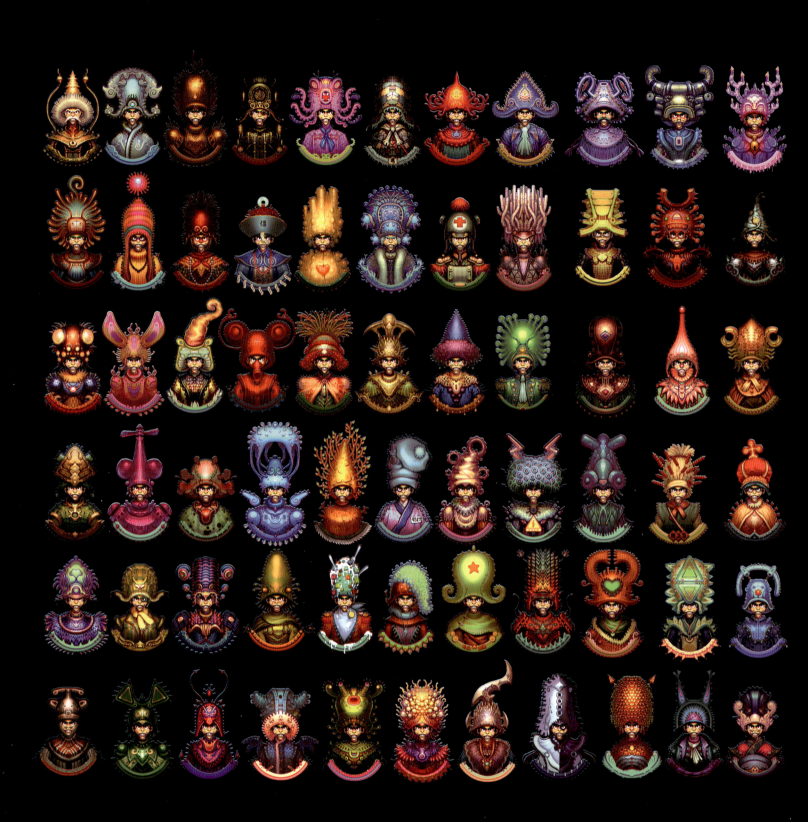

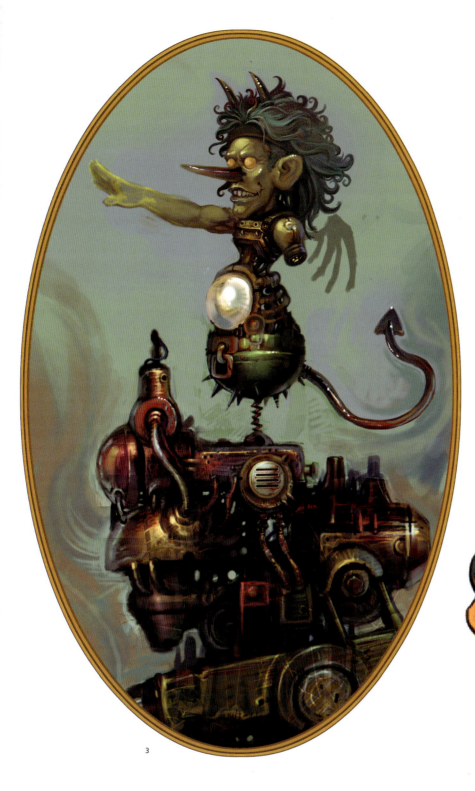

3

❷ Mask

❸ Guiding

❹ Self-portrait

4

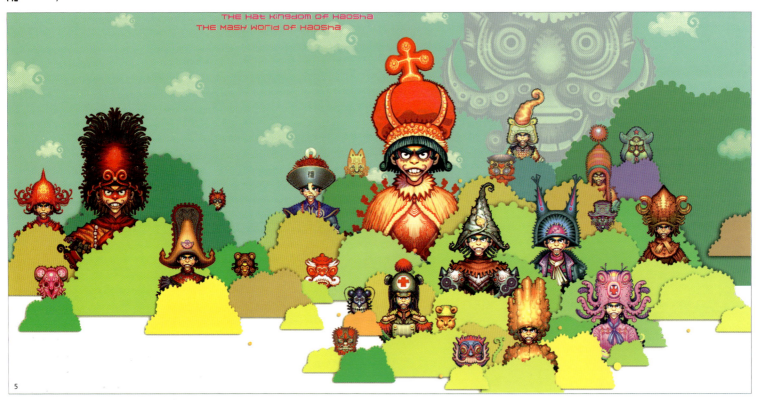

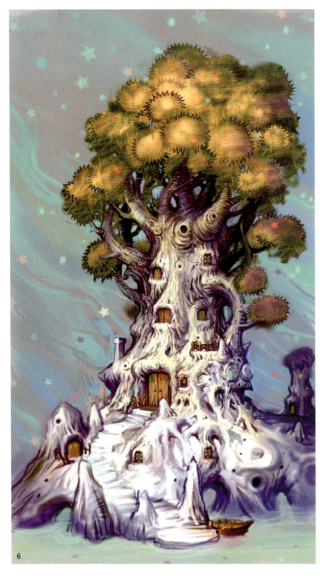

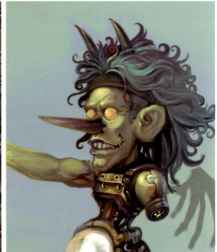

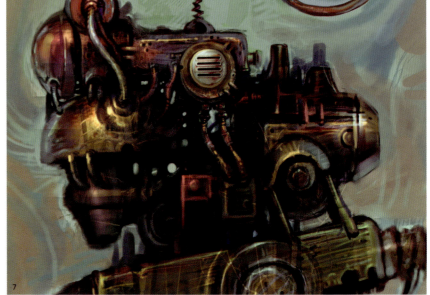

❺ Poster of Mask Caps

❻ The Fancy Cabin

❼ Direction (part)

-- What is impressive about The Hat and The Mask is the unique use of color and texture. Can you say something about that?

-- The colors I use most often are medium yellow, blue green, and red. Very pure colors are used only to decorate small spaces so that the overall effect is natural and—to use a trendy word—harmonious. I also like the yellow-green tones since I customarily color my pictures that way. As far as the texture is concerned, I hope my illustrations enable the viewers to appreciate the surface quality the moment they set their eyes on them. Personally, I prefer rough and rusty metal textures to smooth metal ones.

❽ Skate Boards

❾ The Gloomy Little Dragon

8

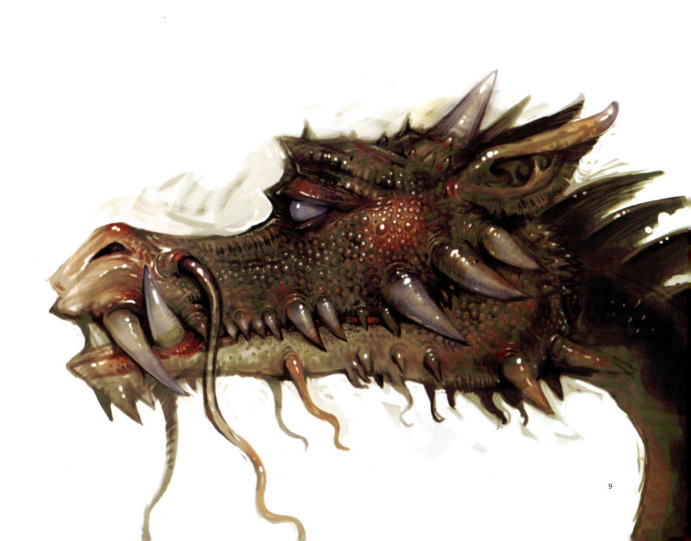

9

10

-- What fantasy did you have in the past? And how far away do you think you are from that fantasy now?

-- I dreamed to make a lot of wooden people or robots by myself, and let them stay with me in my study. Then, I would decorate my study to create a fanciful atmosphere of fairy tales and science fiction. Back home after work, I would retreat into another world, where the tinplate toys and keepsakes could help me escape the troubles of the real world. But right now, I still haven't found the right materials to build what I want.

11

12

13

🔟 Weapons

⓫ A Collection of Conceptual Designs

⓬ Airship

⓭ Cap (line-drawing)

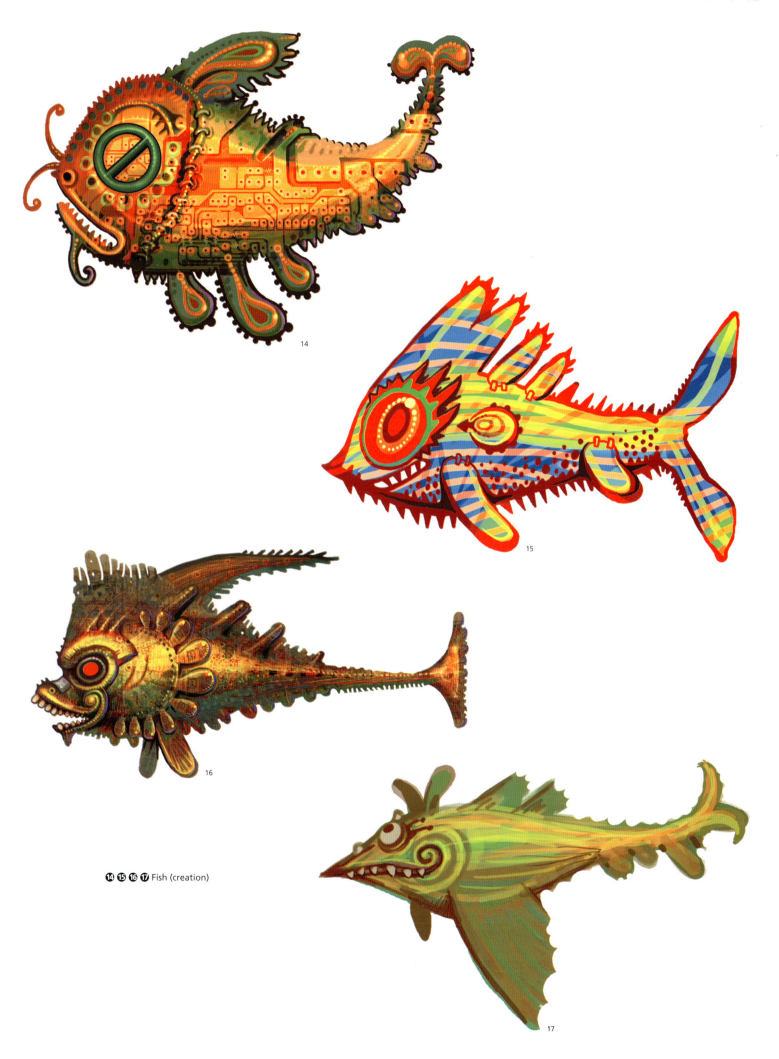

14

15

16

🔞 🔞 🔞 🔞 Fish (creation)

17

Min Wang (Ahua)

Name: Min Wang (Ahua)
Profession: Director and Founder of Huatin Concept Design Studio
Blog: http://blog.sina.com.cn/ahuaart

Life as Beautiful as a Flower
A Special Interview with Min Wang, Freelance Illustrator

Min Wang has a simple life philosophy, and hopes for a beautiful life like every other person. But unlike the others, he hates to live a quiet life. His work experiences with animation, game, design, books, comics, and videos have given him a colorful resume, and enabled his newly-established Huatin Studio to offer art-related services to clients home and broad.

Wang's sense of adventure and responsibility fills his studio with sunshine and oxygen. He knows that a life with just one possibility is no more than a dull garden, so he chose to start his own company rather than to hold onto a steady job. He also knows that a life lived for oneself is one lived in a desert, so he develops training programs to bring skills to more people, to promote the advancement of the profession, or more profoundly, to build a life as beautiful as a flower for all people around him.

Interview

-- What made you decide to leave the game company to start your own venture?
-- Well, it's a question of personal values. I love adventures and trying new things. To me, variety is the spice of life. I wouldn't live a life that allows me to see everything at a glance: 20 years from now, I will pay off my house loan; 50 years from now, I will have a normal pension and medical insurance. That's not the meaning of life as I see it, nor is it the life I want. I had been a professional for 7 years in that company, with a stable high income and a senior management position. If I were going to stay there until old age, I would have a comfortable life. But I have a lot of dreams and the courage to follow my dreams. That explains what I chose to live my own life and work in my own way. As luck would have it, my new career is growing steadily. Things are unpredictable at times, but it is the unpredictability of my life that creates miracles and wonders.

-- In recent years, of all the projects your studio worked on, which one do you think is the most interesting? And which is the most challenging?
-- Some initial ad concepts and animated titles stand out to me. These designs showcase our creativity and hence very interesting. But what's most important is that we are a happy and creative team. The most challenging one is an outsourced project we worked on for a foreign country. Despite the small size of our team and tight schedule of the project, we managed to realize the "impossible dream" by creating an ingenious work plan and doing up to five times the normal workload. The fact that our small team outdid those "big boys" earned us positive recognition from the foreign clients.

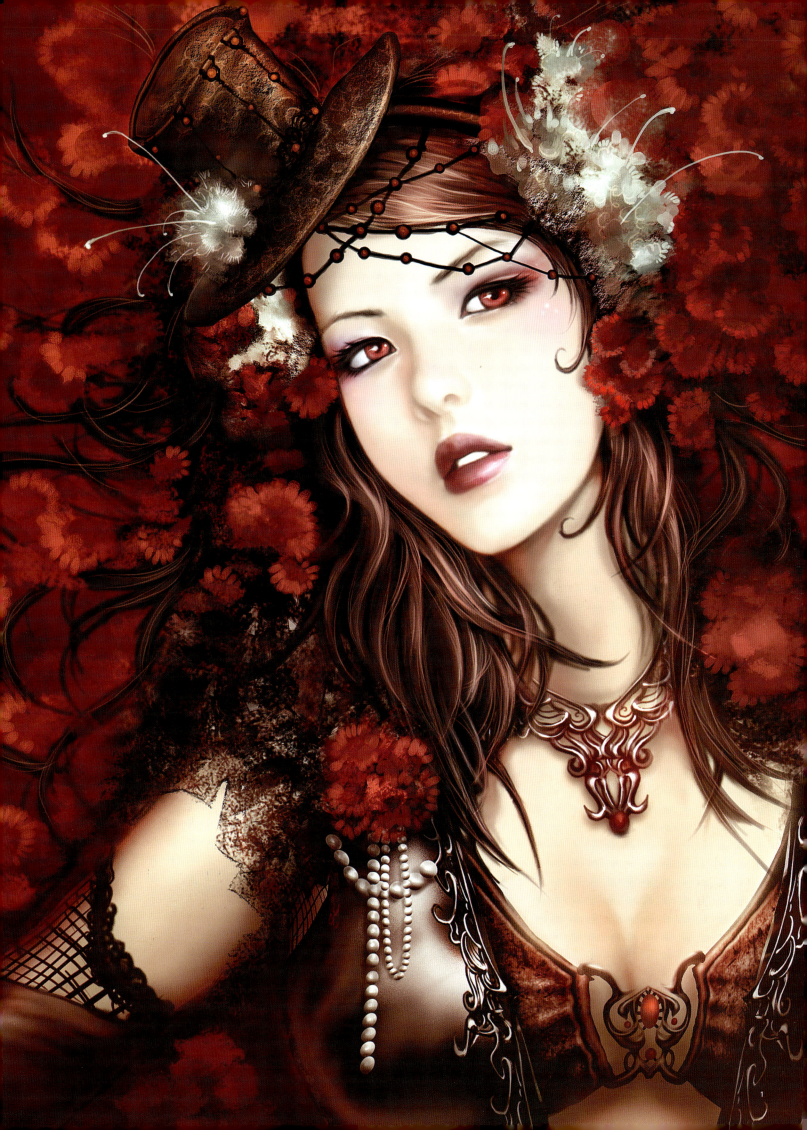

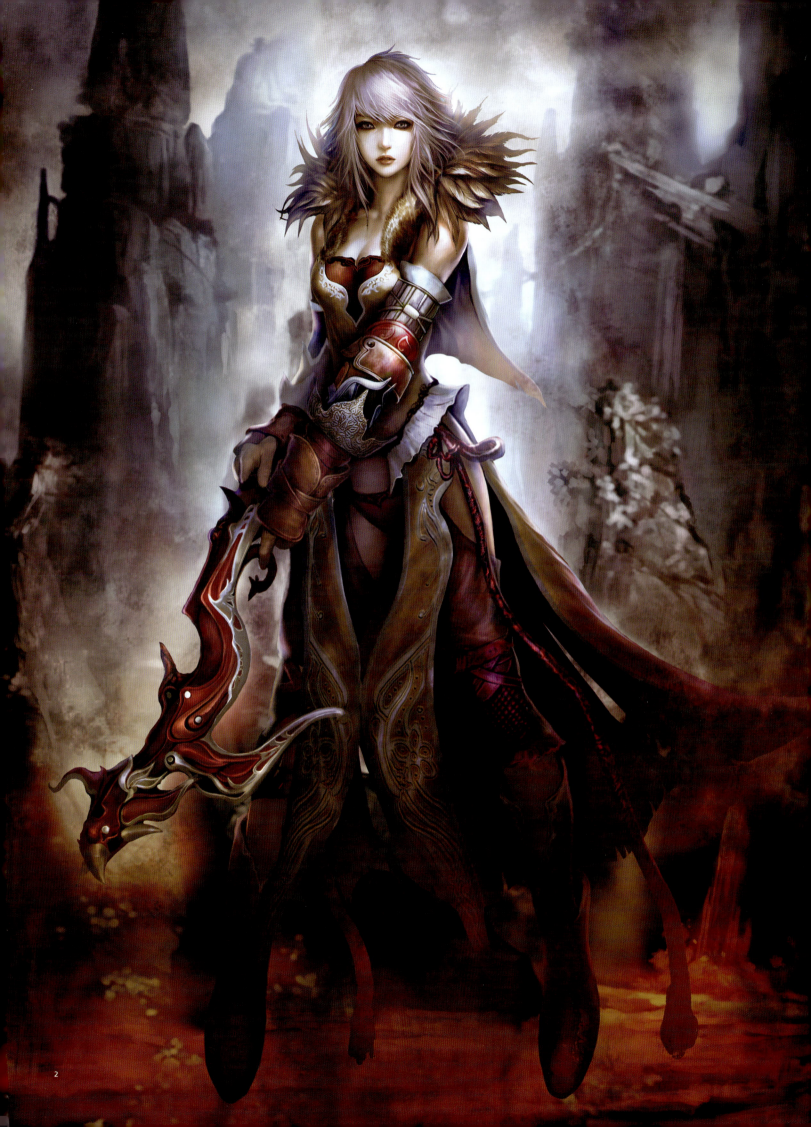

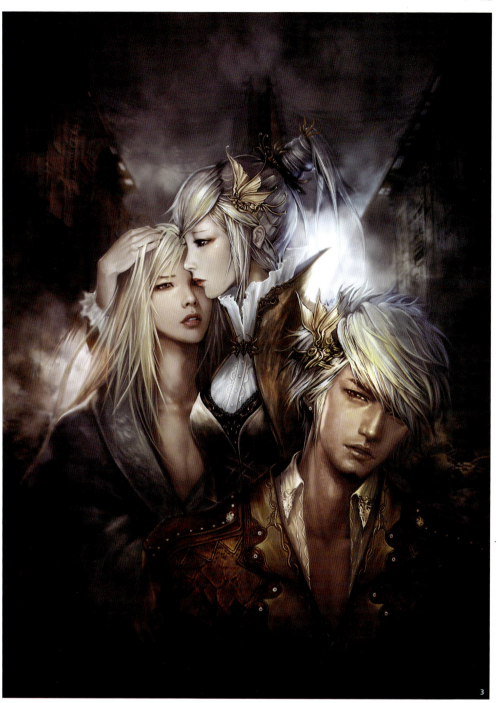

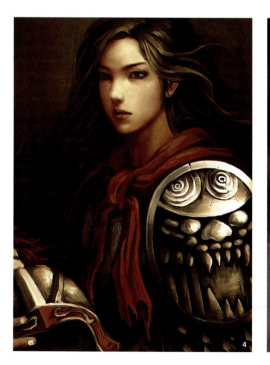

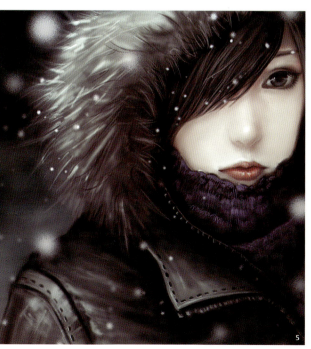

2 Girl Arrower

3 Duke of Mapusaurus Roseae

4 Hua Mulan

5 Winter

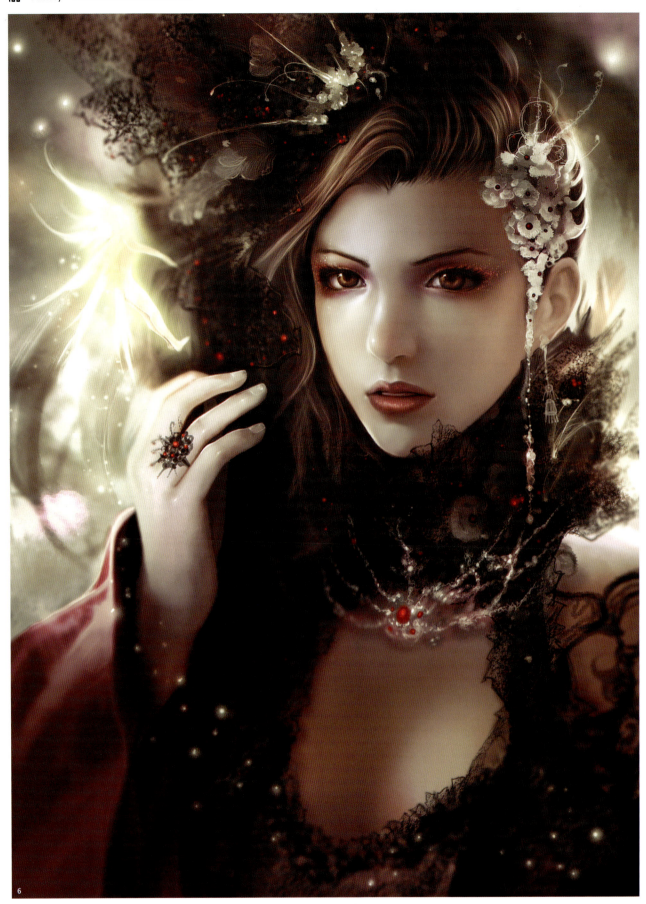

6

❻ Western Region

❼ Warrior

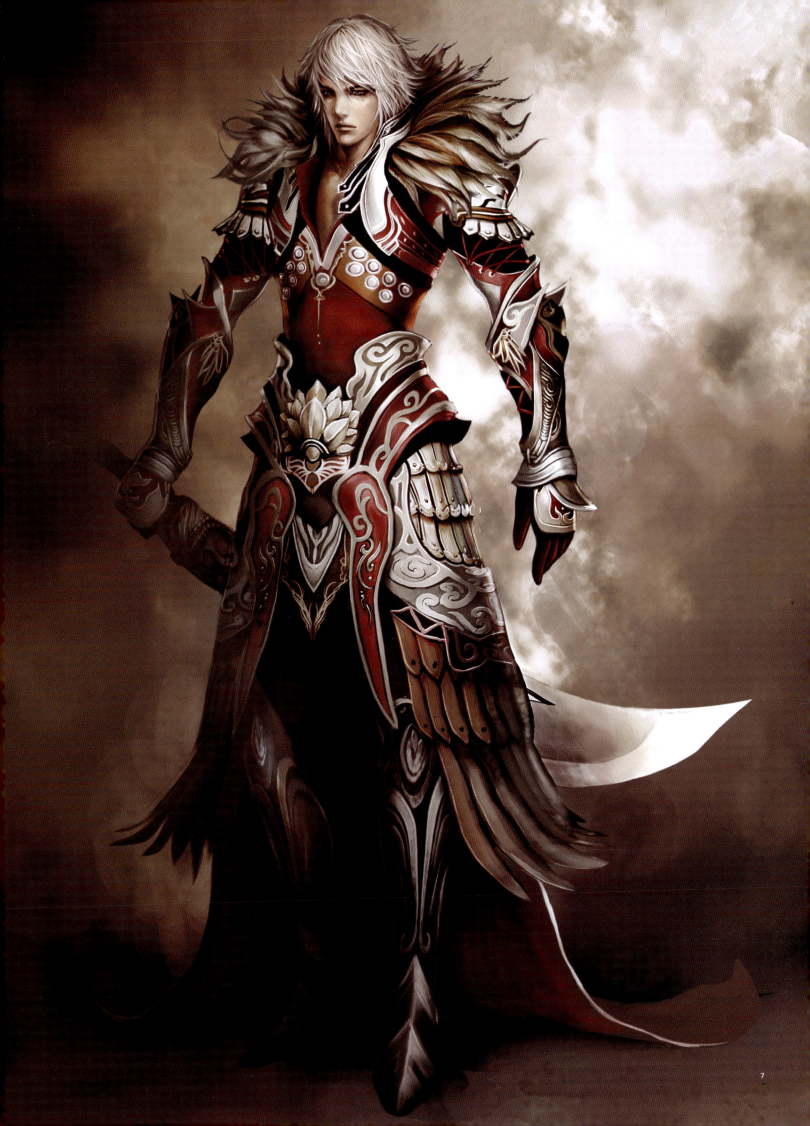

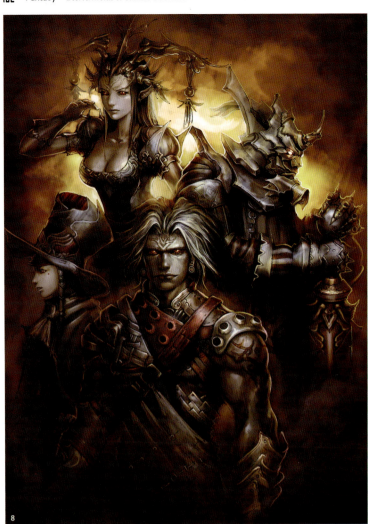

8

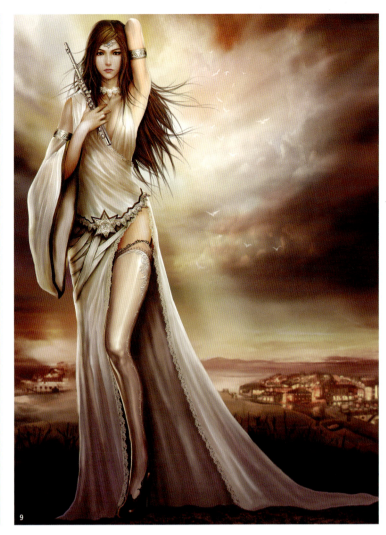

9

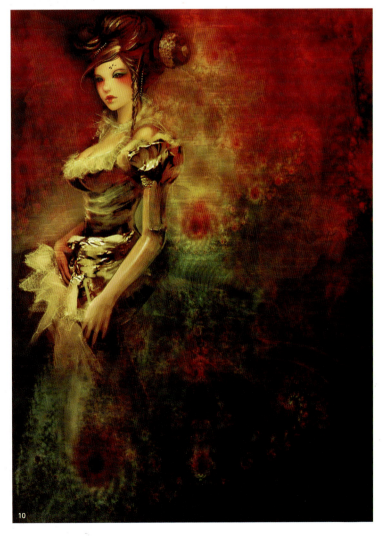

10

❽ Foreigners from land 8

❾ The Classic Poster

❿ Magnificence

⓫ Twins

-- In your view, what should a newly established team do to get into the market and to gain recognition? And how does one successfully break into the international market?
-- Well, ha ha, beats me. We ourselves haven't really broken into the international market yet, nor have we gained recognition from all our potential clients. We're just beginning to do that. But one thing I know for sure is that we must strive to complete each project going on right now successfully, to offer the most satisfying products, to outperform the predictions of our clients, and to give them more of what they want. Only by so doing can we build up a solid name and reputation. And better things will sure come our way.

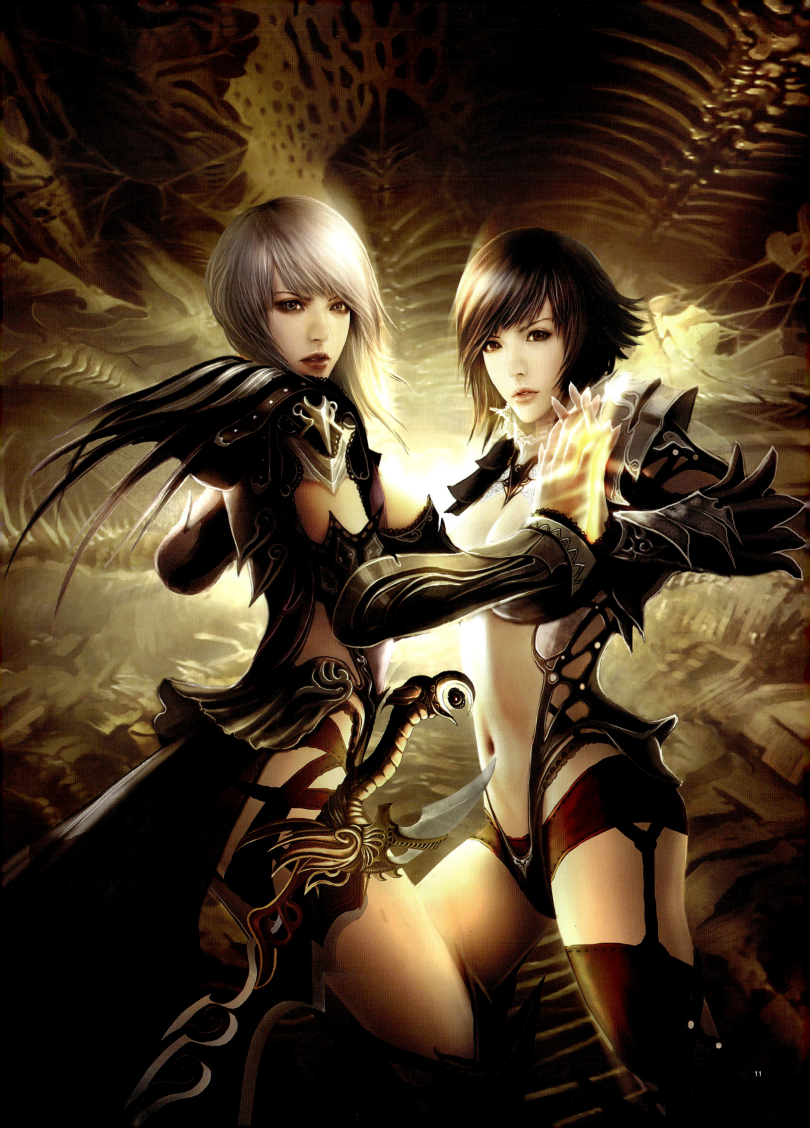

Xiangjun Zhou
(Foxliyue)

Name: Xiangjun Zhou (Foxliyue)
Profession: Project Artist at Kingsoft Season Game Studio

Warriordom in and Out of the Studio
A Special Interview with Xiangjun Zhou, Game Artist

Kingsoft Season Game Studio features an everlasting theme—warriordom. For ten years this Zhuhai-based studio has been producing swordsmen, knights on horse-back, gallant heroes and their romances, providing millions of cosplayers with opportunities to fulfill their dreams. As China's best and most productive costume game developer, Kingsoft Studio has created for Chinese gamers a dreamlike warriordom. It is fair to say that all members in this studio have the heart of a "true warrior."

Three years ago, Foxliyue (Zhou's online name) chatted with me about the warriordom of his studio, where he had spent six to seven years as a warrior. Currently, he is head of a project team. What preparations, you may ask, is he making right now?

What would he do to exceed his past accomplishments? And what, after so many years, does the warriordom in his heart look like?

The world is changing, but something here remains the same.

Interview

-- Three years ago, the focus of our interview was "warriordom" and today we will continue with that theme. Do you think historical games in China still have room for further growth? Will there be a bottleneck?
-- It's hard to tell right now. Despite the growing number of such games, more and more players still find them to their liking, as is also the case in the West, where millions of Medieval Magic and Dragon Games have flooded the market. Games, after all, are made for gamers, who pay for the experience. Some westerners have a "Knight Complex" and, not surprisingly, the Chinese players have a "Swordsman Complex." As a result, new versions are always popping up. In fact, there's still plenty of room for further growth, since the number of game players is too small in comparison with our huge population. For the bottleneck issue, I would say it's not a question of whether we continue to do the warriors, but how we can produce unique warriors. Personally I want to work on different themes, including our own science fiction games, because I don't think science fiction is the privilege of western people alone.

-- It seems that Kingsoft has its own flagship products. As a project artist, when you recruit a new member, what abilities do you think are especially important?
-- Our studio has specific written requirements for recruiting new employees. Apart from technical abilities, an artist applicant should love games and art, with creative passion and endurance.

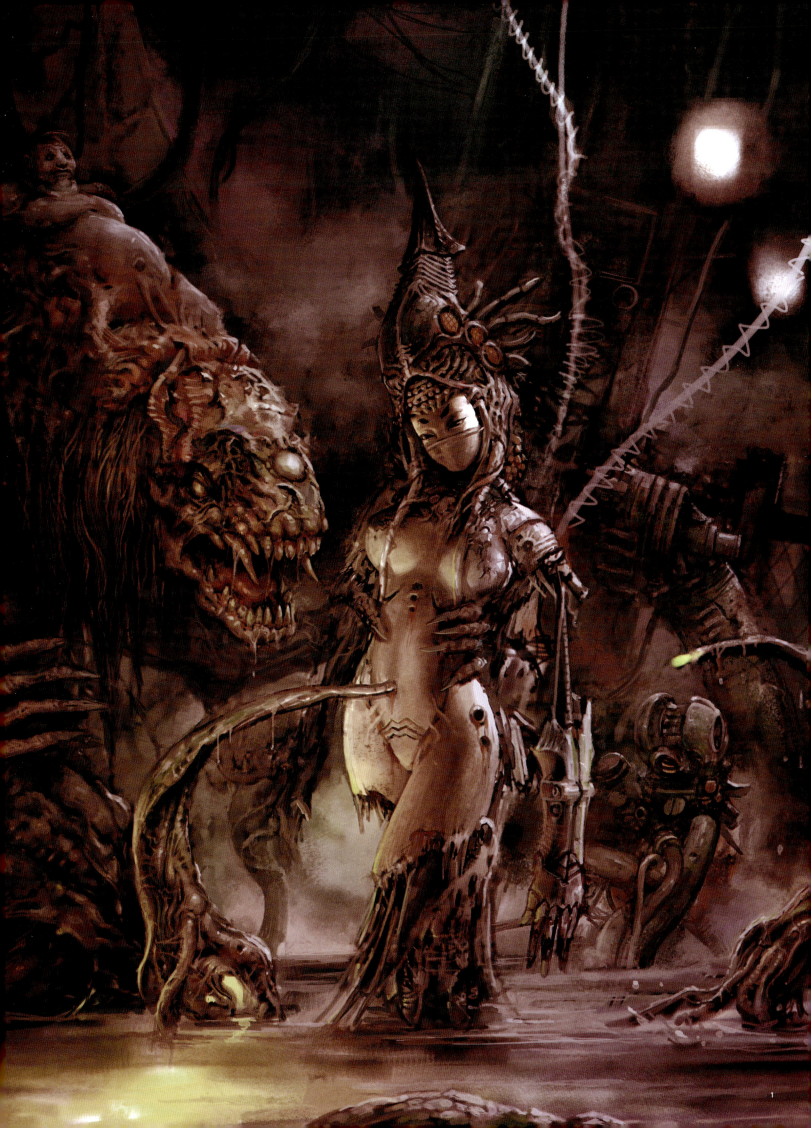

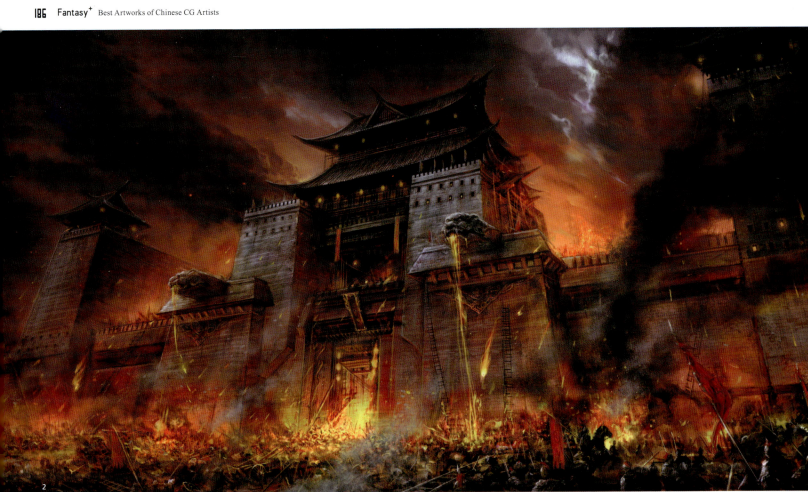

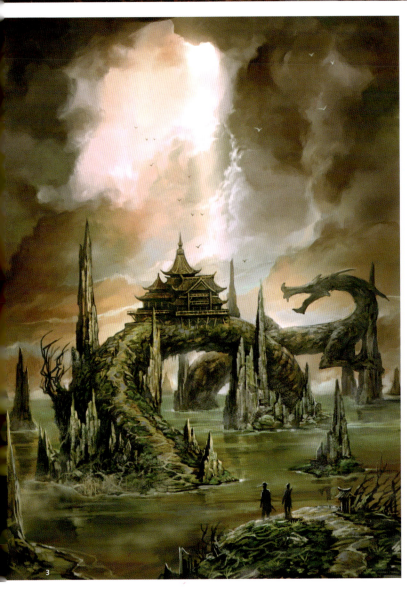

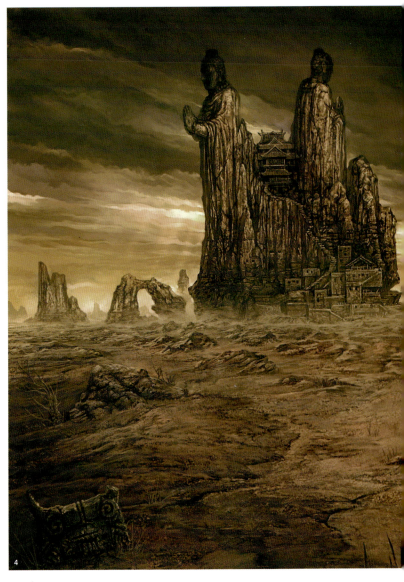

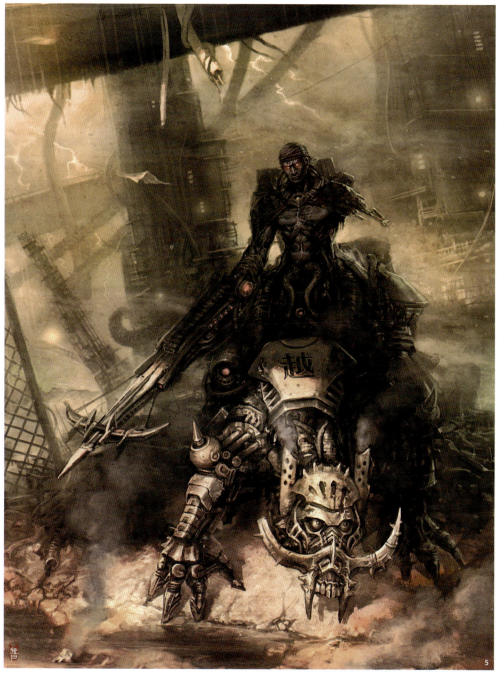

-- *Many of your works are your personal creations, not works commissioned by the company. Why is that?*
-- Not all works are used for the company's projects. Some involve trade secrets, and the themes do not change very often. I need to improve my skills by working on different themes and making time to draw what interests me. It's been so much fun since I was a kid.

❷ Login Interface 1 in The Legend of Swordman

❸ Wolong Bay

❹ Scenario of the Legend of Swordman

❺ Knight Future

❻ Login Interface 2 of The Legend of Swordman

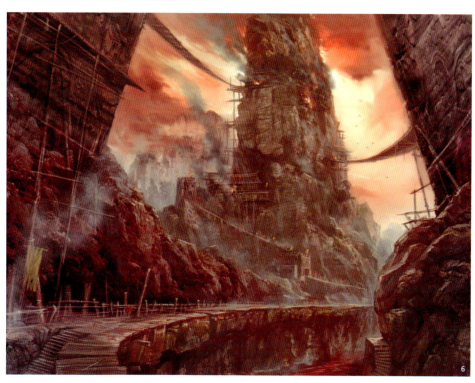

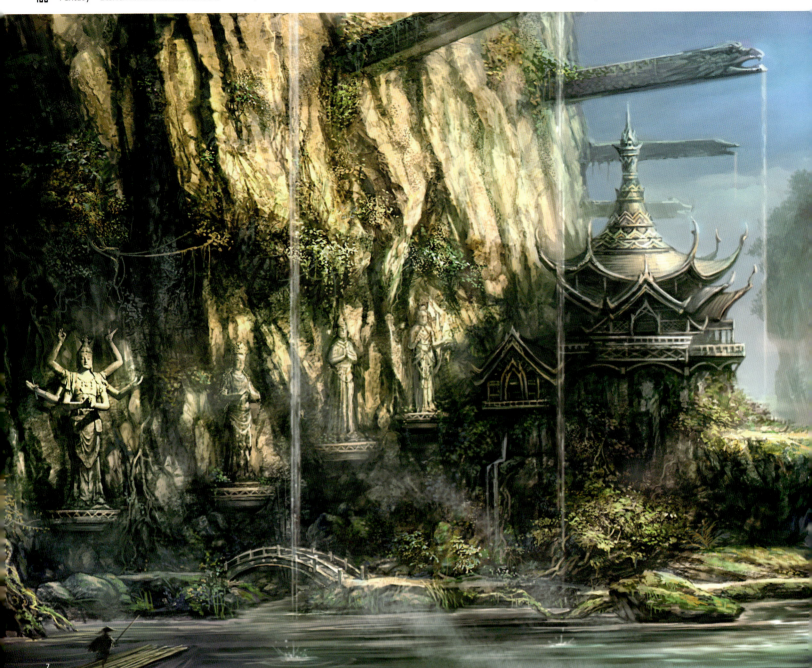

7

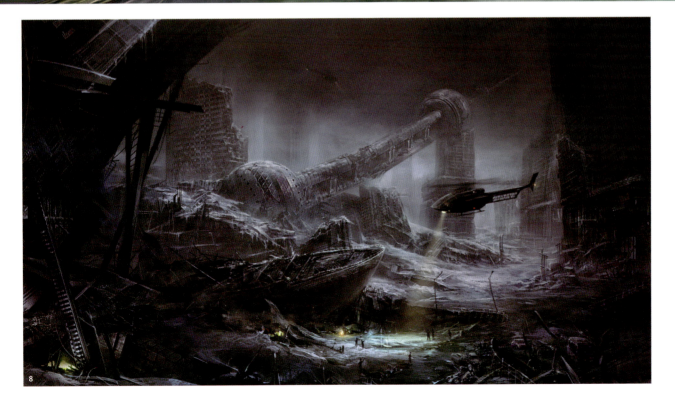

8

❼ Login Interface 3 of The Legend of Swordman

❽ Bye-bye, the Earth

*-- **This is the warriordom in your heart, isn't it?***

-- You said it.With each and every painting, a guy indulges in his own world. To most artists, the spiritual garden is their favorite haunt, and they stay there daydreaming, forgetting to go home. In fact, game players sometimes have the same feeling. I've been looking to design a game like this: The setting is a metropolis in future China; Doomsday is drawing near; tension and metal prevail everywhere. Just thoughts, no action. In any event, I think a world like that must be fun and buzzing with Oriental culture.

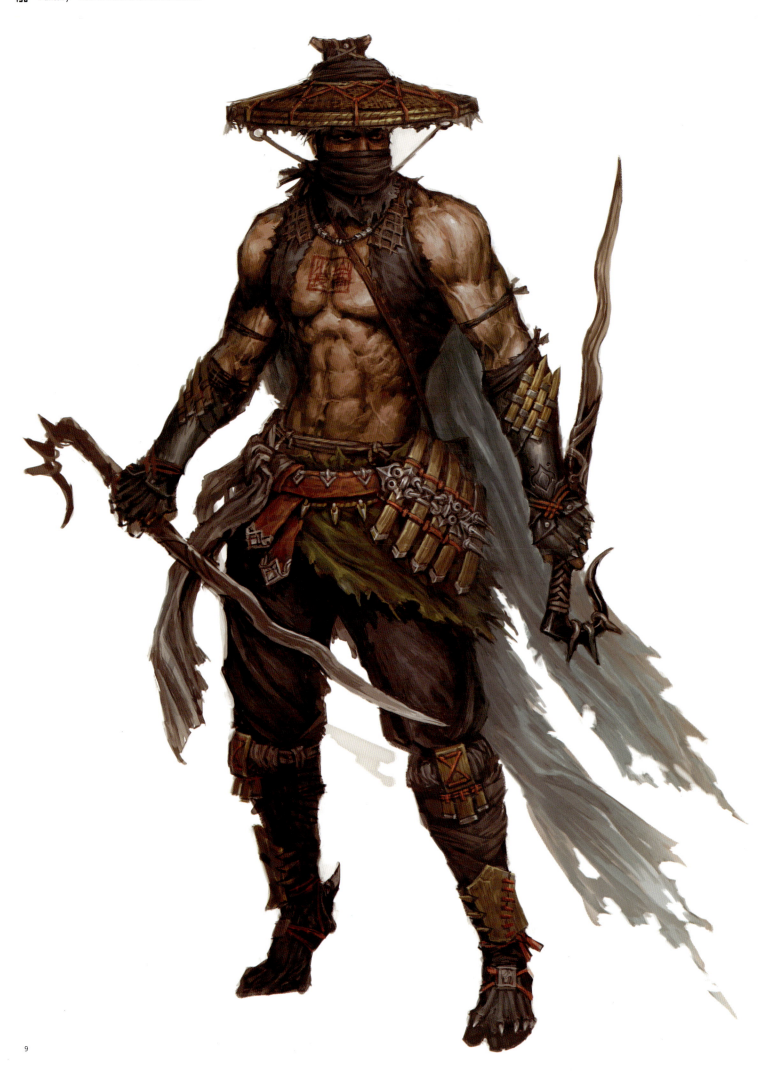

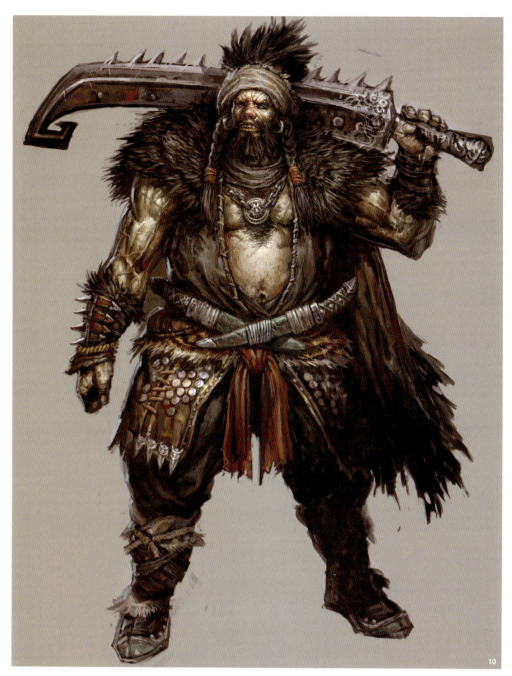

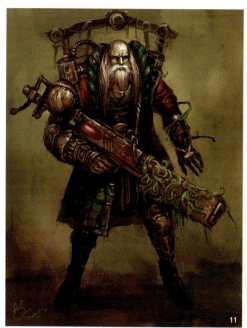

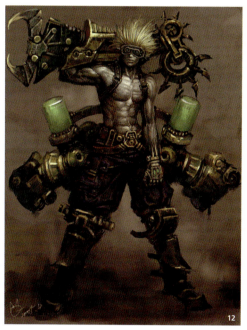

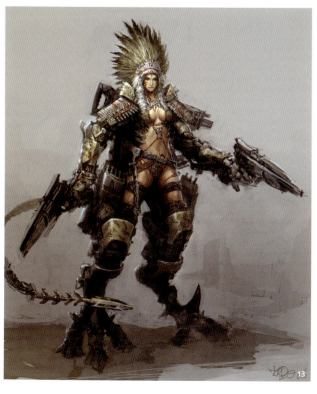

❾ Cut-throat

❿ Horse Thief

⓫ Sniper

⓬ Warrior

⓭ Warrior Girl

Fantasy+ -Best Artworks of Chinese CG Artists
Author: Vincent Zhao
Project Editors: Guang Guo, Yvonne Zhao, Xiaoqiang Yi
English Translator: Hongjun Ma
Copy Editor: Gill Davies
Book Designer: Jing Yu

Fantasy+ -Best Artworks of Chinese CG Artists
©2009 by China Youth Press, Roaring Lion Media Ltd. and
CYP International Ltd.
China Youth Press, Roaring Lion Media Ltd. and CYP
International Ltd. have all rights which have been granted to
CYP International Ltd. to publish and distribute the English
edition globally.

First published in the United Kingdom in March 2009 by
CYPI PRESS

Add: 79 College Road, Harrow Middlesex, Greater London,
HA1 1BD, UK
Tel: +44 (0) 20 3178 7279
Fax: +44 (0) 20 3002 4648
E-mail: sales@cypi.net editor@cypi.net
Website: www.cypi.co.uk
ISBN: 978-0-9560453-2-4

Printed in China